Figuring It Out

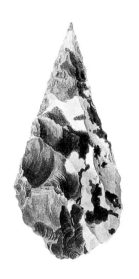

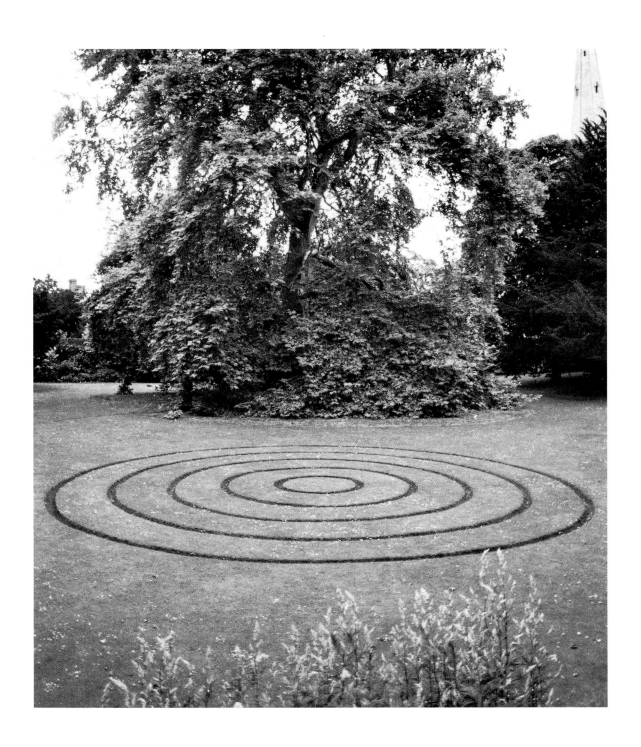

Colin Renfrew

Figuring It Out

What are we? Where do we come from?
The parallel visions of artists and archaeologists

with 175 illustrations, 55 in color

 Thames & Hudson

For Jane
and for
Helena, Alban and Magnus

Half-title Handaxe, published by John Frere in *Archaeologia*, 1800.
Frontispiece *Turf Circles*, 1988, by Richard Long.

First published in hardcover in the United States of America in 2003 by
Thames & Hudson Inc., 500 Fifth Avenue, New York, New York 10110

thamesandhudsonusa.com

Library of Congress Catalog Card Number 2002100531
ISBN 0-500-05114-3

Printed and bound in Singapore by Star Standard Industries

Contents

Preface

J ust about the most interesting question for anyone alive today is figuring out who we are – trying, that is, to understand what it is to be human, and what we are doing here on this earth and how we got here and where from. Of course, there are many different approaches to that question, and they vary according to the interests and beliefs of the researcher. Some religious faiths have the answers ready and conveniently available.

This book takes a fresh look at the human past, our past, with the purpose of answering that question and of understanding better our own place in the present world. In effect, the book is about you as much as it is about me: it seeks to understand who we are as human beings, and how we have come to be what we are. The dream of coming to an understanding of our situation in the scheme of things, of contemplating, in effect, the human condition, is not a new one. Every culture, every civilization has its own creation myth, its own Book of Genesis, which tells the story of the Creation, of how the world came to be, and of how humans found their place within it.

In our own time, several answers have already become clear. Cosmological studies have outlined for us the origin of the universe, from the Big Bang to the present day, with the origin of the solar system and of the earth. The elucidation of the double helix of DNA has revealed to us one of the fundamental mechanisms of life, and insights into the processes of evolution by natural selection have made intelligible the origin of species. Painstaking exploration in Africa over the past century has given insights into the origins of our own species, *Homo sapiens*, while advances in the application of molecular genetics are filling in the story in greater detail.

Yet even if we have some insights into the very early origins of humans as hunter-gatherers in the far-off days of the last Ice Age, we have very little understanding of what happened after that, of just what triggered the developments that led on to the emergence and sometimes to the subsequent decline of the great civilizations of the world, and so along a path that leads right down to the modern electronic age. How did we get here? What paths of development have led human societies from the testing exigencies of those hunter-gatherer days 40,000 years ago to the very different realities of the modern urban world?

This book will explore two active approaches towards the comprehension of the modern material world – without denying that there may be others – and show how they converge. The first, not surprisingly, is the science of archaeology, by which we study the early human past by means of the only evidence available to us, the material remains of that past. The second, perhaps less obviously, is visual art – the contemporary visual art of the modern Western world. I have come to feel that the visual arts of today offer a liberation for the student of the past who is seeking to understand the processes that have made us what we are now. Over the past century or so the visual arts have transformed themselves from their preoccupation with beauty and the representation of the world into something much more radical. Today, I would claim, the visual arts have transformed themselves into what might be described as a vast, unco-ordinated yet somehow enormously effective research programme that looks critically at what we are and how we know what we are – at the foundations of knowledge and perception, and of the structures that modern societies have chosen to construct upon those foundations.

The world of the visual arts today is made up of tens of thousands of individuals, most of them doing their own thing. Among them are creative thinkers and workers who are nibbling away, all the time, at what we think we know about the world, at our assumptions, at our preconceptions. Moreover, the insights that they offer are not in the form of words, of long and heavy texts. They come to us through the eyes and sometimes the other senses, offering us direct perceptions from which we may sometimes come to share their insights. These visual explorations, I shall argue, offer a fundamental resource for anyone who

wants to make some sort of sense of the world and of those very different worlds of communities in the past. It is not that this resource offers new answers, or that it will tell us directly how we should understand the world. On the contrary, it offers us new, often paradoxical experiences, which show us how we have misunderstood, or only imperfectly mastered, what we think we know.

The visual arts work through the contact of the artist with the material world. The artist sees that world, experiences it, and then acts upon it, embodying and expressing that experience, and thereby offering us as viewers further experiences. That is obvious enough. What has been insufficiently grasped, however, is that this interaction with the material world has as its exact counterpart the processes by which human societies have themselves, over the centuries and millennia, perceived the material world and then engaged with it through action upon it. This engagement process, I shall argue, is what distinguishes human action from other natural processes. It is the very process that has led us to become what we are. The point here is not some philosophical analysis of the nature of human action (although that may be necessary), but simply to draw attention to the fact that the work of the visual artist and the processes by which societies undergo fundamental change have much in common. This insight offers a very special opportunity to the observer who seeks to understand either or both.

My thesis, then, is that our understanding of the human past is at present very limited. It is limited to what the archaeologists have so far had to tell us from their studies of the material remains that have come down to us from earlier human societies. The archaeologists have dug them up and classified them, they have dated them and put them in museums. But they have not always understood them very well. My argument is that the vast and incoherent 'project' in the contemporary visual arts, mentioned above, has been so radical in many respects that it offers us fresh ways of undertaking the duty of the archaeologist, fresh opportunities to analyse and understand the human past. In the first chapter I shall give an example of how the work of the brilliant contemporary sculptor Richard Long can lead to a reassessment of some of the great monuments from the early history of humankind. These are often

1 *The Beginning of the World*, 1924, by Constantin Brancusi.

the principal remaining documents to survive from the societies that made them. To see them in a fresh light is therefore to reach a new understanding of those early societies, and in turn a new understanding also of how we have become what we are.

This book, then, sets out to explore the ways in which the insights and the critical questions of the contemporary sculptor, painter, performance artist and others can feed back into our own project of studying and understanding the early human past. Such an improved understanding can itself feed back into our evaluation of the human condition and our perception of how we have come to be what we are.

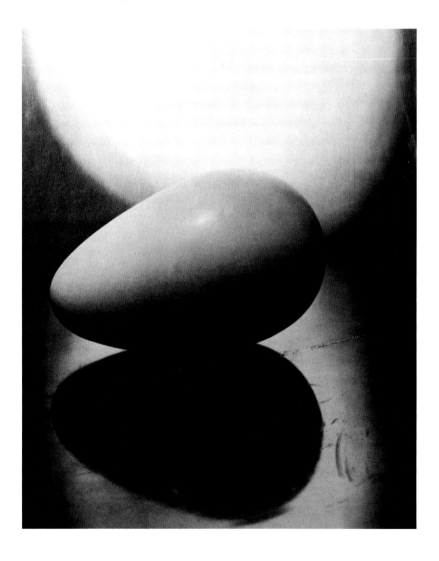

What are we?

O ne way of knowing who and what we are is by understanding how we have become what we are. That is the perspective I have adopted here. For it seems to me that the best way of understanding what is sometimes called the human condition – the place of humans in the world – is through the examination of the processes of change that have transformed human societies from the small groups of hunter-gatherers who were our ancestors to the urban-dwellers of the present day.

The enterprise of this book, looking at art as archaeology and archaeology as art, carries with it the promise of interactions between two fields, in both of which, in different ways, we seek to investigate the 'human condition' – to engage with and to comment upon what it is to be human. I have found that the enigma of how we come to understand our place, the place of each of us, in this bewildering world is imbued with great immediacy as we contemplate the works that contemporary artists – sculptors and painters mainly – have created.

The fundamental questions were posed graphically and effectively by the great French painter Paul Gauguin just over a century ago. Along with Van Gogh and Cézanne, Gauguin was one of the major Post-Impressionist heralds of the modern era in art. He chose to spend his later years among the South Sea Islanders of Polynesia, and came to see the world through their eyes and to depict it in what he thought of as their terms. It was in Tahiti that he painted what he conceived of as his testament,[1] a work that is clearly an allegory of the human condition with its depiction of childhood, maturity and old age [2]. It was also ahead of its time: one of those works that implicitly assert the unity of humankind. It carries with it an ambitious title, painted clearly at the top

left-hand corner of the canvas [13]. It poses the questions that are the principal preoccupation of this book: 'D'où venons nous? Que sommes nous? Où allons nous?' That is to say: Where do we come from? What are we? Where are we going to?

Of course, the merit of the painting is also that it places these rather abstract philosophical questions in a context where specific human beings are seen to live out the implications through their own daily experiences of birth, life and death by means of Gauguin's mastery of colour and skilful and sometimes inspired depiction of the human body. These are the issues that underlie this book. We all need some sort of answer to these questions, and the study of our early human past, reviewing how we have become what we are, offers one positive approach.

Yet I have become dissatisfied with the answers that many archaeologists currently offer on these basic issues. The solution is sometimes given in terms of what has been called the 'human revolution', an event that supposedly took place upwards of 40,000 years ago. Supposedly it brought to Europe our own species, *Homo sapiens sapiens*, and with it new capacities of speech and thought which resulted in a much more skilful adaptation to the environment, and a new self-consciousness made manifest in the palaeolithic cave art of France and Spain. Before their arrival, Europe was peopled by hominids who did not have the same capacities. This, it is suggested, was the key moment when humankind emerged, and the rest (so to speak) is history. But this simple narrative carries with it problems which on examination are so overwhelming that in reality it can be said to explain very little. That is what I call the 'sapient paradox'.

The sapient paradox

Briefly, it is this.[2] The evolution of the human species has been reconstructed in outline by generations of archaeologists and anthropologists working in Africa and elsewhere. We know of our earliest African ancestor of some three million years ago, *Australopithecus*. Then we know that about two million years ago our closer ancestor *Homo habilis* lived in Africa and made the sort of simple pebble tools that have been found at Olduvai Gorge in Kenya. From them descended *Homo erectus*, who

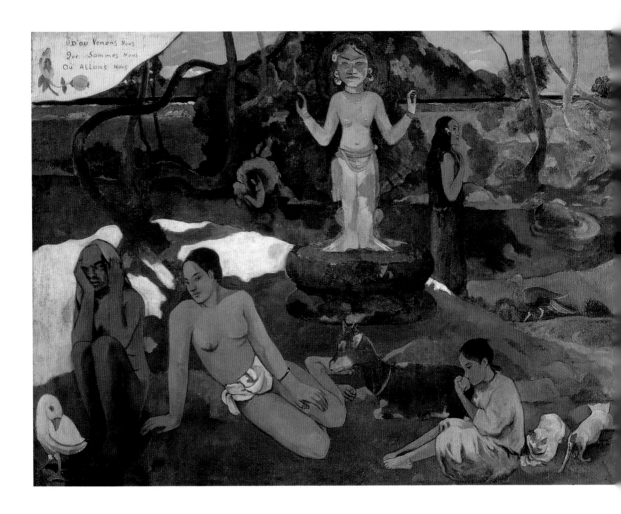

dispersed from Africa to Asia and Europe about a million years ago, leaving the earliest stone tools of those continents, notably the famous 'handaxes' – beautifully worked stone tools – so familiar to us from finds in France and England.

But we now also know – although the matter is not beyond dispute – that our own species, *Homo sapiens sapiens*, emerged in Africa about 150,000 years ago,[3] and that some 60,000 to 80,000 years ago there were dispersals, again to Asia and Europe, and soon to Australia, and later to the Americas. Our species is characterized by more sophisticated tool manufacture, including the use of blade tools.

Remarkably, humans today differ very little genetically from those humans who lived, for instance, 40,000 years ago in France, as Cro-Magnon finds suggest. Research on ancient DNA has shown that the earlier inhabitants, the Neanderthal hominids, were somewhat different from us, and

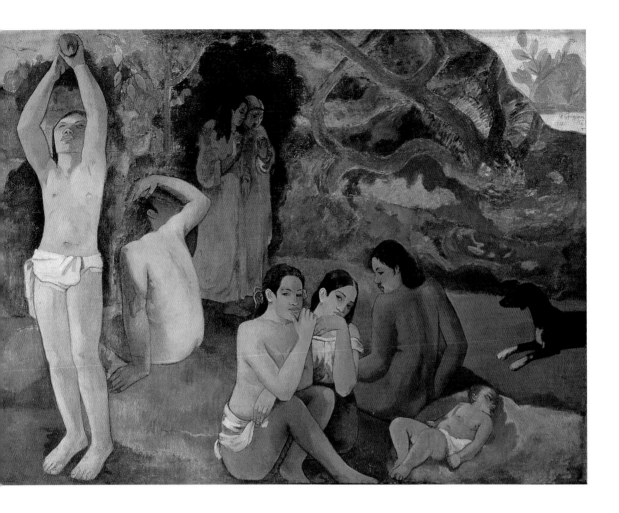

do not form part of our direct ancestry. But on the basis of our present understanding, the difference between ourselves and our *sapiens* ancestors of 40,000 years ago is so restricted that it falls well within the range of modern humans worldwide, and indeed probably within the range of modern humans in Europe today. We are pretty much the same. This is partly illustrated by the remarkable cave art that appeared in France and Spain. The palaeolithic date of the cave paintings of Altamira was recognized a century ago. Since then important discoveries have been made every few years: the great painted cave of Lascaux was found at the end of World War II. And the recent find of the Grotte Chauvet indicates, if the radiocarbon dates are to be believed, that such painting [102] was flourishing in sophisticated form some 30,000 years ago.

Anthropologists have emphasized that we do not differ significantly in our bodies, nor probably in our genetic make-up, from these our

2 Paul Gauguin's 'testament', painted in Tahiti in 1897 and entitled *D'où venons nous? Que sommes nous? Où allons nous?* This is an allegory of the human condition, which Gauguin situates, perhaps for the first time in the Western tradition, outside Europe and Western Asia.

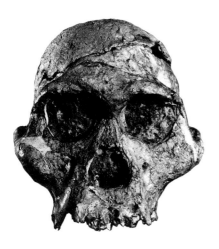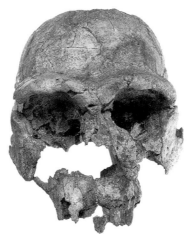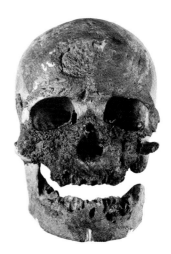

ancestors of 40,000 years ago. The hardware – if I can put it that way –
is the same. They have stressed the significance of what they call the
'human revolution', suggesting that it may have been at this time that our
capacity for effective speech, using a wide range of grammatical struc-
tures, emerged. Our capacity for social life was enhanced. And when we
look at what it is to be human, self-consciousness, or self-awareness, is
part of the equation. So when you listen to biological anthropologists,
you sometimes come to feel that, by 40,000 years ago, the die was cast.
Fully modern humans had arrived. The future was in our grasp.

But these 'modern' humans, as they undoubtedly were anatomically,
did not change the world very quickly. The cave art, and the beautifully
worked 'Venus' figurines that soon followed it, only appeared in quite
limited areas – Europe and a bit further east, on what we now regard as
the steppe lands. Although humans did create symbolic works in other
parts of the world, it is essentially only in Europe and a little to the east
that we see during the Upper Palaeolithic period the dazzling cave art of
the Franco-Cantabrian style, and the 'mobiliary art' in bone, antler and
stone that we so much admire today.

Although our *sapiens* ancestors demand our admiration for surviving
the climatic changes that they endured, and indeed for colonizing the
whole world, it was not until some 30,000 years later – around 10,000
years ago – at the end of the Ice Age, that we see the beginnings of
settled life, with permanent villages or even towns. That is admirably
documented, for instance, by the important farming site of Çatalhöyük

in Anatolia, to which we will return later. It is not until then that we see the explosion of settlement, based upon farming, with permanent housing, new crafts such as pottery and weaving, effigies of the gods, the development of wide trading networks and, after a few thousand years more, the emergence of urban life.

In Europe it is not until the neolithic period that we see the megalithic phenomenon, starting around 4000 BC, with built stone monuments like Newgrange in Ireland, or Maeshowe in Orkney, or indeed the Ring of Brodgar. These were produced before metallurgy was practised in those regions. They played their part in societies that 3,000 years later were on the brink of urbanization.

This then is the 'sapient paradox'. How come, if the 'human revolution' took place 40,000 years ago in Europe, and even earlier in some other places, we had to wait another 30,000 years for these things to happen? As I have said, it is sometimes suggested that it is the new hardware – the essential genetic mutations associated with our own species – that was of decisive importance. Important it may have been, but it is rather in the changes that followed, changes in the 'software', in how we learnt to do things, and in our developing relationship with the physical as well as the social world, that the fundamental shift came about.

I shall argue in the course of this book that the key to understanding these changes lies in the *process of engagement* between our human prede-cessors and the material world, a process that involved intelligence and cognitive abilities as well as work and perseverance. Our archaeological investigation has to involve what one may term 'cognitive archaeology' – the study through the material record of the thought processes and the symbolic developments of our prehistoric forerunners.

So this is one of my two themes. Thus, although we shall be looking a good deal at contemporary art, the ultimate goal of this line of inquiry remains at least in part archaeological – that is, to use such insights as we may gather to illuminate our understanding of the human past. Part of that illumination process may be described as 'reflexive': by examining how we think today about the past, the conventions of thought and the analytical means, by re-examining our own assumptions and procedures, we may come better to understand that past itself.

3, 4 and 5 The evolution of *Homo sapiens*. *Left* Fossil skull of one of our earliest hominid ancestors, *Australo-pithecus*, about 2.5 million years old, from Sterkfontein, South Africa. *Centre* Fossil skull of *Homo erectus*, the earliest hominid species to disperse from Africa to much of Asia and Europe, and the maker of the widely found 'handaxes', about 1.7 million years old, from Koobi Fora, Kenya. *Right* Fossil skull of our own species, *Homo sapiens sapiens*, about 32,000 years old, found at Cro-Magnon, near Les Eyzies, France.

The creative analogy

The other major theme here is the relevance of contemporary art to our project of better understanding our place in the world, and doing so through the contemplation of the human past. To symbolize the magnitude of the task of understanding ourselves and our present condition through the vestiges of that past, I would like to introduce two images.

The first is a group of figures by Eduardo Paolozzi[‡] in the National Museum of Scotland. Paolozzi is one of Britain's greatest postwar sculptors, and his figures will serve as an emblem for the uncertainty

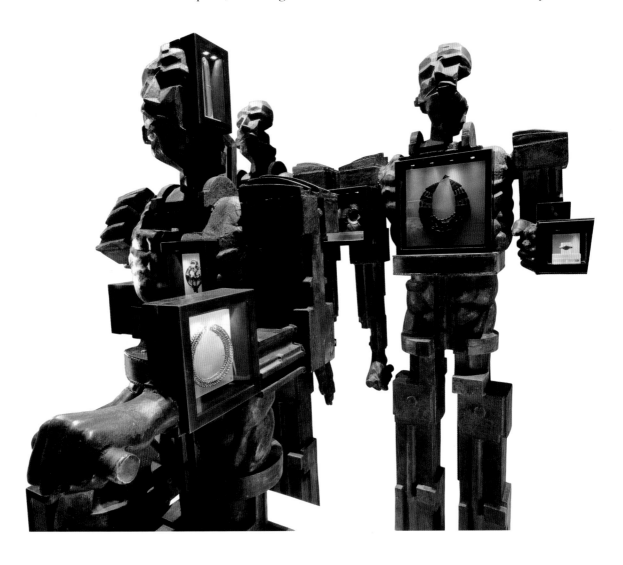

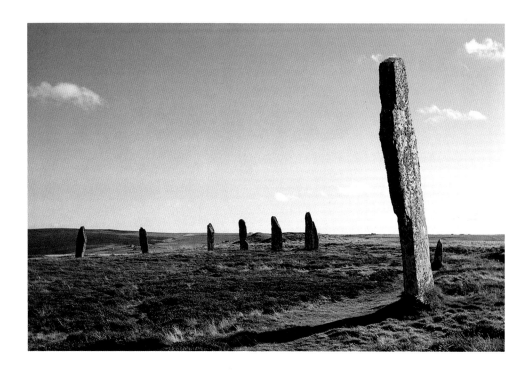

that we face in confronting that past. The figures in Edinburgh are highly unusual in that they have, set into their chests and elsewhere, a series of glass panels, through which items of prehistoric jewellery and other ancient finds may be seen. In fact, they serve as giant reliquaries containing some of the most important early finds from Scotland's past. Each is a powerful presence: intimidating perhaps, suggestive, unmistakably human, but not altogether so. And what are we to make of the objects that they hold? How can we date them, infer what may have been their use, ascribe them to the people that made them, understand what they may have meant to their makers? These are familiar, indeed universal, problems for the archaeologist, and they are emphasized by this unusual mode of display. The figures, like the objects, are enigmatic – their meaning is not entirely clear to us, but one feels a deep sense that they do have meaning. They have something to say.

The second image is a place, a created place. I have chosen to illustrate one of my favourite historic sites in all the world: the Ring of Brodgar[5] on the Mainland of the Orkney Islands. It is a circle of standing stones, situated on a neck of land lying between two lakes, the Loch of Stenness and the Loch of Harray. Beyond it the land narrows to a causeway between the lochs, and on the other side is a similar, smaller

6 *opposite* Presenting the past: bronze figures by Eduardo Paolozzi in the Early People Gallery in the Museum of Scotland. Each figure contains an inset display space in which a prestigious artefact from Scotland's early past, for instance a prehistoric gold earring or a silver Pictish chain, is displayed behind a glass panel – a contemporary version of the medieval reliquary.

7 Creating place and community, establishing the centre: the imposing prehistoric stone circle, the Ring of Brodgar, in the Orkney Islands, *c.* 3000 BC. But what mean these stones?

circle of standing stones, the Stones of Stenness. Both monuments, dated to around 2500 BC, are what the archaeologist calls 'henges' – the basic form is a circular ditch, here cut in the rock, with either one or two entrances where the ditch is interrupted. In some cases, as most famously at Stonehenge in southern England, the monument contains a circle of standing stones. On Orkney, these stones, which being cut from the local laminar sandstone are flat and thin, stand stark against the sky. Nearby is a recently excavated village settlement of about the same date, and only a few hundred metres away, across the placid waters of the Loch of Harray, is situated one of the finest of the prehistoric chamber tombs of Europe, Maeshowe.

The Ring of Brodgar – and indeed this whole complex of monuments – is impressive in a way that is difficult to describe. It is simple in form. Its presence heightens one's awareness of the landscape at the juncture of the two lochs, and offers a focus to the gentle slopes which surround them and the hills beyond. As so often in Orkney, the light from the sea, or in this case the lochs, and the light from the sky seem to merge in lucid brightness. No one who has been there could doubt that this was and is a special place, which had a very special meaning for its makers.

When it was first described in detail a century and a half ago, the Ring of Brodgar was very little understood. The methods were not then available to date it to the neolithic period, the time of the first farmers of Orkney, nor was its relationship to the great wealth of other prehistoric monuments in Orkney recognized. Today, as a result of subsequent research, we know a great deal more. But as a monument, its presence somehow still transcends our knowledge or understanding. There is more to say, although we do not yet know how to say it.

Our interest but very limited understanding before the Ring of Brodgar, or indeed before the Paolozzi figures, is very much like our initial reaction when we look at the great range of works that are exhibited to us in the name of 'modern art'. Indeed, there is a crucial analogy here between the position of the visitor to the Ring of Brodgar, seeking to learn something of the past through this formidable relic, and the visitor to an art gallery hoping to come to terms with some initially rather puzzling object which is presented as a work of art.

Go into a contemporary art gallery – say, Tate Modern [12] – and you will find all kinds of weird and wonderful exhibits displayed for your delectation in the name of art. As I will discuss in the second chapter, the nature of art has changed considerably since the days when you could expect a painting to consist of a piece of canvas decently framed and hung on the wall and to represent a recognizable scene, and a sculpture to be a statue that knows its place upon its plinth.

Today, the sceptical gallery-goer may feel that anything goes. A Paolozzi sculpture may at first sight resemble a heap of junk. William Turnbull is one of the greatest living British sculptors, yet when he calls a work *Head*, and what you see is a roughly circular lump of bronze [53], you may not at first feel greatly the wiser.

Here I am referring to works by some of the living artists, upon whom I set most store, and about whom I shall be talking further. I should say at the outset that their works are not always easy to get to know. One of the most distinguished living British figurative painters is John Bellany [8], but why do his seafarers so often have a fish on their head? I have the greatest admiration for Andy Goldsworthy, and gallery-goers are increasingly coming to appreciate his brilliant interventions in the world of nature [9] for the illumination they give – an arch constructed by him from fragments of ice can bring with it a sense of wonder. But this is not sculpture as we knew it fifty years ago. One of the wisest living artists in Britain is Ian Hamilton Finlay, and in the final chapter here we will be considering what we can learn from him about writing and its impact upon human existence. But you have to know something of his work and understand the role of a cryptic inscription on stone in a landscaped garden [10] before you can see the point. David Mach is one of the most subversive contemporary sculptors, and his massive construction of a submarine or a temple out of used car tyres [11] may at first seem unexpected, at the very least. I shall argue that he gives us new insights into the way humans use things, and into the world of the consumer durable.

These are some of the artists on whom I shall be relying to develop my arguments.[6] But unless you are already well acquainted with some galleries of modern art and their contents you may find some of those things cryptic and enigmatic. I agree, and that is exactly my point. It is

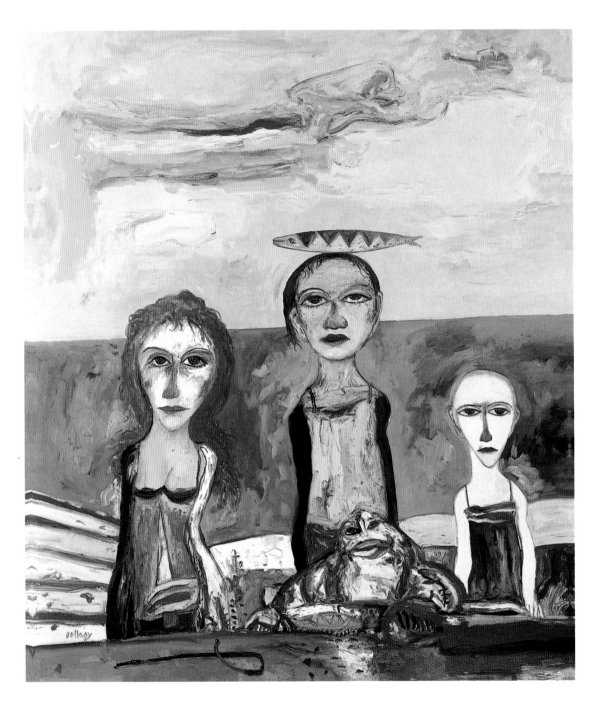

my central thesis that there is an apparent analogy between the position of the observer, the gallery-goer who sees such works for the first time, and the archaeologist, who has excavated assemblages of artefacts from the past and has to make some kind of sense out of them. You the viewer and you the archaeologist are in much the same position. You are coming

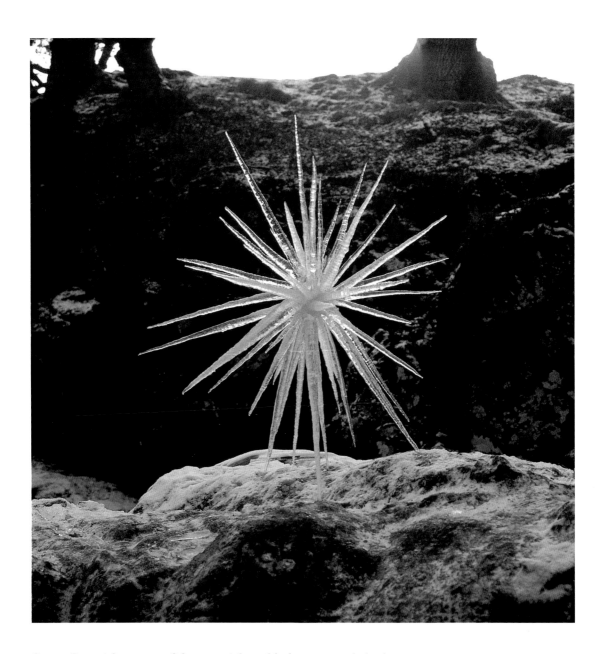

face to face with aspects of the material world, the man-made (or human-made) material world. What is it? What does it mean? What were the people that made it that way getting at? How do we undertake the task of ascribing meaning to material culture?

My argument is that this is no superficial play on words. It is not even a metaphor, where one viewpoint is translated into another. I am asserting that the task is the same: this is no analogy. It is to look at the material world that humans have made and to make for ourselves some

8 *opposite* Contemporary allegory: *Seafarers*, 1998, by the Scottish painter John Bellany.

9 Sculpture in the landscape: *Icicles*, 1987, by Andy Goldsworthy.

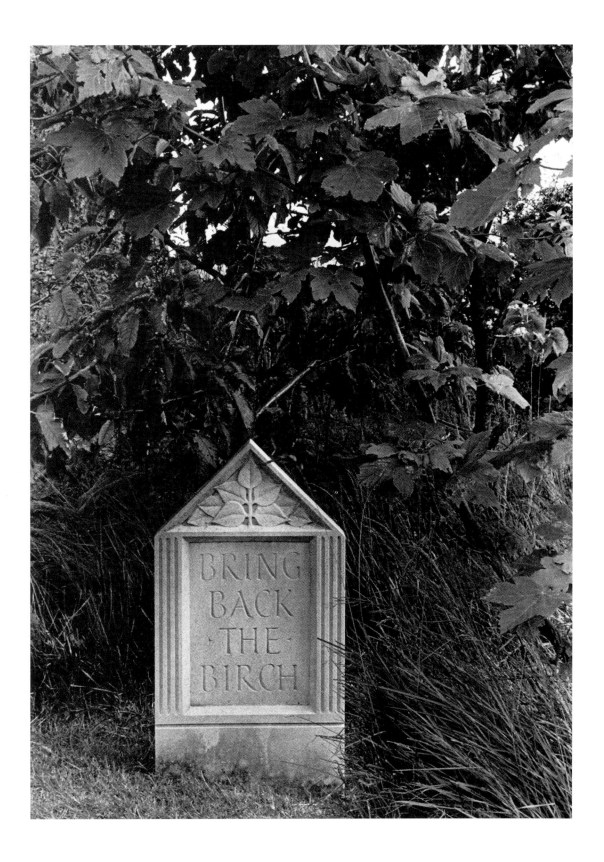

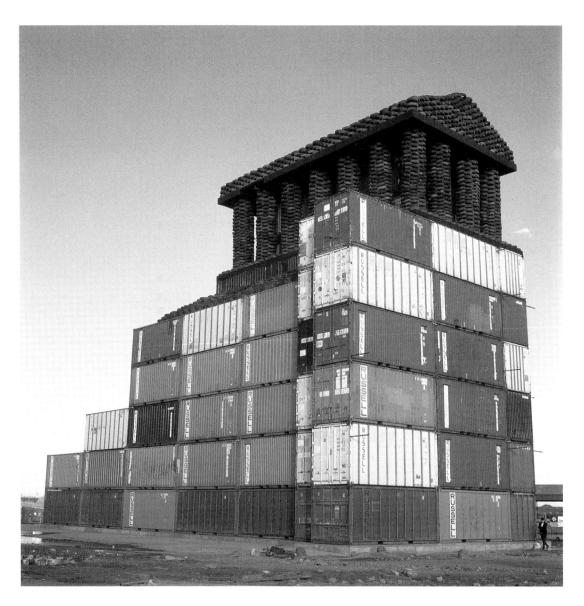

sense out of it. Of course, we would like to know what the original makers were thinking. But we shall never know that completely. As postmodern thinkers have pointed out, you can never know just what a writer, even of our own time, was thinking or experiencing as she or he wrote the text before us now.

So the task of putting oneself into the shoes of a prehistoric craftsman or a contemporary sculptor is not really feasible. But for the cognitive archaeologist there is the hope of getting some understanding of the thought processes and the cognitive world in which that

10 *opposite* Elegiac inscription in the garden: *Bring Back the Birch*, 1971, by Ian Hamilton Finlay with Michael Harvey, in his garden at Stonypath, Scotland.

11 Sculpture in an urban context: *Temple at Tyre*, 1994, by David Mach, at Leith Docks, Scotland.

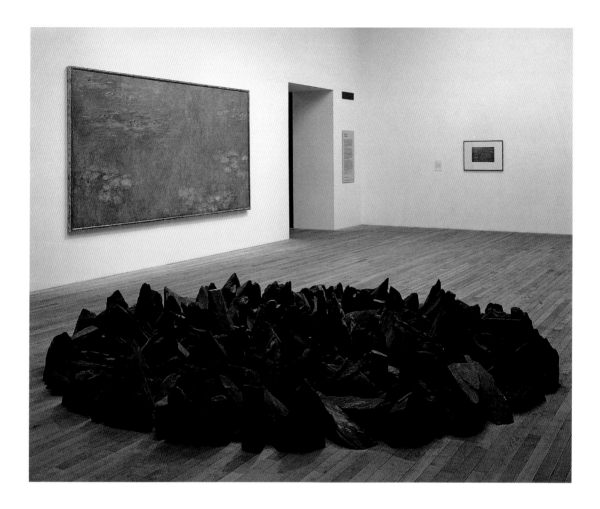

individual lived, just as for the gallery-goer there is every hope of seeing
what the sculptor or the painter is getting at. Most of the names of
modern movements in painting were initially given by hostile critics –
Impressionists, Fauves, Cubists. But we have since come to look more
favourably upon Monet, Matisse and Picasso.

Hence, I would invite you to take the juxtapositions and comparisons
that I shall offer as seriously intended. They are also supposed to be fun,
since contemporary art is fun. You will find plenty of humour in the work
of Mark Dion, discussed in Chapter 3. There is even humour in the work
of Ian Hamilton Finlay, even if it is sometimes of a rather sardonic variety.

In the next chapter I want to take a specific case to develop the idea
that we should be more open to the sensory experience of visiting
ancient sites or inspecting the relics of the past. Archaeologists, and
indeed everyone who participates, should perhaps be more open to

the full range of sensory experiences that occur during the excavation process. I want to show how contact with the work of the sculptor Richard Long made me very much more aware of the value of such openness, and of the potential of contemporary art for enlarging and sensitizing our range of responses.

In the two chapters that follow I shall then trace some episodes in the history of the visual arts over the past century, and the various different ways of seeing the world that have become clearer and more explicit as a result. These ways of seeing and understanding – ways of figuring it out – are available to the archaeologist as he or she tries to make sense of the material record of the past.

Then in the remaining three chapters I shall try to apply this approach in grappling once more with those questions that Gauguin posed and that are central not only to the work of any archaeologist, but to anyone who wishes to reach some understanding of our place in the world.

12 *opposite* The analogous problem confronting the visitor to the gallery of contemporary art: what mean these stones? Works by Claude Monet and Richard Long in the inaugural display at the new Tate Modern, London, 2000.

13 *D'où venons nous? Que sommes nous? Où allons nous?*, 1897, by Paul Gauguin, detail of figure 2.

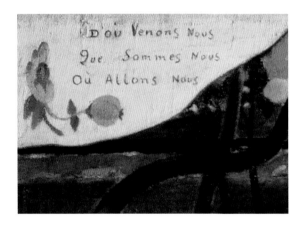

Encounters:
Art as archaeology,
archaeology as art

I would like to begin this chapter by saying something about the excavations that I conducted at Quanterness, a neolithic chambered cairn in Orkney, and to indicate how a chance experience that occurred afterwards led me to take much more seriously than I otherwise might have the work of Richard Long, whom I now regard as one of our great sculptors.

Twenty-five years ago I had the pleasure of beginning the excavation of the chambered cairn of Quanterness,[1] north of Kirkwall [14]. The site had been investigated briefly by the antiquary George Barry in 1805, and then forgotten. (Forgotten, that is, by all except Audrey Henshall, the distinguished specialist in the chambered cairns of Scotland, who published what was known about the site in her great corpus.)

This was back in the early days of the radiocarbon revolution, when the chronology of prehistoric Europe was still very uncertain, and I was seeking to confirm the independence of the European megalithic monuments from their supposed predecessors in the East Mediterranean. It was still widely supposed that most of the main developments in European prehistory were the result of innovations taking place in the East Mediterranean, where the early civilizations of Egypt and Sumer did

indeed begin. Underlying this belief was the notion of the diffusion of culture as the dominant process producing change in prehistoric times. This diffusion was supposed to have proceeded from the Orient to Europe.

At that time, Orkney was still considered to be the end of the line, and a monument such as Maeshowe was generally dated after 1800 BC, since it had to be later than the supposed prototypes in the Mediterranean. Other chambered tombs of what was called the Maeshowe type were assumed to be based upon the prototype of Maeshowe (itself seen as an import from outside of Orkney) and were therefore considered as being of a later date. I imagined that the reverse might be true and that Maeshowe represented the culmination of an Orcadian tradition, and that Quanterness would prove to be much earlier. Underlying all of this was my wish to understand better the neolithic practice of what Richard Bradley[2] has called 'altering the earth' – the widespread tendency to build great monuments of earth and stone seen over much of northwest Europe, not least in Wessex, where there are earthen long barrows and other monuments such as the cursus, which are detectable today only from aerial photography, but which in their day were prodigious achievements.

So, after seeking permission from the landowner and the Scottish Office, we began work at Quanterness.[3] It was a turf-covered mound, but there was still a small aperture at the top, the result of the depredations in 1805, which showed the cairn to be of stone and indicated that it did indeed contain a chamber or chambers as Barry's sketch had suggested. Our first task was to remove the modern flagpole from the top. We entered the central chamber from above [15], since our predecessors had got in that way, and we also looked for the original entrance at the east side. At the west we cut a careful section down the side of the mound in order to investigate the structure of the cairn. As we dug down into the interior of the central chamber (whose roof had collapsed in 1805) we came upon the original stratified deposits, with a vast mass of human and animal bone [26], containing also a few artefacts – fragments of pottery and a few stone tools. These were carefully plotted in position in a painstaking operation, in which we were aided by electric light [25] supplied via a long cable from the farmer's outbuildings.

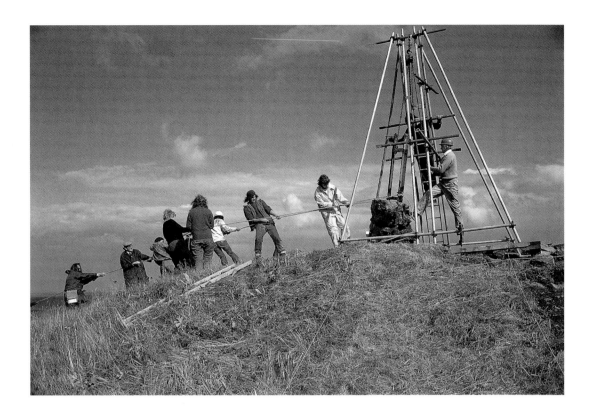

The result of the enterprise was a clear picture of the highly impressive structure of the monument, with its six side chambers [27]. The bone remains suggested to the relevant specialist that as many as 390 individuals might originally have been buried there, and that this was an 'equal access' tomb, available alike to male and female, young and old. Indeed, I went on to interpret it as supporting the view that the chambered cairns, like the long barrows of Wessex, provided focal points for the local communities that created them. These monuments were emblematic structures, symbolizing the existence and the land rights of the community as a whole, as well as serving as the place of burial for its members.

There is of course much more that could be said about the excavations and our findings, and indeed about more recent excavations that throw fresh light upon the prehistory of Orkney. However, the point of my story is not so much the archaeological significance of this specific excavation, as how a subsequent experience led me to reflect anew upon that project and upon the whole enterprise of archaeological excavation in general.

Just a few years afterwards, in 1979, an exhibition was held at the University of Southampton, where I was then based, consisting of a

single sculpture by Richard Long, already a well-established sculptor, but one whose work I had not previously encountered. The sculpture was called *Chalk Line* [17], and like many people at that time I found it difficult to accept as a 'work of art', for it did not in any way conform to my expectations as to what a sculpture should be. It consisted simply of pieces of chalk that Long had laboriously carted into the gallery and set down tidily and carefully to create a wide, regular line. The individual pieces of chalk did not form interior lines or structures – to that extent they were laid randomly. But there were no large gaps between them. At the same time the edges were clear and definite. And that was it.

Since I was not at that time familiar with the sculpture of Long, I had no way of setting *Chalk Line* within the wider context of his other work. Probably, like most of those who saw it, I would have passed it by with a shrug as yet another example of the inscrutable character of much contemporary art. I did not have a context in which to situate the work, which in consequence did not seem very accessible. In short, I didn't understand it.

But there was something that caught my attention, that struck a chord with my previous experience. I was at once impressed by a superficial similarity between the stone line as exposed by the excavation trench [16] on the west side of the Quanterness cairn (which ran downhill from the summit) and Long's *Chalk Line*. Of course, the parallel sides of my stone line were very much the result of the way we had cut the turf overlying the cairn. Yet there was something about the meticulous precision with which Long had executed his work, and the attention of the neolithic builders who had placed their stonework so carefully, and (it has to be said) the care of the excavators – us – in excavating the top of the cairn very neatly and cleaning the stones properly before they were drawn and photographed.

This experience focused my attention more closely upon *Chalk Line*, and I began to see it as rather impressive, arresting even. It induced me to take a closer look at Long's work, which in turn soon obliged me to enlarge

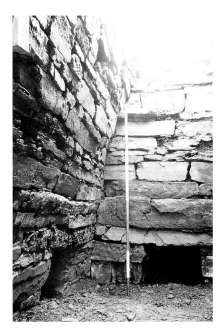

14 *opposite* Archaeologists at work: removing the twentieth-century flagpole from the top of the neolithic chambered cairn at Quanterness, seen against the blue sea and sky of the Orkney Islands.

15 Excavation in the main chamber of the cairn at Quanterness. The roof had collapsed in 1805. The entrance to the north side chamber is seen partly cleared. The scale is in metres.

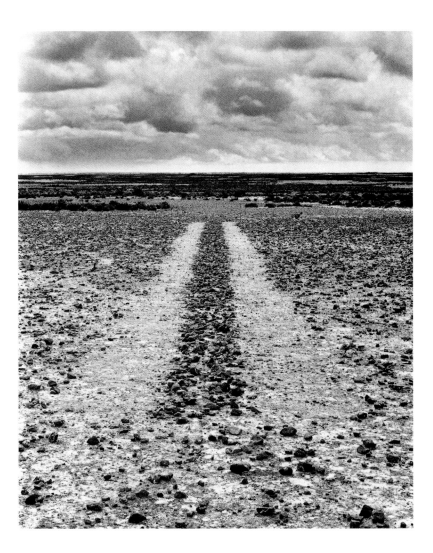

18 *right* Kilroy was here: *A Line in Bolivia*, 1981, by Richard Long, made with minimal disturbance of the desert surface.

19 *opposite above* Walking on top of the world: *Mountain, Lake, Powder Snow*, Lappland, 1985, by Richard Long.

20 *opposite below* Art in words: *A Moved Line*, 1983, by Richard Long, offers a visual record of a twenty-two-mile walk undertaken by the artist.

much' which is in fact the special and remote place where Long has chosen to situate his 'line'. Long has made his mark, and although what he has undertaken is only the work of a few hours, he has in a sense created a monument, a personal monument to his presence and indeed to his existence. Yet while visually striking, the disturbance to the environment has been minimal.

Sometimes the effect of Long's intervention is not only striking but so carefully judged in its measured impact as to seem rather beautiful. That may be a difficult term to define or justify. But in the case of *Mountain, Lake, Powder Snow*, made in Lappland in 1985, there is something unexpected and wonderful and very light about the work that may warrant such a subjective assessment. Here, as so often, Long prefers the

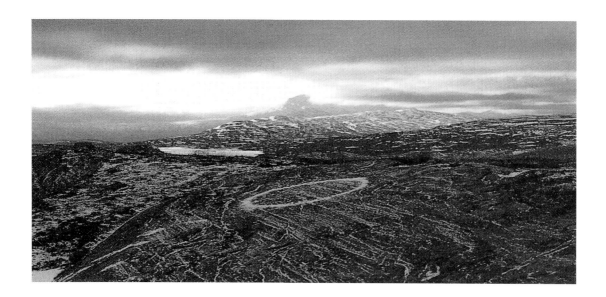

simple forms of the circle or the straight line as the basis for his action.

These works are all by-products of walks, and in a sense records of them. The walks have been undertaken in many parts of the world, over all the continents. And the records can be photographs of these interventions, or other ways of recording them, such as notations on maps. Then there are Long's 'word works', which are a different form of record, but essentially the same in intention. Instead of a photograph, Long provides a record of impressions, noted in sequence, generally following a particular theme or line of thought. Again the work is printed, in an edition of one (usually) upon a large sheet, which is framed. This is the 'work' and it is exhibited in the gallery.

Later, Long adapted the technique of his 'interventions' – the use of local materials to form a simple shape, often a line or a circle, in the landscape – for gallery use. He began to bring these materials into the exhibition space and create there the sorts of forms that he had previously created in the open air in the course of his walks. *Chalk Line* in Southampton was one such indoor work.

Long has made few written statements. But those that he has made illustrate the point that there is no hidden

A MOVED LINE

PICKING UP CARRYING PLACING
ONE THING TO ANOTHER
ALONG A STRAIGHT 22 MILE WALK

MOSS TO WOOL
WOOL TO ROOT
ROOT TO PEAT
PEAT TO SHEEP'S HORN
SHEEP'S HORN TO STONE
STONE TO LICHEN
LICHEN TO TOADSTOOL
TOADSTOOL TO BONE
BONE TO FEATHER
FEATHER TO STICK
STICK TO JAWBONE
JAWBONE TO STONE
STONE TO FROG
FROG TO WOOL
WOOL TO BONE
BONE TO BIRD PELLET
BIRD PELLET TO STONE
STONE TO SHEEP'S HORN
SHEEP'S HORN TO PINE CONE
PINE CONE TO BARK
BARK TO BEECH NUT
BEECH NUT TO STONE
STONE TO THE END OF THE WALK

DARTMOOR 1983

22 Simplicity of resource: *River Avon Mud Hand Circles*, 1996, by Richard Long, at Jesus College, Cambridge.

photographed the result. Now is that a 'work of art'? That depends upon your definition. It took me a while to realize that it is, and that if it didn't at first seem so to me, then it was my definition that needed repair and maintenance, not the work. That is an issue to which we shall return in the next chapter. But it is also a presence, a presence at its most ephemeral. Each work by Richard Long is at once so simple and so deliberate, so fragile yet so carefully placed, that it becomes an existential statement. That may sound pretentious, but it means what it says. Each of these works by its very effect upon the viewer becomes a declaration of human existence. It says: 'I was here and I did this. It may not be much, but this is what I did.' And underlying that is the implication that I was here and that I exist. Not 'Cogito, ergo sum' – 'I think, therefore I am' – but 'Fingo, ergo sum' – 'I create, therefore I am', the basic statement of the artist through the ages.

Something of this is also evoked by some of Long's mud works. Just about the only images that he allows himself, apart from the traces left by throwing mud at the wall, are the marks of his hands. Sometimes he deliberately uses mud hand-prints. And here, of course, his work echoes some of the earliest known expressions of human activity. For in the palaeolithic art of France and Spain[6] we see hand outlines – not quite mud prints, but instead the outline of the hand left when paint is applied around it. Long may well have been aware of these when he chose to create works made out of hand-prints. And in the frenetic works where Long has applied very liquid mud in an agitated way, we see something of the traces left when our Upper Palaeolithic precursors agitated mud on the wall of a cave.

The pay-off

Richard Long is of course aware of the prehistoric remains to be seen in Britain's landscapes. But I don't think he has been fundamentally influenced by them in the production of his work. It is rather we who are influenced when looking at prehistoric features in the landscape by the experience of knowing the work of Richard Long. When I wrote many years ago[7] that the long barrows and chambered tombs were 'the

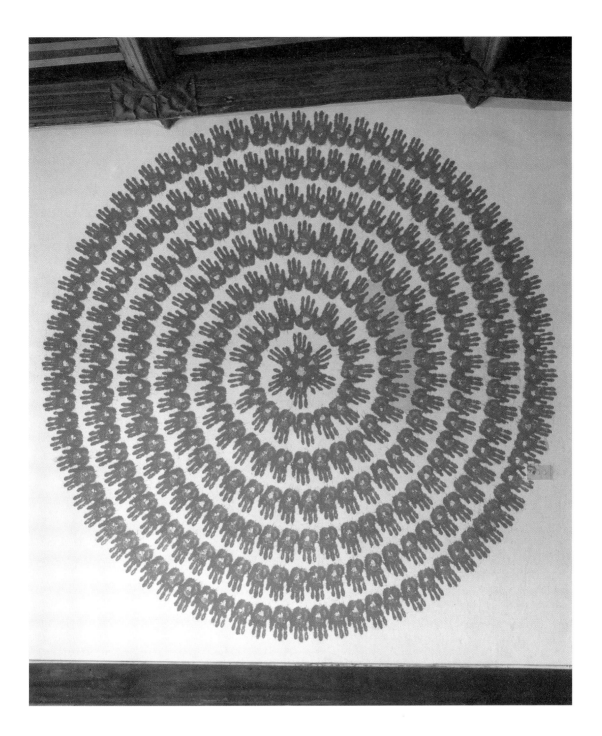

territorial markers of segmentary societies', I did not attach particular attention to the word 'marker'. I was simply drawing attention to the patterning seen in the distribution in the landscape of some of these monuments. In Orkney, for instance, the chambered cairns like

Quanterness tend to be spaced so that each one could very credibly have been the focal point for a farming community, signalling that the surrounding territory was the preserve of that particular social group. Each group was on the same scale as its neighbouring ones, and these were distributed across the landscape. That is why they were 'segmentary societies'. You can see this pattern clearly in Orkney today. And the central area, with the Ring of Brodgar and the Stones of Stenness, appears as a grander centre, perhaps a social focus for the island as a whole and for the various communities that occupied it around 2500 BC.

Now, however, under the influence of Richard Long, the word 'marker' takes on a new significance. I am more inclined to see the chambered cairns, the long barrows and cursus, and the standing stones as 'markers': features introduced into the landscape by the architects or sculptors who devised them. And each such feature is a statement, the product of a deliberate and conspicuous act. We often call these things 'monuments', and indeed they are. They were made to be remembered: they evoke and incorporate and even create memory. And unlike the field works by Long, these prehistoric features are permanent, or at least enduring. This is the 'altered earth' to which Richard Bradley has referred, it is the created landscape, the social landscape of which Chris Tilley[8] has written. But for me the beauty of this experience is that the realization of the power of these constructions in shaping not only the landscape but the social order, does not come to us through the interpretation of words but through pure visual experience. Through Long's work I see these prehistoric monuments more clearly as works of deliberation, and as assertions of the intention that the presence of their makers should be seen, known, accepted (since ownership or land rights are involved) and remembered.

And this was achieved through the physical experience of the builders – by their labour, their moving of the soil – just as it is achieved by the deliberation and pertinacity of Long today. And it is communicated to us through our own experience, through what we see and feel in the gallery as we contemplate Long's work; through what we see and feel in the meadow or on the hill when we encounter the cairn; through what we see and feel as we walk around the circle of stones that constitutes the

23 Richard Long completing *Orcadian Circle* at Jesus College in 1992, following a visit which he had made to the Orkney Islands in the previous year.

Ring of Brodgar; through what we see and feel as we crawl down the entrance passage of Quanterness cairn or Maeshowe. Now, I am well aware that this might be called a 'phenomenological' approach. It is based upon our experience of the world through the senses. But the nice thing is that I don't have to use the word 'phenomenological' in order to perceive and understand it. It is not necessary that I grapple directly with the philosophy of Heidegger (upon whom Julian Thomas and indeed Chris Tilley have drawn in their informative writings upon this theme). For instead I have myself *been* there and *felt* that already. I speak from personal experience. And I have felt it partly at least because I have been conducted to it through the pioneering work of Richard Long.

Experiencing

One experiences the work of Long through the senses – in the gallery or outdoors (as with *Turf Circles* [34] or *Orcadian Circle*). This and other encounters with contemporary art have led me to seek to include more deliberately, in my view of the experience of excavation, the various

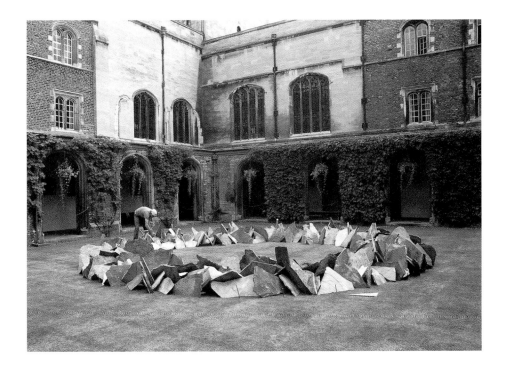

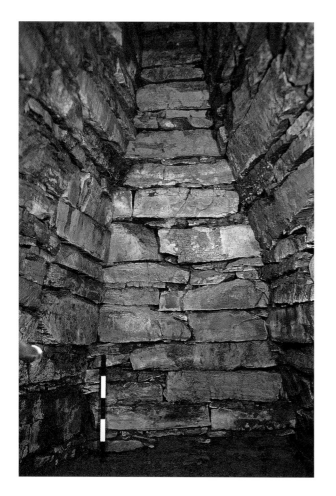

sensory impressions that one undergoes in the process – the parched days under a hot sun in Greece; the pouring rain and sustained wind on the day at Quanterness when, working together as a team, we had to backfill that west section in the course of a few hours, and never mind the weather. But also the sense of mystery and solitude when I was the first to enter, perhaps for thousands of years, one of the side chambers at Quanterness and stand up with the cold, damp sandstone all around me, and reach my hand above my head to touch the still complete corbelling of the ceiling. You don't find much about these moments in the printed excavation report, but they are an integral part of the reality.

Visual images alone cannot evoke the silence and the occasional drip of water when you are alone inside a chambered cairn, or the thud on the ground overhead when someone arrives outside, nor the quiet, damp smell inside a monument that has been at peace for 5,000 years. Sometimes one may notice features, if one savours the moment, which were also relevant at the time the site was in use those long years ago.

Then there is the play of light and dark: the feeling of intense activity during excavation in the narrow space, promoted by the glare of electric lights which produce more light than has been available there for the five millennia and more since sunshine was excluded from the construction. And the yellow plastic of the helmets of the team of archaeologists strikes a strongly incongruous visual note among the harmonies of brown – stone, soil, bone. These are the sense impressions of the present rather than the past, and these too are relevant as we evaluate the contrast between past and present.

24 Entering side chamber G of the Quanterness cairn, where the sandstone corbelling has been in place since its construction in *c.* 3400 BC. This is one of the earliest completely preserved built spaces in the world which can still be entered nearly 5,500 years after its construction.

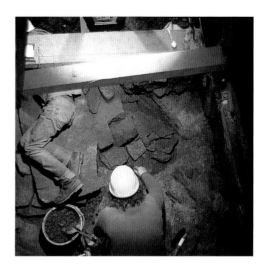

Most are difficult to capture and record: one is aware of such impressions as they occur and then they are gone. An excavation is a busy place where many things are happening and one does not always consciously register all these images and sounds, the experiences of touch and temperature. But it is this complex of sense impressions that constitutes the present reality, not merely the measurements that we seek to abstract and record. The past reality too was made up of a complex of experiences and feelings, and it also was experienced by human beings similar in some ways to ourselves.

Yet some recorded images do succeed in recalling for us some aspects of the atmosphere during the excavation process, for instance in the enclosed space of the side chamber at Quanterness where the yellow plastic helmets of the diggers intruded anachronistically into the monochrome of the until recently undisturbed space. Something of the feeling that one experienced oneself of being somehow alien to that earlier world survives in that photograph.

When you are there, actually digging, you are acutely aware of the brown of the sandstone, and then the brown of the soil, and the brown of the rich compressed layer of fragmentary bone – thousands of bones and little but bone, except for a few fragmentary sherds of pottery, themselves as brown as the soil. When excavating a buried surface one does not always think in painter's terms of the colour harmonies involved. But there are concordances of colour to which one becomes sensitive and which, when you are actually there, help to form one's impression of the place.

The interior of the Quanterness cairn in the moist climate of Orkney presented one such series of harmonies. It offered also the contrast as one came out into that bright, clear Orcadian light, to that brilliant landscape beloved of poets such as

25 Light and dark: visual oppositions of the excavation process. Electric light and garish plastic contrast with the browns of the sandstone blocks and the soil on the floor of side chamber F at Quanterness.

26 Composition in brown: the bone layer in side chamber F in course of excavation.

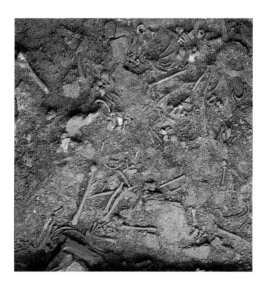

Edwin Muir and George Mackay Brown. These happenings are part of the experience of excavating. And any excavator knows that the reality of being there, in that place, and feeling those effects of wind and rain and light, is part of the pleasure that one takes in the enterprise of fieldwork.

I now feel that too often, in our work as researchers and scholars, we are prone to suppress these immediate sense impressions. They are, of course, subjective, and perhaps do not at first accord with our notions of the objectivity of scientific endeavour. But the latter reaction is an error on our part. For it must be a richer strategy to maximize the range of experiences[9] and impressions that we undergo and record. All experience is subjective. The scientific rigour can come in the evaluation – one may then pause to ask, does one feel this consistently? Is it an impression shared with other observers? What may we infer from it? There is plenty of time for the testing of hypotheses or for the hypothetico-deductive method if these are taken as criteria of scientific rigour. But the experience has to come first.

And then there are the aesthetics of the excavation process, if I can refer to them as such: the pleasures of digging. There is the physical satisfaction, as you hold the trowel, of feeling the layer that you are trying to separate peel away neatly and easily from that which lies beneath, so that one senses that one is not inventing a sequence of arbitrary levels, but really examining the record of the past, layer by layer, as it was laid down.

The recording process also has its pleasures and satisfactions. There is the gratifying feeling, as the stratigraphic excavation proceeds, that order is being created out of chaos. The careful marking and recording of layers, the three-dimensional plotting of finds, the systematic sieving of the residues through a mesh of standard size, all introduce a lucidity and order into the excavation process and offer the hope that the resulting data will yield meaningful patterns on analysis. That too is a kind of cognitive archaeology.

Then there is the satisfaction of a piece of excavation work well conducted: the skeleton beautifully cleaned to be photographed; the pleasure of good archaeological craftsmanship; the stratigraphic section accurately and effectively recorded and drawn.[10] At Quanterness we had the good fortune of having as site architect Alec Daykin, a man with great

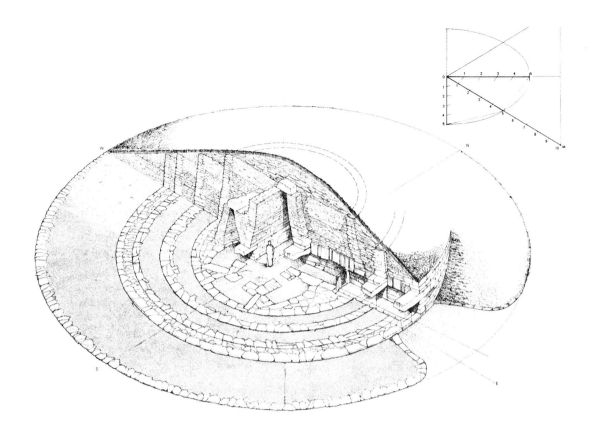

fieldwork experience, an ingenious engineer and a meticulous draughts-
man. So the resulting drawings of the stonework have their own style
and bring their own satisfaction, as well as enhancing one's appreciation
of the skill of the ancient masons. Archaeological draughtsmanship is an
art in itself, and can illuminate the methods of manufacture and the style
of the original object or structure. And then there is the visual satisfaction
of the well-conceived reconstruction, as in Alec Daykin's axonometric
drawing of the entire structure at Quanterness. There is even the satis-
faction, almost physical, when you at last hold the book in your hand, the
completed excavation report with all contributions safely incorporated,
rather like a fleet of small boats returned safely home to harbour.

 These are some of the pleasures of the archaeological process.
But in recognizing them more explicitly lie possibilities for the better
appreciation on our part of the task that we are undertaking, and the
better interpretation of the site under investigation. The end product
remains a scientific publication, but it will be the richer for all the
personal experiences that have gone into its completion.

28 *below* The material pleasures of texture: *Tiled Path Study, with Broken Masonry*, 1989, painted fibreglass, 122 x 122cm, by the Boyle family.

29 and 30 *opposite* Surprise of discovery: The Lady of Phylakopi, a Mycenaean figure from Melos, Greece, *c.* 1300 BC, height 45cm, seen during excavation (left) and after restoration (right) with head reinstated. It is now on view with the other finds from Phylakopi in the Archaeological Museum, Melos.

The pleasures of archaeology

Encounters with the past, or at least with the material world that carries the traces of that past, have a physical and material reality. That is one reason why archaeologists' interactions with the objects of their inquiries and sculptors' engagements with their chosen material have something in common. There are, moreover, further aesthetic aspects to archaeology, other pleasures that one should not overlook. The first is the joy of discovery: to be the first to uncover an object, and then to hold in your hand something that has lain buried in the earth for thousands of years. I shall never forget, during my first excavations as a schoolboy at Canterbury, when digging with the distinguished excavator Sheppard Frere, the fascination of discovering pieces of Roman pottery, the occasional piece of Samian Ware gleaming red in the earth; then the find of a Roman coin, with all its potential chronological implications; and then later, carbonized grains (which at that time were not considered of much value). Or years later, when excavating at a Mycenaean shrine at the bronze-age site of Phylakopi[11] on the Aegean island of Melos, finding what looked like a pottery stand *in situ*. I took it, as a very special object, to our excavation field laboratory for cleaning. Then the vase-mender pointed to two small protuberances which resembled breasts, suggesting that above the break there might well originally have been a head, and that the 'stand' was in fact the representation of a human figure. On returning to the site, I learnt that such a head had been found. Then, when the two were united, I caught the first glimpse for 3,200 years of this small and now reconstituted sculpture, The Lady of Phylakopi.

Along with discovery, there are also the satisfactions of reconstruction. To work with a professional vase-mender

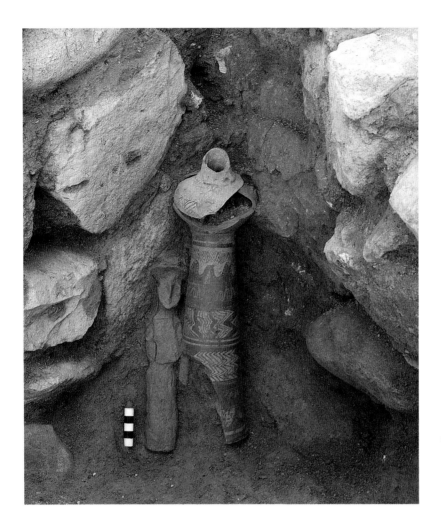

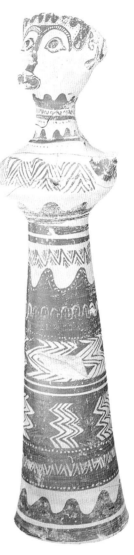

who has before him thousands of fragmentary sherds[12] from a single stratigraphic level, and to see him select out those that he feels might join together to form the reconstructed pottery vessel, is an instructive experience – witnessing his almost uncanny sense of what might fit with what. This, and the skill with which the fragments are glued together so that the entire profile of the vessel emerges, and the missing spaces are carefully filled with plaster, so that the whole pottery form can be determined and photographed, perhaps a form hitherto unknown to the archaeologist: these give a palpable sensation of knowledge being advanced.

Then there is the very physicality of the excavation process: the experiences of soil, earth and stone.[13] The basic activity of archaeology is the process of digging, digging with care using the archaeologist's trowel, not just the pick. In doing so one comes to feel the changing textures of

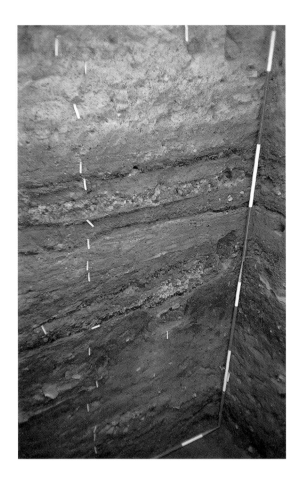

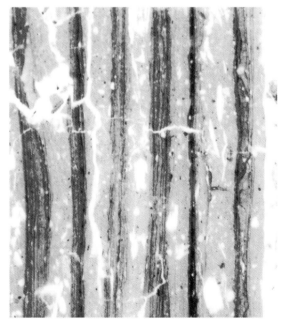

the strata, the compact density of the trampled floor, the loose fill of the post-hole. And working on one of the deeply stratified sites of Western Asia or the Balkans, the tell mounds that may attain a depth of up to 20 metres of accumulated strata [31], there is a fascination with the very formation processes by which this prodigious deposit has accumulated.

But there are also more subtle pleasures and experiences in the exploratory work of the archaeologist involving the detection of patterns that are often far from obvious. One of these is to detect something of significance through very faint traces – like the detection of writing on a writing tablet through infra-red photography. Or, during our Quanterness excavations, the raising of a slab at the lowest level of the tomb and the discovery of a trace, a stain, that could be interpreted as the only surviving indication of a human burial. Or again the experience when a pattern at last begins to show at the end of a magnetometer survey, gradually pieced together with the aid of a computer from thousands of observations. Or the clear determination, through the microscopic study of a thin section taken from a plastered wall [32], of the precise number of times that the wall has been re-plastered. Or again the realization from the air that the patterns of cropmarks, seemingly meaningless at ground level, in fact reveal the plan of prehistoric structures. Once, while visiting the British School at Rome, I had a refreshing evening with Kate Whiteford,[14] who was then artist in residence. We later

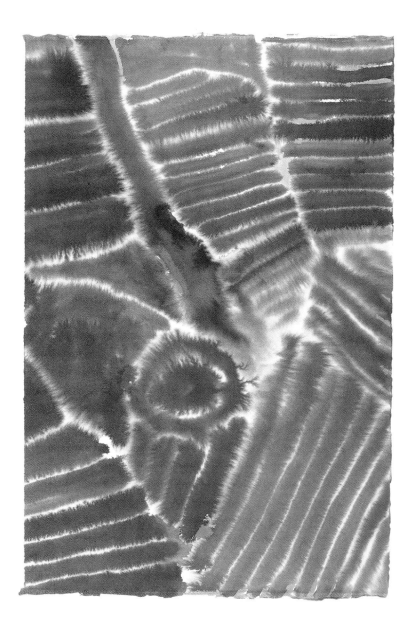

collaborated on a book, where aerial photographs of ancient features in the landscape inspired her own sensitive reaction to this process of 'remote sensing', which was the title I proposed for the book.

From archaeology to art

My argument here is that as students of the past we gather all our information from our various encounters with the material remains of that past. Certainly this holds true for the prehistoric period, when there are

31 *opposite above* Texture, layering, sequence: the deep sounding at the tell mound of Sitagroi, East Macedonia, Greece, 1968.

32 *opposite below* Sensing with the microscope: micromorphology image of successive layers of wall plaster, seen in section, from the early neolithic site of Çatalhöyük in Turkey, *c.* 6700 BC, showing by gradations in colour and texture repeated episodes of plastering on the wall of a house or shrine, and successive dark layers of soot.

33 Remote sensing: *Cassino*, 1997, by Kate Whiteford. The Scottish artist explores in watercolour her reactions to the subtle gradations by which aerial photography reveals the ancient landscape.

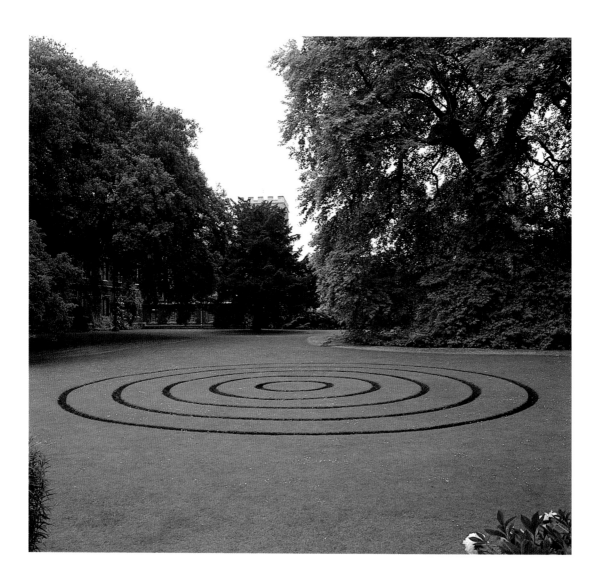

no written records to guide us through the interpretation of texts. That puts us on an equal footing[15] with all those who visit galleries or museums to look at works of art, to find pleasure and enlightenment in the works of great artists, for the experience of the gallery-goer is very similar. It is an encounter with the material creations, the 'works of art', that painters and sculptors have made.

At the same time, those encounters are not just visual – they are something more than the experience of looking at photographs in a book. Experiencing sculpture, though we may not be allowed actually to touch the work, is nonetheless also tactile: it is made of a palpable material, be it marble or wood or stone. It changes in the light. It may be

coated with dust or burnished to a polish. Moreover, it is our interaction with the work that we experience, not some disembodied notion but the physical reality of being present with it, alongside perhaps dozens of other people, in a gallery, or in a church where an organ may be playing and incense burning.

In order to make the most of these encounters, to assimilate them to the full, we need to be alert with mind and senses.[16] Looking and experiencing can and should be a very positive activity. Over the past century that activity of looking has changed profoundly in the field of visual art, because we have come to have a very different understanding of the nature of a 'work of art' and of what happens when we look at it. The postmodern reader has a very different view today of what it is to read a text than the reader of a few decades ago. Then, the aim might have been to reach a valid perception of what the writer intended: the reader was the passive recipient. Today, it is up to the reader to interpret that 'text', and the reader brings to that task a full range of contemporary perceptions and preoccupations. What the writer intended is by no means the most important question. When contemplating the past, I do not myself adopt the 'relativist' position of that postmodern reader, for I imagine that the past really happened, even if it is difficult now to reconstruct it with precision. This might be called a 'realist' view. But I do accept the notion that, in approaching a painting or a sculpture, it pays to be an active viewer, acutely aware of one's own part in the interaction that is taking place. Precisely the same holds, I feel, for the interaction between the archaeologist and the material remains with which we work and which are our basic source of information. That is one reason why I think the archaeologist and the student of the past can learn from the changes that have taken place over the past century in the way we approach the task of confronting and interpreting a work of art. The parallel between the positions of the archaeologist and the art viewer is more than an analogy.[17]

For that reason we shall, in the next two chapters, consider how, over the past century and more, our view of the 'work of art' has changed, along with the way we approach it. We shall find that useful later as we seek to interrogate the material record of the past.

34 Perennial forms: *Turf Circles*, 1988, by Richard Long, in the Fellows' Garden at Jesus College, Cambridge.

What is art?
The tyranny of
the Renaissance

Simplicity in art

In this chapter I want to ask a question that may have been implicit in the discussion in the last chapter, but that we successfully managed to skirt around: what is art? We shall see, when we review the history of taste, that there is no easy answer. Art, like beauty, lies in the eye of the beholder. Indeed, before this chapter is finished, I want to try to grasp that nettle too, and discuss our attitude to beauty.[1]

I also want to discuss the work of one of Britain's major living sculptors, William Turnbull. Already, more than forty years ago, Turnbull was producing works of what seemed the greatest simplicity, and he has continued to do so ever since. I first encountered his work while I was at university, and indeed one of my most valued possessions is a very simple painting that he produced at that time, in the 1960s. It is one of a series of canvases he produced using the very simplest means: flat, unvarying surfaces of paint, in this case in just two contrasting shades of blue, applied uniformly to the canvas and meeting in a well-defined edge. At that time Turnbull was also making sculptures out of sheet metal, some of them brightly coloured, again sometimes of a breathtaking simplicity.

It was a comparable quality of simplicity that first attracted me, like many others, to the prehistoric marble sculptures of the Cycladic islands,

35 'This repulsively ugly head'. Lifesize marble head, c. 2500 BC, from Amorgos in the Cycladic islands of Greece.

which are currently much in demand by museums and collectors. Indeed, I went on to study the archaeology of the early bronze-age Cyclades for my doctoral dissertation, and have continued to work in that area ever since. The juxtaposition of sculpture by Turnbull and that of the early Cyclades allows us to consider some interesting questions in the history of taste and to begin the task of establishing our own position or frame of reference when we approach 'art', whether of other cultures or of contemporary Western artists. And of course we soon discover that it is difficult to do this without answering the question: what is art?

In this chapter I wish to present first the seeming paradox of changing responses to the sculpture of the prehistoric Cyclades, as indeed to the arts of other non-Western traditions, which in the past were sometimes regarded by Europeans as 'primitive'. This then leads us on, after an aside on the ethics of collecting, to the history of taste and to what I have termed[2] (with respect to aesthetic matters) the 'tyranny of the Renaissance'. It is then possible to come to the heart of some of these questions with the aid of the art of William Turnbull. For here we have a body of work by a living artist whose own comments are available on what that sculpture means to him and the way he approaches his work as a sculptor. The work of William Turnbull or Constantin Brancusi allows us to discuss some of the issues that inspired the modern movement in the arts in the twentieth century.

Cycladic sculpture

In 1891, the German archaeologist Paul Wolters published his account of a simple, lifesize marble head that had recently been discovered on the island of Amorgos. He correctly identified it as prehistoric, and we now know that it belongs to a period around 2500 BC, about 2,000 years earlier than the sculptures of Classical Greece which were already very familiar to connoisseurs. In his account Wolters[3] wrote of: 'dieser abstossend hässliche Kopf' – 'this repulsively ugly head'.

36 Marble folded-arm figurines from Doka-thismata in Amorgos, of the kind frequently found in graves in the Cycladic islands.

37 *opposite* Nearly lifesize Cycladic marble figure, *c.* 2500 BC, from Amorgos, today in the National Museum in Athens.

The marble head was the first of many such discoveries, although few of them were on such a scale. Another find on Amorgos was a nearly lifesize figure, although again, as with the head, the precise find circumstances were unclear. Then, a few years later, two little sculptures, each about a foot high, were identified as coming from the small Cycladic island of Keros: a harpist, with very simple lines, and a flautist, playing the double flute which the Greeks of the Classical era 2,000 years later came to call the *diaulos*.

Other scholars found these more attractive than had Wolters, and in 1898 and 1899 the Greek archaeologist Christos Tsountas laid the basis for the systematic study of the Early Cycladic period with a series of excavations in the cemeteries of the Cycladic islands, notably in Paros, Antiparos and Siphnos, and then on the island of Syros, where Tsountas also excavated a fortified settlement. From these at last came some understanding of the contexts in which these sculptures had been found. Although such finds were rare and most Cycladic burial sites had very modest grave goods, about one grave in twenty or thirty did contain a 'figurine', and some had two or more. Subsequent study of the associations in the graves, and some limited excavations of settlements, has allowed us to trace the development of the most frequent variety,[*] the

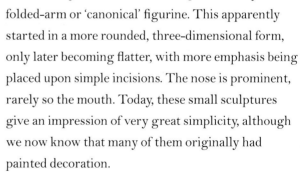

folded-arm or 'canonical' figurine. This apparently started in a more rounded, three-dimensional form, only later becoming flatter, with more emphasis being placed upon simple incisions. The nose is prominent, rarely so the mouth. Today, these small sculptures give an impression of very great simplicity, although we now know that many of them originally had painted decoration.

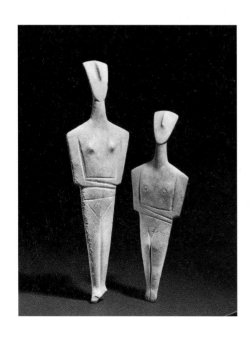

They belong to the Cycladic early bronze age and were made during the third millennium BC, and we can now follow their development from neolithic prototypes through to the different varieties of the folded-arm form. The very large, almost lifesize figures are particularly impressive, although unfortunately none of them comes from a well-documented

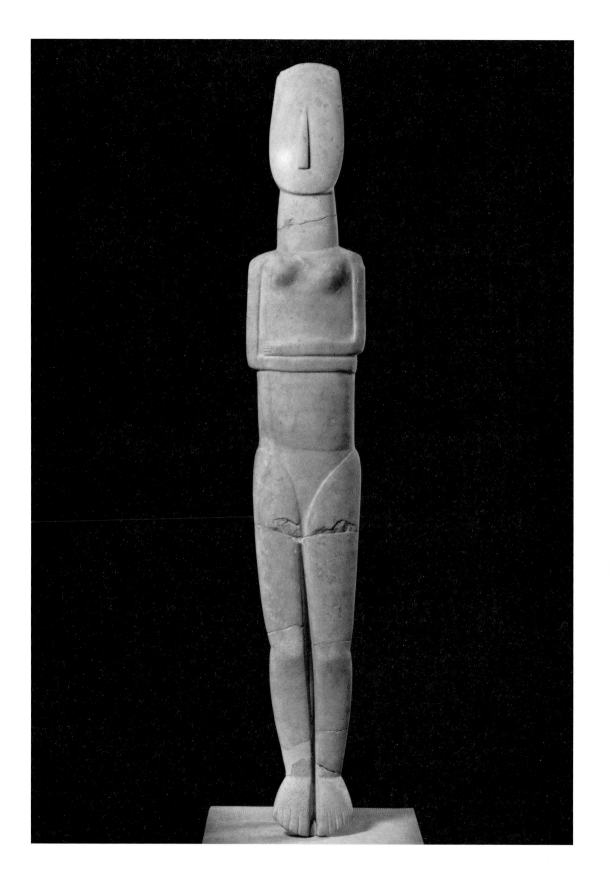

archaeological context. At the same time there is a series of very simple marble vessels – simple beakers and footed vessels and bowls in the earlier period, and more elegantly shaped cups and footed cups later.

It was in the early years of this century that some of these sculptures were noted by modernist sculptors,[5] such as Brancusi and Giacometti and later Henry Moore, and found to be compellingly beautiful. The very striking head in the Louvre [38] was discussed by the critic and photographer Christian Zervos, who published a well-illustrated book on the subject, *L'Art des Cyclades*, in 1957. Already before that date these works were finding a place in many private collections. Over the past thirty or forty years they have become sought after by collectors of contemporary art as well as collectors of antiquities. They are, indeed, now highly highly fashionable. At auction in New York, at Sotheby's or Christie's, a middle-sized figure, of perhaps fifty centimetres in height, can easily sell for over a million dollars.

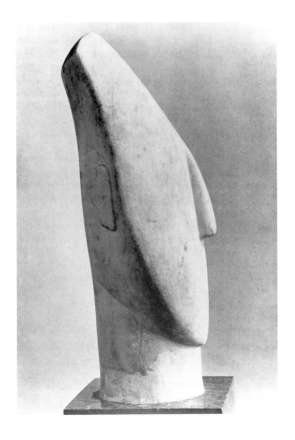

Many people today find these works exceedingly beautiful, and it is clear that much of their appeal lies in their simplicity. In Athens, in addition to the National Museum, there is a private collection, the N. P. Goulandris Museum of Cycladic Art, which is primarily dedicated to their display. And indeed they are beautifully exhibited in showcases that make clear that these are not thought of as mere archaeological items, but are regarded as major works of art in their own right.

But are they? Were they made to elicit such esteem? And if they were, how come that just a century ago they were widely felt to be 'repulsively ugly'? The answer, of course, lies in the history of taste. And in that answer we shall also find at least part of the reply to the question 'What is art?' The position is akin in some ways to the assessment by Westerners of the arts of Africa and Oceania. For a long time

these were dismissed as 'primitive art', and felt to come rather low in the scale of human achievement. Here, too, evaluations have changed significantly over the past century. The key to the question resides in a phenomenon in the history of Western taste – the so-called 'tyranny of the Renaissance'.

Aside: Putting the ethics in aEsTHetICS

First, however, it may be relevant to introduce a digression on what one might term 'the ethics of aesthetics', an issue that is very topical, particularly where Cycladic antiquities are concerned. Today, there is widespread looting of archaeological sites in order to recover antiquities which may then be sold at considerable profit to private collectors and even to museums. Of course, such looting is not new – in ancient Egypt, for instance, the cemetery priests and guardians had to go to enormous lengths to preserve the mummies of the pharaohs and their accompanying grave goods from professional tomb robbers. Most of the great museums of the world are stocked with antiquities that were acquired in what we would today regard as doubtful circumstances. Certainly, before Tsountas began his Cycladic excavations in 1897, the contents of Early Cycladic graves were appearing on the market and being purchased by private collectors and museum curators.

The situation in the Cyclades, however, has been particularly bad. By far the majority of the Early Cycladic sculptures known to us have come from undocumented and illicit excavations. In nearly every country of the world the nation's heritage is protected by laws that prohibit the excavation of archaeological sites without an official permit. This is certainly true of Greece, but as in other countries such illicit excavation nonetheless remains common. Just as in Italy (where they are called *tombaroli*), the Greeks have a word for these looters of archaeological sites: *archaiokapiloi*. As a result of their shady interventions over the past century, we can say very little about the circumstances in which the marble sculptures of the prehistoric Cyclades were made and used. It is a melancholy fact that none of the large, nearly lifesize figures and heads on display today has been found in

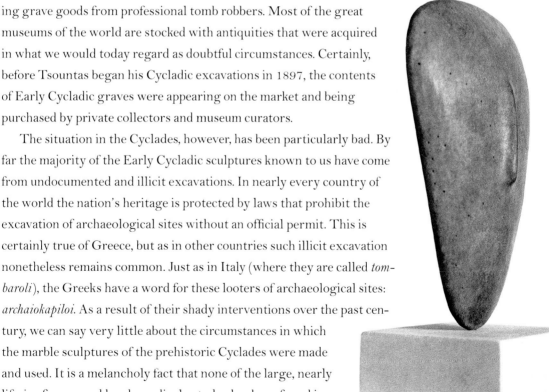

38 *opposite* Cycladic marble head, *c.* 2500 BC and about lifesize, probably from Keros in the Cycladic Islands. This head, today in the Louvre, Paris, was much admired by artists in the early twentieth century, including Brancusi.

39 Comparable simplicity in the work of the contemporary British sculptor William Turnbull: *Mask*, 1982.

the unscrupulous collector and, above all, the unprincipled museum curator. In my own view, then, it is not the esteem for properly excavated and published antiquities that is at fault, but the dishonest willingness to purchase unprovenanced pieces, even among those who consider themselves to be respectable citizens. For if they are unprovenanced they may well have been looted, and their purchase sustains the looting process.

This is a problem that will not easily go away. It is the case that the looting of archaeological sites is a major problem in many parts of the world, in Peru, for instance, and in West Africa, just as much as in the more traditionally studied homelands of early civilization in the Near East and the Classical world. With the collection of unprovenanced antiquities comes also the work of the forger and the faker. It is difficult, if not impossible, to distinguish between a good fake and an original so far as Early Cycladic sculptures are concerned. The American archaeologist Oscar White Muscarella[7] has recently argued, in his book *The Lie Became Great: Forgery of Near Eastern Cultures*, that the world's museums and private collections are stuffed with forgeries, on a scale greater than is usually suggested. That is inevitably the risk where antiquities without a reputable source are concerned. *Caveat emptor*, one might think – let the buyer beware. But if 'collectors are the real looters', it may be more accurate to say *pudeat emptorem* – let the buyer be shamed.

In this book I now follow the current ethical practice of restricting archaeological examples either to finds whose context of discovery is known and published, or to finds that have been published and in the public domain since before 1970, the year of the UNESCO Convention on the Traffic in Illicit Antiquities.

The tyranny of the Renaissance

Let us, however, turn from the consequences of excessive esteem to the vagaries in that esteem and to the history of taste. In seeking to understand how Paul Wolters in 1891 could find 'ugly' a marble Cycladic head that would have pride of place in any archaeological or art-historical museum today, it is necessary to assert that taste in the Western world has been subject for more than five centuries to the consequences of the

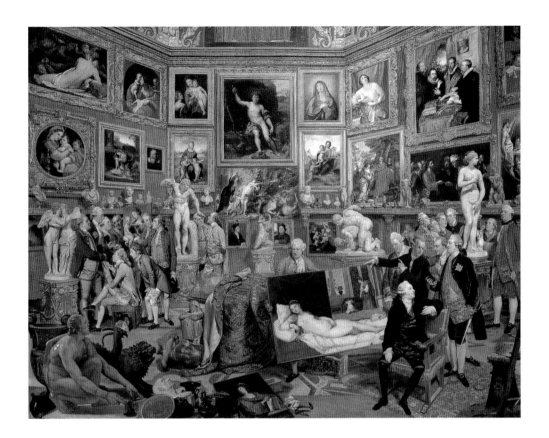

Renaissance. For during the Italian Renaissance there developed a view of 'art', of the nature of sculpture and painting, which so closely followed Greek prototypes, as transmitted through the world of Rome, that any works not also conforming to that ideal were rejected as barbaric and indeed 'primitive'. It is largely because of that powerful convention that the arts of other continents, executed according to very different stylistic principles, were regarded in the West as inferior. And it is for much the same reason that the 'moderns' at the beginning of the twentieth century were regarded by many of their contemporaries as revolutionary, and that in Britain today works that do not conform to the particular brand of 'naturalism' of the Classical/Renaissance ideal are still widely considered not only to be avant-garde but also in a sense unnatural.

As Francis Haskell and Nicholas Penny[5] so clearly showed in *Taste and the Antique*, the princes and collectors of Renaissance Rome and Florence esteemed above all else 'antique marbles' such as the Venus de Medici, which we can see surrounded by admirers in the Tribuna of the Uffizi in a painting by the eighteenth-century artist Zoffany. For the Renaissance,

such representations of the female form, to be reinforced by later discoveries like the Venus de Milo [see 61], and their male equivalents, seen for instance in the Apollo Belvedere and later in Roman copies of the Discobolus of Myron, established a norm, a sense of what was 'natural' for the viewer. Such rediscovered works of the Classical period as the Belvedere Torso and the Laocoön were among the greatest treasures of the Vatican collections. They won the admiration of the sculptors of the Renaissance, not least Michelangelo, who emulated and perhaps surpassed them in his *David*, or in the 'captives' originally executed for the funerary monument of Pope Julius II. Among the earliest to be admired were the splendid four bronze horses of St Mark's in Venice,[9] looted from Constantinople during the Fourth Crusade in 1204. This was a relatively late episode in their already chequered history, since they had arrived in Constantinople as booty during early Byzantine times, and may have originated at the great Classical sanctuary of Delphi in Greece. In any case, they have continued to exercise a fascination for artists, most recently the distinguished British sculptor Barry Flanagan [41].

In Renaissance sculpture we can follow the Classicizing influence[10] from the works of such earlier Renaissance masters as Pisano and Donatello through the High Renaissance of Michelangelo and on to the Baroque period with Bernini and his contemporaries. By the time of Rodin in the nineteenth century the possibilities of this Classical/Renaissance idiom had almost been worked out. It became difficult for the sculptor to choose the human figure as a subject for naturalistic representation.

Much the same is true in painting. The Classicizing naturalism of wall painting or the better-documented vase painting of fifth-century BC Greece was maintained in the portraiture of the early Roman world. But then the tradition changed direction and took on a new spirituality with the development of Byzantine painting, so that Byzantine art lies a little outside the Classical conventions and does not maintain the 'naturalism' of its predecessor. From the time, however, of such great Early Renaissance painters as Giotto and Cimabue, the Classical influence again came to be felt, continuing very directly in the work of Mantegna, more subtly in that of Raphael or Bellini. From then on, although Western painting developed its own internal history in the Baroque with the personal

41 Reliving the legacy of the antique, from Constantinople to Venice and beyond: *Bronze Horse*, 1983, by Barry Flanagan.

style of a Caravaggio or an El Greco, this was still a figurative art that aspired to elements of the Classical ideal.

Of course, it would be a gross oversimplification to suggest that the history of Western sculpture or painting can be summarized in terms of the working-out of a single feature or aspect. But it is still broadly fair to suggest that it was not until the Post-Impressionist era, and Cézanne and Van Gogh, that the mould was broken. With Matisse's seemingly arbitrary colour sense and Picasso's insistence that one painted the whole of what one knew rather than simply what one saw from a single viewpoint, the tyranny of the Renaissance was broken.

From that time on, painting could explore more explicitly the formal qualities of shape and colour without being constrained to offer an accurate or 'naturalistic' representation[11] of the world from a single vantage point. Picasso's *Les Demoiselles d'Avignon* (1907), one of the earliest

42 *Les Demoiselles d'Avignon*, 1907, by Pablo Picasso, one of the first works in which he broke with the convention of the single observation position, preferring to represent things as known rather than things as seen.

43 *below* Picasso's portrait of Ambrose Vollard, 1909, where his 'analytical Cubist' style is fully developed.

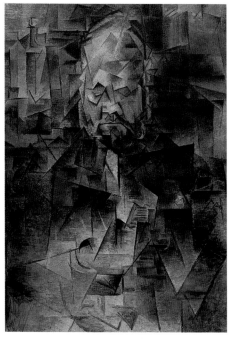

paintings executed in the 'Cubist' style, is generally regarded as one of the first works directly to rupture the conventions that had been established by the earliest Renaissance masters. One sees also that Picasso has been influenced by the very different formal qualities of some African art. Within five years he had developed his 'analytical Cubist' style so that his portrait of Ambrose Vollard is far removed from a Classical or Renaissance portrait, although it has a wonderful refinement of its own, with great restraint in the range of colours used. Nonetheless, to his dying day, Picasso remained in some senses a figurative painter, since there was always a 'real-world' visual subject for his work, even if his treatment of it departed radically from the Renaissance tradition.

But a painter such as Piet Mondrian could bring

about further tough-minded transformations. There are radically simplified works in his *Pier and Ocean* series of 1914 that one can look at in much the same way as one approaches and enjoys a Cubist work of the same period by Picasso. The structure of the pier is hinted at in the lower centre of the canvases, and the waves and reflections of the sea inspire the formalized patterns of intersecting lines above. But within a few years Mondrian was painting works of almost total abstraction, with black lines intersecting rigorously at right angles, the range of colours used being restricted to white, red and blue. These works had implications for design and architecture as well as for painting: the Bauhaus, the great design school with which Mondrian was associated, went on to become one of the principal influences that helped to shape the visual elements of the modern world in which we live.

In the field of sculpture Brancusi was one of the first to exploit the new formal freedom. In works such as *Mlle Pogany* and *Torso of a Young Man* [46, 47], he simplified the human form to an extreme degree. *Torso of a Young Man* is relevant to the present discussion, since when one compares it to one of the very early, Archaic Greek sculptures of young men (*kouroi*), one recognizes again the formal elements with which Greek sculptors began as they set out along the path towards naturalism. It was not until the early decades of the twentieth century that an

44 *left Pier and Ocean*, 1914, by Piet Mondrian, one of a series of studies in which the scene is reduced to a formal composition of horizontal and vertical elements.

45 *right Composition in Black and White and Red*, 1938, by Piet Mondrian, in which the artist's non-figurative style, using black lines on white with a few coloured areas in red, blue and yellow, is fully developed.

46 *left Mlle Pogany*, 1931, by Constantin Brancusi. The head is almost as simple as the Cycladic head in the Louvre (see figure 38), with which Brancusi was acquainted.

47 *right Torso of a Young Man*, 1922, by Constantin Brancusi, in which the elements of the human body are reduced to simple cylindrical forms.

48 *opposite Bird*, 1925, by Constantin Brancusi.

approach that was at once more formal and more simple again became possible. Perhaps that is why a Brancusi head bears a greater resemblance to an Early Cycladic head than almost anything else produced in the intervening four-and-a-half thousand years. With works like *The Beginning of the World* and *Bird* [48] Brancusi reached the simplicity of form that, as he was well aware, had already been attained in the prehistoric Cyclades more than four millennia earlier.

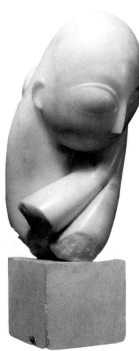

On art

It is when we look more widely at the impact of the so-called 'primitive' arts, the 'art' of other traditions, upon Western sculpture and painting at the beginning of the twentieth century, that we realize how Eurocentric and culturally specific the application of the term 'art' has been. For so often with the idea of art comes the assumption that craftworkers in other cultures have or had a similar outlook to our own, or that their work should be evaluated following the criteria of excellence that we, in our Graeco-Renaissance traditions of taste, have erroneously come to think of as 'normal' or even universal.

We have become used to the concept[12] of the 'masterpiece', produced for a grateful patron or an admiring public by an Old Master of almost divine inspiration. But we should remember that this notion of the artist as genius is very much a product of the High Renaissance, with Michelangelo and Leonardo as its inspiration. Earlier, during the Middle Ages, the 'masterpiece' was the work produced by an apprentice craftsman at the end of his apprenticeship to show that he had achieved a high level of accomplishment in his chosen craft – a modest early version of the 'diploma work' of art schools (and even of the Royal Academy) in the nineteenth century. For the ancient Greeks, a sculptor or a painter was an artisan who worked with his hands and not a person to be highly esteemed socially, although his work might be warmly admired.

In most cultures at different times and places it would seem that a sculpture or a painting was generally created to meet a specific purpose. Such a work might simply have a decorative role, or it might, for instance, be an effigy to facilitate the worship of a deity. In the Byzantine world, of course, images of the Deity or of the Virgin came to be valued in their own right and worshipped as having divine powers. Such 'idolatry' was, however, at other times seen as impiety and provoked episodes of iconoclasm which had their echoes in the destruction of 'idols' during periods of puritan ascendancy in later northern Europe. But in the world of the Renaissance, as we have seen, antique statues and soon the works of such esteemed masters as Michelangelo or Bernini came to be valued very highly.

The point came where works were actually made simply in order to be admired. Those with a primarily religious purpose, made perhaps to serve as an altarpiece in a major church, came to be admired as much for the quality of the painting as for the piety they expressed. The churches of Venice, for instance, are full of Late Renaissance masterpieces by Bellini and Titian. The great princes of the Renaissance, along with their collections of ancient marbles, also had their galleries of paintings [40], and it is here, in a sense, that the notion of 'art for art's sake' emerged most clearly. And that is what 'art' came to mean. It was a term applied to representational works that were made to elicit admiration and offer enjoyment. They might be works made within the Christian tradition, like all the great altarpieces, created in honour of the Deity and intended to facilitate and encourage devotion. But many others were secular, made for private pleasure or as public or civic monuments – like the statues of David produced by Donatello and later by Michelangelo. And so through the subsequent centuries and down to our own day, the artist came to be seen as a creative worker who makes 'art'. And now, in the present era, that 'art' no longer has to be representational, nor necessarily decorative. The definition of art has changed and, as we shall see in the next chapter, any definition has to be a broad one. We might try the following:[13] 'Any painting or sculpture or material object that is produced to be the focus of our visual contemplation or enjoyment.' It is implicit in such a definition that the work does not at the same time fulfil some other primary purpose. A television set, therefore, would not in itself be a work of art, nor would an advertisement on a hoarding. Or would it? Those are matters to which we shall later return.

The point of this discussion is to allow us to obtain a clearer perspective upon the sculptures and painting of other traditions than our own. It may be appropriate for us to enjoy an Upper Palaeolithic cave painting or a 'Venus' figurine [59, 60] as if it had been made for our contemplation and enjoyment like a work of art of the present day. But it was probably not made with precisely that purpose, and we shall misunderstand it if we imagine that we can readily grasp the motivations of its makers. We are ethnocentric if we apply our own concept of 'art' to the products of other cultures and eras. A Cycladic head is no more 'art' than a Maya stela. We

may esteem both just as highly as a work of art by Brancusi or Turnbull, but we misunderstand their makers' intentions if we ascribe to them motivations or sensibilities resembling our own today. We may, if we wish, enjoy such works as art – so long as we do not pay money for unprovenanced pieces. But we have to be acutely aware that we are looking at such a piece from our own eclectic and largely decontextualized standpoint. Unless we are particularly well informed, we are not likely to be looking at it in any more coherent context than that of our own eclecticism.

But that does not alter the fact the we do find some of these things beautiful.

Formal values: 'Primitive' v modern

Armed with such an awareness, we can admire the impact of the sculpture and painting of other cultures upon our own declining Classical/Renaissance tradition and the rising tide of modernism as exemplified by the work of European artists in the first two decades of the twentieth century.

Photographs of the studios of Picasso and Braque as early as 1908 and 1911 respectively show the artists surrounded by examples of 'ethnographic art', mainly from Africa but also from Polynesia and other areas. Many drawings by Picasso survive which show his close interest in the formal properties of such sculptures, and one may see in the Musée Picasso in Paris today many splendid objects from his collection [51].

Gauguin, as we saw in the Introduction, was one of the very first Western artists to draw upon sources that were then widely regarded as 'exotic'. The enormous impact of the sculptures of other cultures in helping Western artists free themselves of European visual conventions has been the subject of scholarly research in recent years. In 1967, there was an excellent exhibition[14] at the Musée de l'Homme in Paris, 'Arts primitifs dans les ateliers d'artistes', with sculptures from Africa, Asia and the

49 A corner of Georges Braque's studio in Paris, photographed in 1914, showing some of the ethnographic objects from which he and his fellow Cubist, Picasso, drew inspiration.

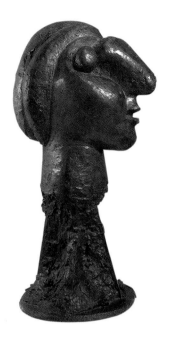

Americas taken from the studios of a wide range of sculptors active early in the twentieth century, including Braque, Max Ernst and Henry Moore. And in 1984 the Museum of Modern Art in New York organized a major exhibition, '"Primitivism" in 20th-Century Art' (note the inverted commas now), which juxtaposed ethnographic works from the collections of distinguished modernist pioneers with works by the artists themselves, with the clear suggestion that the latter drew inspiration from the former.

Alberto Giacometti was one of those most strongly influenced in this way. And Paul Klee, one of the most inventive of modern painters, found his imagination stimulated on many occasions by a wide range of works from other cultures. But once again it was Picasso who drew most heavily, in particular upon African sculpture. For instance, in the Musée Picasso there is a Nimba mask from Baga in Guinea which is likely to have been a contributory influence in the creation of *Head of a Woman* of 1931–32. The intention in making comparisons of this kind is not in any way to suggest that such works by modern sculptors and painters should be regarded as derivative. It was they who had the freshness of eye to see the merits, the plastic values or qualities, of many of these works. From Gauguin onwards, a number of artists, many of them centred upon Paris, found encouragement and inspiration in such works.

50 and 51 Bronze *Head of a Woman*, 1931–32, by Pablo Picasso, showing the influence of the Nimba mask from Baga, Guinea, seen on the right, which was in Picasso's collection and is now in the Musée Picasso.

And in highlighting and reinterpreting aspects of them, they educated the Western avant-garde in the merits of works that lay outside the European tradition of Greece and the Renaissance.

It was in the wake of such pioneers, from Gauguin to Picasso, from Klee to Ernst, that 'esteem' for what had been regarded as 'primitive' art developed. And it was at this time that artists and then connoisseurs began to take more seriously the sculptures of the Early Cyclades[15] with which we began this chapter. Brancusi in particular is on record as having admired the Louvre head [38], and Henry Moore in his turn was greatly impressed by Early Cycladic sculpture that he saw in the British Museum. It was at this time that private collectors in the modern field began to extend their collecting activities to include both ethnographic works and antiquities that took their fancy, such as those of the Cyclades. It was therefore also at this time that the demand for such antiquities increased, going beyond the narrow circle of antiquarians and archaeologists and extending now to the more eclectic tastes of the collectors of 'modern art'.

With the increased appreciation of formal values of various kinds that some of these sculptures offered, the way was open to a reassessment of the Classical/Renaissance tradition itself. In general, it is fair to say that the 'Archaic' and 'pre-Classical' phases of development of ancient art have become more widely appreciated. Today, connoisseurs of Renaissance painting may likewise prefer the work of the Sienese 'primitives' (so called) to the more polished works of the High Renaissance. Certainly, in the field of Greek art,[16] beginnings, as represented in the Archaic sculptures of the seventh and sixth centuries BC – for instance, in the *kouroi* and the *korai* which were particularly characteristic of those centuries – are now often favoured over the more 'naturalistic' (or at any rate more energetic) achievements of the Hellenistic era.

While offering these general reflections on taste and style, let us bear in mind that the craftworkers in Africa who made these 'ethnographic' works, or the village carvers of the prehistoric Cyclades, were just as much individuals as the twentieth-century 'masters' to whom we have been referring. It is therefore astonishing to note how little research has been done to identify the work of individual sculptors in Africa or

Polynesia, even when it was known that they were still alive. For the prehistoric Cyclades, attempts have been made to recognize, on stylistic grounds, the 'hands' of individual 'masters', just as scholars have succeeded in doing with the painters of Greek vases. In the latter case, however, the task is made easier by the fact that they sometimes signed the vases, and the more elaborate detailing makes it easier to recognize personal idiosyncrasies. The task of recognizing the 'hand' of the prehistoric sculptor seems much more problematic.

Indeed, I am aware of only one attempt to use historical (and oral) sources to reconstitute the oeuvre of a single, recent sculptor working outside the Western tradition. It concerned Olowe of Ife[17] in West Africa, a sculptor active in the 1930s and 1940s, many of whose works in wood, forming part of architectural complexes, were photographed *in situ* at a time when their authorship was still remembered and acknowledged. Tantalizingly, it seems that no photograph survives of Olowe himself. This interesting case reminds us, however, that the skilled craftworker was an individual, who created a life's work and in doing so no

doubt developed a personal style just as do artists of the present day. The goal of the carver may not have been consciously to produce 'art' in the manner of the contemporary artist. Indeed, in a non-monetary economy, the process of commissioning work from a sculptor must perforce be very different from that in the gallery-mediated commercial transaction of the present day.

Turnbull and simplicity

Armed with these reminders of the changing nature of taste, and of the ethnocentric nature of the term 'art', and with an awareness of the still-pervasive dominance of Classical/Renaissance notions of what is 'natural' in representation, we can now return to notions

of 'beauty' and 'simplicity'. These days, few people speak of 'beauty':
it suggests an absolute, like 'truth' or 'objectivity', to which few would
now lay claim. But in practice many artists still set out to make works
that they and others find to be 'good to look at'. It is here that I should
like to return to William Turnbull. For to do so allows us to follow an
important strand in contemporary art.

Turnbull[18] was born in Dundee in 1922. He served in the Royal Air
Force during World War II, and the most influential experience of his
early years was not so much his time at the Slade School of Fine Art in
London, but rather his years in Paris afterwards, when he encountered
the work of Brancusi and Giacometti. On his return to London he was
active in the Independent Group, which formed in 1952 and whose
exhibition 'This Is Tomorrow', held at the Whitechapel Gallery in 1956,
was recently reconstructed at the Institute of Contemporary Arts.

As a starting point, let us take one of Turnbull's earlier works, *Head
II* (1955), which serves to illustrate both his place in the mainstream of
the modernist traditions of twentieth-century art, and his own indepen-
dent, very serious and very sustained endeavour to seek what is *essential*
in the undertaking of representing the human form. For it is worth
observing that almost every bronze by Turnbull is in some sense a
representation of the human body or the human head. The other subject
that has preoccupied him over the years is that of the horse.

Head II is a lump of bronze placed broodingly upon a flat stone

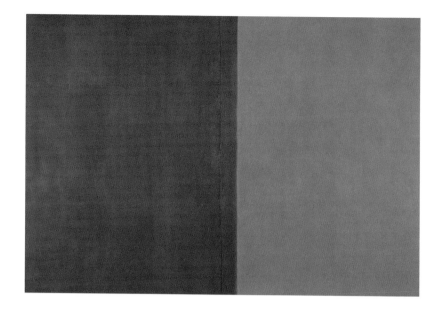

56 *right* *1–1962*, 1962, painting by William Turnbull showing a simplicity comparable to that of his sculptures.

57 *below* *3 x 1*, 1966, sculpture in painted steel by William Turnbull, photographed at Jesus College, Cambridge.

58 *opposite* *Queen*, 1987, a bronze sculpture by William Turnbull reflecting both archaeological and ethnographic influences, but unmistakably a work by Turnbull.

two decades earlier. The trend towards 'abstraction' which led him to the works in steel of the 1960s and 1970s can however still be detected.

Among Turnbull's recent works in bronze, as among the earlier ones before he turned to the use of steel, are several that recall simple prototypes from various ethnographic and archaeological contexts, including

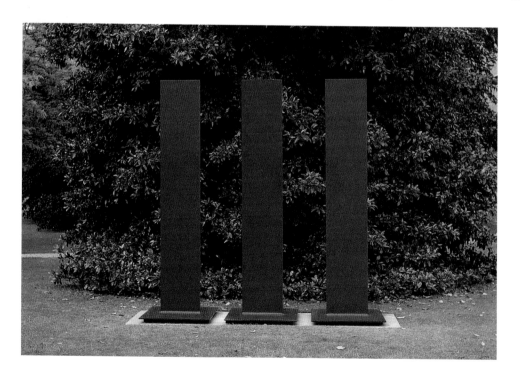

the Early Cycladic. But these are not to be considered as derivative. They draw upon the same sense of form, the same pleasure in simplification as do the prototypes, including the Early Cycladic ones. As Turnbull has observed in relation to the Louvre head [38], also admired by Brancusi, in a remark[21] related to the one quoted earlier:

What enamoured me the first time I saw it, was how something could be so simple, and be more like a head than any portrait could be. Perhaps again by the fact of this wonderful sort of metaphor, and the tension. It's a mask, it's a face, it's a thing, it's an object.

Beyond representation

In these sculptures, especially the recent bronzes, Turnbull seems to be working towards some ideas about the human form that are universal: the forms are evidently human, yet they are of such simplicity that they no longer fall within the style of a single culture or civilization. Of course, in a sense he is still part of the Classical/Renaissance tradition with its strong preoccupation with the human form, but that is an interest not surprisingly shared by other cultures too. Certainly, if one looks at the Khmer sculptures of Cambodia, which Turnbull admires, one sees some of the same qualities of stillness and inner tension.

For me, these works, like those of Brancusi, achieve a special kind of perfection. In the field of painting, there is a comparable sense of simplicity reaching towards something universal in the work of the American painters of the Abstract Expressionist school. This is not the occasion to extol the work of Mark Rothko. You have to stand in front of one of these impressive canvases and feel yourself drawn into the space with which the work surrounds itself. Or again you need to stand in front of Barnett Newman's *Vir Heroicus Sublimis* in the Museum of Modern Art in New York and feel how the interaction with it enhances your own sense of where you stand. These works in their different ways have an overwhelming sense of presence.

In the early years of the last century Roger Fry[22] wrote that 'the

59 and 60 Early
representations of the
human form: 'Venus'
figurines from the Upper
Palaeolithic in Austria and
France, c. 22,000 BC.
Left 'Venus' of Willendorf.
Right 'Venus' of Lespugue.

61 *opposite* Double take:
the Venus de Milo comes
to 53rd Street. *Looking
towards the Avenue*,
1989, bronze, by
Jim Dine, in New York.

modern movement was essentially a return to the ideas of formal design
which had been almost lost sight of in the fervid pursuit of naturalistic
representation'. He quoted the art critic Clive Bell as arguing that
'A work of art [has] the peculiar poetry of conveying the "aesthetic
emotion", and it [does] this in virtue of having "significant form".'
Today such statements do not seem to resolve the focus of discussion so
much as to restate it. What is the nature of this 'significant form'?
Certainly we could find some analogous statements in the writings of
Henry Moore. Alberto Giacometti[23] expressed something of the same
sense of generality of an appreciation of formal properties remote from
what is sometimes considered to be 'realism' (and without allowing
himself to become too wrapped up in metaphysical concepts):

Realism is a lot of rubbish… What we call the great styles in art are those
that approach most closely the vision one has of things. Yet the works of
the past that I find most resembling reality are generally to be judged the
farthest from it. I mean the arts of style: Chaldean, Egyptian, Byzantine,
Fayumic, Chinese things, Christian miniatures of the high Middle Ages…
For me, Egyptian painting is realist painting, although they call it the most
stylized. Anyone among us resembles much more an Egyptian sculpture
than any other kind of sculpture ever made… That's the style that gives the
truest vision.

I'm not sure how far this elevation of Egyptian sculpture takes us
[see 143]. But what we can recognize here is that, in enjoying the sculp-
tures and paintings of the world, we can employ a taste and sense of form
that resembles that of Turnbull or Giacometti. Clearly it is very different
from the taste of Richard Long, whose work we looked at in the last
chapter. And the result is an art very different from that of Mark Dion or
Marcel Duchamp, which we shall examine in the next chapter.

However, to remind us that this same sense of form that we have
been admiring in Brancusi and Turnbull is there in the sculpture of
earlier periods, I shall end here with just one or two images that take us
back to the mobiliary art of Upper Palaeolithic Europe,[24] from the
rounded forms of the 'Venus' of Willendorf to the echoing curves of
the 'Venus' of Lespugue.

We do not know, and we shall probably never know, quite why they were made. They may not have been created simply and solely to be 'good to look at'. They may also have had ritual functions, or served as toys, or as educational aids. But it is difficult not to imagine that at least one of the intentions of the maker of each was that the work should be well made and indeed be 'good to look at'. The same is surely true of the 'abstossend hässliche Kopf' from prehistoric Amorgos [35] that repelled Paul Wolters a century ago and that we so much admire today.

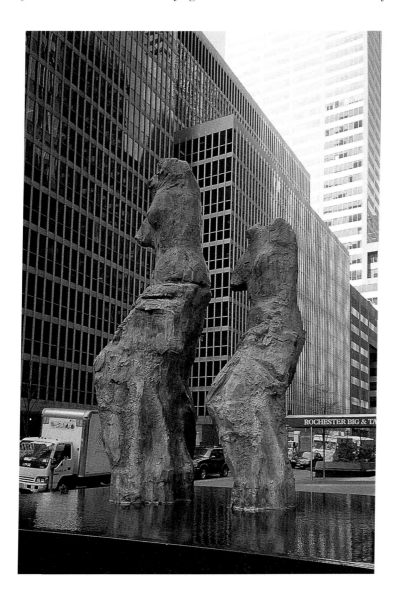

Off the plinth: Display and process

Process in art: The second break with traditional ways of seeing

We established in the last chapter that there are risks in thinking of paintings or sculptures from other cultures or from the prehistoric period as 'works of art' in the modern sense. We saw that the concept of the work of art in Western society is a legacy of the Classical/Renaissance tradition which was modified but not altogether transformed in the early twentieth century by such moderns as Picasso and Brancusi, and indeed by William Turnbull.

But the concept of 'art' has since been broadened through practice in such a way as to become unrecognizable. It is often suggested that with the work of Anthony Caro in Britain, perhaps preceded by that of David Smith in the United States, sculpture came 'off the plinth'. It no longer had to be set upon a pedestal, and materials other than marble and bronze were used. The use of steel, sometimes painted, did indeed bring sculpture off the plinth and into the real world.

But we have seen with Richard Long rather more radical initiatives. Sculpture in the open air, where landscape features are involved, not simply sculpted objects, has led some critics to speak of a new direction: Land Art. And if the work of Michael Heizer or Robert Smithson in the United States was in that sense the counterpart of that of Richard Long in Britain, the work of Christo and Jeanne-Claude is something else again.[1] They have made the procedure of *wrapping* very much their own: objects, prominent buildings, bridges have become the focus of a series of major projects whose culmination is indeed the enveloping, for a period

62 Art as process: wrapping. *Wrapped Reichstag*, 1971–95, by Christo and Jeanne-Claude.

63 *Surrounded Islands, Biscayne Bay, Florida, Miami*, 1980–83, by Christo and Jeanne-Claude.

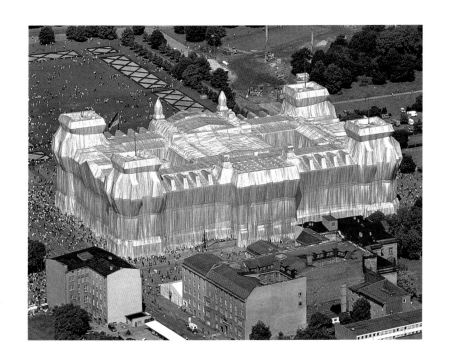

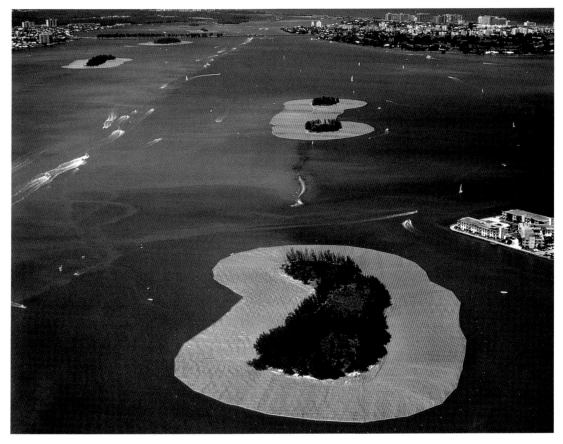

64 The real thing – art as conservation: *Away from the Flock*, 1994, by Damien Hirst.

65 *opposite* Material memory: *House*, 1993, by Rachel Whiteread.

of time, of the structure in question in fabric, loosely wrapped to form an enclosing package. The most celebrated such enterprise was the wrapping of the Reichstag building in Berlin in 1995 [62]. The artists emphasize that the work is not simply the wrapped building, photographed for posterity before the wrappings are removed, but involved the entire process from its inception in the minds of the artists – in the case of the Reichstag, this included a series of negotiations and confrontations with bureaucracy that lasted twenty-five years.

Richard Long also stresses the importance of the *activity*: art as a process is one aspect of his work, just as it has been for his erstwhile student contemporaries at Central St Martins, Gilbert and George,[2] with their celebrated *Singing Sculpture*. Long has also been a pioneer in the field of visual art of the use of words – an aspect to which we shall return, with the work of Ian Hamilton Finlay and Jenny Holzer, in Chapter 6.

We have also become used to seeing artefacts from the everyday world incorporated into installation works. Eduardo Paolozzi and David Mach have created notable examples to which we shall turn in Chapter 5. Rachel Whiteread's remarkable *House* was one of the most impressive – if short-lived – episodes of the 1990s, where an artefact from the world around us, in this case an entire terrace house, was transformed into the

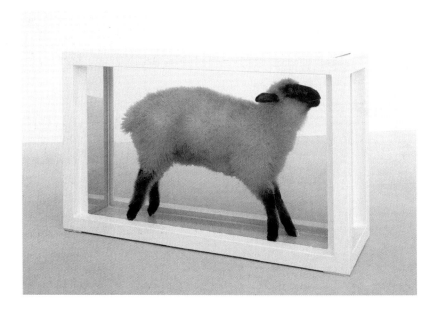

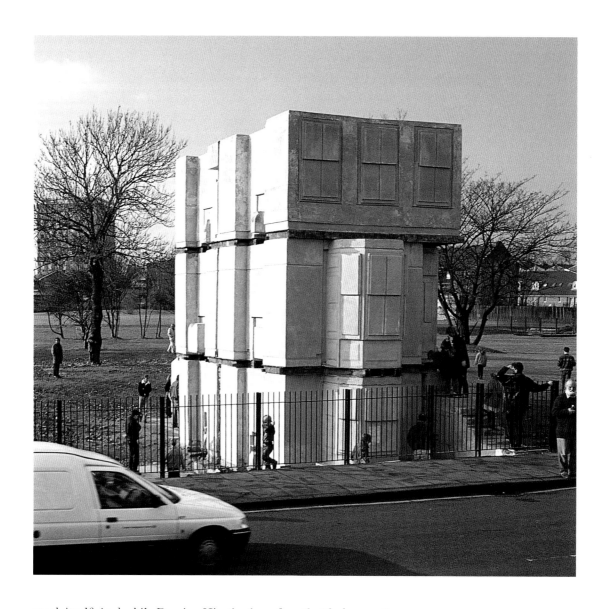

work itself. And while Damien Hirst's *Away from the Flock*, an entire white and woolly sheep preserved in surgical spirit in a glass showcase, may have been over-hyped in the media, along with other works of his BritArt colleagues, it soon gained new overtones with the first cloning of a mammal, Dolly the Sheep, and remains a striking and evocative object. While BritArt may have been skilfully publicized by Charles Saatchi in the 'Sensation' exhibition held in 1997 at the Royal Academy of Arts (and later in New York), and in successive years by the annual award in London of the Turner Prize, I must report that much of it amply succeeds in fulfilling my personal criteria of attracting and maintaining

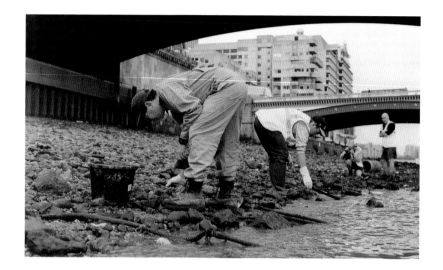

68 *above* Mark Dion on the Thames foreshore at Bankside in July 1999.

69 *right* *Tate Thames Dig*: tents outside the Tate Gallery, where the finds were systematically sorted, classified and conserved.

70 *opposite above* It looks like archaeology: some of the finds from the *Tate Thames Dig* during the classification and conservation process.

71 *opposite below* The final exhibit: finds from the *Tate Thames Dig* in the specially made display cases in the Tate Gallery in 1999.

Mark Dion

Let me present to you the *Tate Thames Dig*, an enterprise commissioned by the Tate Gallery from Mark Dion.[⁴] It was carried out during 1999, first on the foreshore of what is now Tate Britain and of the new Tate Modern at Bankside, and then on the lawns at Millbank. The end product was an imposing showcase with glass-fronted cupboards and drawers, filled with artefacts, inside the Millbank Tate. I visited Mark Dion and his team during the collecting phase on the foreshore, as they

scoured the banks of the river for arte-
facts – of all periods and descriptions
– between the high- and low-tide
marks of the tidal Thames.

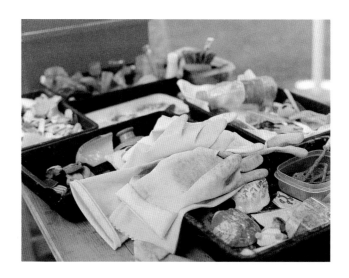

The visitor in 1999 would have
encountered three tents on the front
lawn of the Tate at Millbank during
August, with teams of volunteers
washing, cleaning, sorting artefacts –
sherds of pottery, scraps of bone,
bits of broken glass – all carefully
collected by this same team of
workers involved in the *Tate Thames
Dig*, first at Millbank (Tent A) and
then at Bankside (Tent B). In one of
the tents Mark Dion could be seen
classifying the finds. In another, con-
servation work was under way. One of
the finds was a scrap of paper from a
bottle bearing a message in Arabic
script: paper conservators made a
beautiful job of drying, cleaning and
restoring the delicate, damaged paper.
In a few weeks the finds, suitably
selected, processed, classified and
labelled, would go on display in glass
showcases in the gallery.

All of this seems industrious,
systematic – and it does provoke some
questions. This certainly looks like
archaeology, and when one encoun-
ters the enthusiasm of some of the
volunteers it feels like it too. But is it?
Similarly, Mark Dion calls himself
an artist, and the end product is on

Which brings us back to the *Tate Thames Dig*. Is it archaeology? As an archaeologist I was asked to give a lecture in conjunction with the enterprise. I pointed out that Dion's selective displays are the result of meticulous processes of recovery, conservation, classification and installation. They are coherent, interesting, good to look at. Yet on closer examination they are not quite what they seem. Dion's work is plausible, persuasive. But a nagging suspicion remains: are they the real thing? The uncertainty widens – how do you actually judge whether or not it is the 'real thing', and on whose authority? Indeed, what is the real thing? How different would it have to be to make the grade? What are the relevant criteria? These innocent paradoxical displays invite examination; they pose questions. They lead us to ask again just what it is we do when we are doing archaeology or zoology or botany.

Surely archaeology is what archaeologists do. We dig up the past, don't we? We undertake surface surveys, carefully collecting and recording fragments of old things, and these end up in museum cases. Is that not what Dion is doing? But of course there is something that doesn't quite fit here. Dion an archaeologist? He doesn't have the professional training. He is not a member of the Institute of Field Archaeologists, nor indeed of the Society of Antiquaries.

In that lecture I set out solemnly to explain that 'archaeology may be defined as the study of the human past as inferred from the surviving

74 *Tate Thames Dig*: archaeology (or beach-combing?) on the foreshore at Bankside.

75 *opposite* Excavation with military precision: Sir Mortimer Wheeler's site of Arikamedu, India, in the colonial era, 1946.

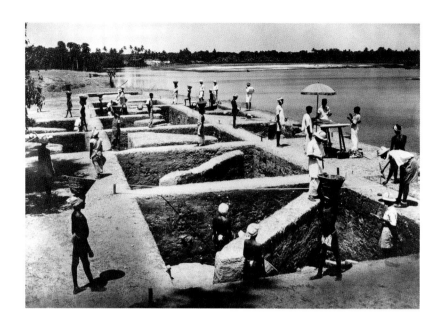

material remains'. It is primarily about knowledge, about information, and it depends mainly upon stratigraphic excavation, giving particular attention to the precise context from which each find comes. From a study of these contexts of association the archaeologist is able to make statements about the diet, the technology, the social life, even the ways of thought of the people who used these things. You can do that only to a limited extent from individual objects – that is why unprovenanced antiquities are in general relatively useless. Gathering curiosities from the foreshore is really just beachcombing.

So in preparing my lecture I turned automatically to one of the source books of archaeological practice from which I had learnt as a student, *Archaeology from the Earth*, by that great master of the stratigraphic approach, Sir Mortimer Wheeler,[6] famous also as the Director General of the Archaeological Survey of India at the end of World War II, where he had brought the military precision of a brigadier in the Royal Engineers to bear upon the tactical problems. So I showed illustrations from *Archaeology from the Earth* which had been used to exemplify good methods [75] as opposed to the more informal and less satisfactory approach of earlier workers such as Sir John Marshall. I yield to none in my respect for the late Sir Mortimer Wheeler, but it is evident that they represent a process, a system, that is remote from our own today. For all my aspirations, my own excavations do not really look like those of Wheeler.

It is surely true to say that most archaeological projects today look at least at first sight more like Dion's.

Dion's work thus leads us to reconsider the enterprise of display and the very processes by which we go about our work. In his *Curiosity Cabinet for the Wexner Center for the Arts*, he was inspired by the Aristotelian concept of the Great Chain of Being, where all living beings, as well as some inanimate things, are linked in a great sequence which goes from the simplest to the most complex. It is not unfair to say that Aristotle's vision represents an early initiative to make sense of the world which anticipates in some respects the modern concept contributed largely by Charles Darwin, whose view of evolution again envisages an unbroken trajectory linking simpler living creatures with their more complex successors and which again culminates in human-kind at the summit of its chain's 'ascent'. Dion thus directs our attention both to our own habits of mind where classification, display and process are concerned, but also to the history of our discipline and the origins of our own view of the world.

In a subsequent work [76–78] exhibited in the medieval chapel of Jesus College, Cambridge, in 2001, in collaboration with the sculptor Robert Williams, Dion made his own version of a Renaissance cabinet of curiosities[7] entitled *Theatrum Mundi – Armarium* (an 'armarium' being in effect a library). Again, the work offers an interesting and personal commentary upon the way we classify the world, using concepts derived from two late medieval/Early Renaissance worthies. On the left Dion and Williams have followed the classification of the Jacobean thinker and alchemist Robert Fludd (1574–1637), who divides the world into *Deus* (God, at the top), *verbum* (the word, written and spoken), *intelligensus* (theoretic thought), *intellectus* (applied science), *ratio* (measure), *imaginatio*

76 *Theatrum Mundi – Armarium*: classifying the world according to Robert Fludd (detail). The lower shelf, seen in part, represents *imaginatio* (the world of images and beliefs), then *ratio* (measure), then *intellectus* (practical thought, praxis), then *intelligensus* (theoretic thought).

(figuration and imagery) and *sensus* (the senses, with an emphasis upon food). On the right we see the analogous classification by the thirteenth-century Spanish thinker Ramond Lull (1232–1314), who ordered the world according to a different series of concepts: *Deus* (God), *angel* (the angels), *lelum* (the air and the skies), *homo* (humankind), *brutu* (the animal world), *planta* (the plant world), *flama* (fire) and *lapis* (stone). Here now we see the world of artefacts – the 'artificiosa' – together with the world of natural curiosities, the 'naturalia', classified in a single system, or rather into two alternative systems. These are so evidently constructions of the Renaissance mind that they remind us inescapably that the ways in which we ourselves today classify the world are precisely that – mental constructs, the products in this case of the nineteenth

77 Theatrum Mundi – Armarium: classifying the world according to Ramond Lull. The ascending shelf classification is *planta* (plants), *brutu* (animals), *homo* (humans), *lelum* (the air), *angel* (the angelic world) and *Deus* (God). The angel world is represented mainly by plastic toys, from Mickey Mouse to *Star Wars*, while God, invisible and ineffable, is represented by a seemingly empty shelf.

and twentieth centuries. In both these earlier world views the culmination at the highest level was *Deus* – God – represented by a shelf without any material objects whatever. And in Lull's classification the immediately subordinate category was *angel*, which Dion and Williams have represented by a series of plastic children's toys of Mickey Mouse figures, McDonald's advertisements, monsters, aliens and the like, involving what is a favourite field of imagery for Dion, figurations which he no doubt sees as the modern counterpart of the late medieval angel. Interestingly, the great stained-glass window in the south transept of the chapel, immediately adjacent to the *Armarium*, is a work by the Victorian artist Sir Edward Burne-Jones [78]. In its upper registers are depicted the powers of heaven, as classified in the early Christian hymn

the *Te Deum Laudamus*: Thrones, Powers, Principalities, Dominions, Archangels and Angels supplemented by *imago Dei*, the image of God, i.e. humankind as represented by Adam. We are subtly reminded that human cognition and understanding of the world proceeds through classification, and here is an early Christian version of an Old Testament Judaic classification, one of the very earliest examples of such cosmic orderings to have come down to us.

Dion has an exquisite sense of period style, and a sympathy that allows him to evoke it constructively in a way that we find illuminating, amusing even, without its becoming derogatory or ridiculous. For my last look at his work, I would like to introduce the photographic tableaux [79, 80] that he constructed (in collaboration with J. Morgan Puett) for his fictitious *The Ladies' Field Club of York*.

I have in mind a genuine example of the late Victorian genre of photographic personification, an example dating from 1897, taken at the Devonshire House Ball where we see in photographic tableau the image[8] of 'Edith Amelia, Lady Wolverton, as Britannia' [81]. Clad in an elegant, long evening dress, the seated Edith Amelia poses in profile holding a long trident and flanked by an oval shield with the crossed colours of the Union Jack. The effect is stylish, patrician, patriotic and – at least to the modern viewer – faintly ridiculous. Dion, no doubt with such prototypes in mind, invited a number of women of his acquaintance, most of them currently employed as museum or gallery curators, to epitomize a series of academic disciplines of the late Victorian era. Then, in meticulously posed tableaux, he arranged that each of these ladies should personify one of the disciplines, or perhaps one should say pastimes, of that period. In the resulting work, everything seems authentic, from the costume and background to the quality of the photography and the sepia print.
I much admire the meticulous use of costume and also the sepia prints and the appropriate use of lettering. We see Mrs Herbert Fowler as 'Anthropology' [79], and Miss Mary Bucknor as 'Palaeontology' [80], with all the confident poise and the mildly absurd pretension that today causes us to smile a little when we see 'Lady Wolverton as Britannia'.

This work is charming and witty, but it is also subversive. We are first led to note and to question the academic and intellectual conventions of

the late nineteenth century. Just as these now seem artificial, arbitrary and a little absurd, cannot the same be said (or will it not be evident in a hundred years) of our own conventions and procedures as researchers and as scholars? I think that, in the context established by Dion, the glimpse of the methods of Wheeler [75], which looked everyday and normal when his book was published in 1954, at a time when I was approaching university age, demonstrates that precisely the same is true of our day – or at least of my day. Things look different after fifty years.

The avant-garde of today will soon be past its sell-by date and will join the rest of us in the scrapbooks of tomorrow. But that insight is not, I think, the only point of *The Ladies' Field Club of York*. The work shows that the conventions of display and the systematic processes by which we work are themselves constructs, products of our own time, with arbitrary qualities of which we are not always aware when we adopt them.

Display, collecting and museums: Duchamp and after

Dion's *Theatrum Mundi – Armarium* usefully reminds us of the roots of the prehistorian's discipline. For just as the Western concept of 'art' grew up in the private galleries of the princes of the

Renaissance, so the modern study of natural history and of the early human past emerged from their collections of 'curiosities'. We looked earlier at the Tribuna of the Medici [40], and we could equally have looked at the Belvedere of the Vatican, where Pope Julius II exhibited his antique marbles, including the Apollo Belvedere and also the Belvedere Torso, which so excited the admiration of Michelangelo.

It is at that time also that we see those Renaissance 'cabinets' [82]. (The term may seem a little outmoded, but it survives in the field of numismatics, where the enthusiastic collector still keeps his coins and medals in a cabinet.) At first, curiosities of whatever kind were kept together. It was in 1878 that the British Museum collection was divided into works of nature and of artifice, and the 'naturalia' sent off to South Kensington. The division is still particularly clear in Vienna. If you go to the spacious Maria-Theresienplatz you will see on one side the Natur-historischesmuseum and on the other the Kulturhistorischesmuseum. The division is between nature and fine art – and the archaeological remains, the prehistory and ethnography, very often go with nature, just as in the earlier cabinets of curiosities. So the collections of prehistoric artefacts are found in the Naturhistorischesmuseum. They do not make the grade as 'art'. In New York, in just the same way, 'fine art' goes into the Metropolitan Museum of Art, but the American Indian artefacts go into the American Museum of Natural History along with the rest of the ethnography and all the other natural-history collections, the natural curiosities. Only recently, in response to the growing and fashionable enthusiasm for 'primitive art', has ethnography begun to find a place among the displays of fine art in the Met, in the recently opened Rockefeller Wing. In Paris, President Chirac has recently caught up with the same idea and decreed that the Louvre should now contain some ethnographic materials, in a

79 and 80 *opposite top, left and right* Mrs Herbert Fowler as 'Anthropology' and Miss Mary Bucknor as 'Palaeontology', from *The Ladies' Field Club of York*, 1999, Mark Dion and J. Morgan Puett.

81 *opposite below* Edith Amelia, Lady Wolverton, as Britannia at the 1897 Devonshire House Ball.

82 The beginnings of collecting and of display: the *Cabinet of Curiosities of Ole Wurm*, 1655.

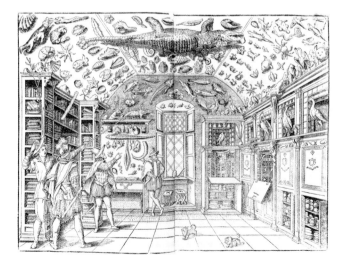

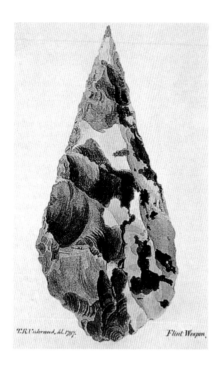

T.R.Underwood, del. 1797. Flint Weapon.

department that he has tactfully called the 'Musée des arts premiers', although there is more than an echo in the phrase of the 'Salle des arts primitifs' of yesteryear.

Nor has the dividing line between artificial and natural curiosities always been easy to determine. During the Renaissance, the chipped flint artefacts, the arrowhead, the handaxe, of what we now call the palaeolithic period were at first regarded as natural products, as thunderbolts and elf-shot. A handaxe, such as that published correctly as a prehistoric stone tool by John Frere[9] in 1800, was earlier described by the seventeenth-century scholar Ulisses Aldrovandi, one of the great zoologists of the Renaissance period, as being 'an admixture of a certain exhalation of thunder and lightning with metallic matter in dark clouds, which is coagulated by the circumfused moisture and coagulated in a mass (like flour with water) and subsequently indurated like a brick'. Matters of classification were by no means self-evident.

The early history of the museum is very relevant to the world of Mark Dion because in the course of his work he is re-creating and in a way redefining the whole process of display. The development of the great museums established the convention for the public display of art: art is what is displayed in the Museum of Fine Art.

Here we should turn to another major pioneering luminary of the early years of the twentieth century: that enigmatic and influential figure Marcel Duchamp.[10] Indeed, today he seems not so much a pioneering 'modern' along with Picasso or Brancusi, as a subversive 'postmodern' with a quizzical eye for the project of the artist and an acute sensitivity to the role of the observer. If postmodernity implies above all self-reflexivity, the re-examination of the role of the self, the observer, in the communication process, then Duchamp was the first of the postmoderns. Already in 1917, with *Fountain*, he highlighted the very significance of putting a work on a plinth for display with a gesture that only fifty years later came to be accorded the revolutionary significance so widely recognized today.

Born in 1887, Duchamp first came to international prominence with his painting *Nude Descending a Staircase* in the Armory Show in New

83 Thunderbolt or artefact? Natural or artificial curiosity? Palaeolithic handaxe from Hoxne, Suffolk, published by John Frere in 1800.

84 *opposite Fountain*, 1917, porcelain urinal, signed 'R. Mutt'. This 'readymade' was rejected by the committee when Marcel Duchamp entered it for the 1917 Indépendants exhibition.

York in 1913, which was clearly influenced by
Futurist concepts about movement. Around
this time Duchamp was undertaking the first
initiatives in what has since come to be termed
'conceptual art'. The underlying idea here was
that it was the choice of the artist and his
deliberate act of placing the object on display
that established its status as a 'work of art'.
Thus, an industrially produced bottle rack
could become 'art'. Duchamp's celebrated
Fountain, now proudly on display (in replica) in
a prime position in Tate Modern, was simply
a urinal, signed by the artist in the guise of
'R. Mutt' and submitted to (and rejected by)
the Indépendants exhibition of 1917.

Duchamp later summarized the intentions[11] behind his 'readymades'
as 'relating notions of aesthetic worth to a decision of the intellect and
not as facility or cleverness of the hand, which I have protested against
in respect of so many of the artists of my generation'. The first of the
'readymades' were *Bicycle Wheel*, made in Paris in 1913, and consisting of
a wheel mounted upon a wooden stool, and *Bottle Rack*, which was simply
that, a metal bottle rack of striking form [87]. They were manufactured
objects that Duchamp had purchased. The series of New York ready-
mades began with *In Advance of the Broken Arm*, which consisted of a
snow shovel. Another was *Hat Rack* [85], which was suspended from the
ceiling and photographed in *Shadows of Readymades* in 1918 [86]. The
implication that, in order to make a work of art, it is sufficient simply to
take an object and designate it as such seemed outrageous, perhaps
incomprehensible, at the time. Even with the hindsight of four-fifths of a
century and the subsequent work of many artists such as (in their differ-
ent ways) Richard Long and David Mach, Duchamp's revolutionary
gesture still sometimes seems more like a paradox than the embodiment
of an actual definition of 'art'. Yet Duchamp's act resounds through
the art of the twentieth century, and will continue to do so in the
twenty-first. It is the very foundation upon which much later work is

constructed. For instance, many of the works of the acclaimed German artist Joseph Beuys involve the placing of materials and objects of personal significance within glass display cabinets, or the presentation of readymade objects (such as a grand piano) in associations and contexts that for him were evocative. These and other works built upon Duchamp's quiet yet revolutionary gesture.

Duchamp was interested in ideas as much as appearances. His *Three Standard Stoppages* of 1914 [88] is widely regarded as the prototype for a certain kind of conceptual art.[12] It involved dropping a horizontal thread one metre in length from a height of one metre onto a horizontal plain, allowing it to twist as it fell, and cutting out wooden templates to record the position and shape taken by the thread as it came to rest. Duchamp carried out the experiment three times, and placed the resulting templates in a box, together with the three pieces of thread. The whole thing was called a *'hasard en conserve'* ('preserved chance'). Now it may be that the gallery-goer in 1914 would not have been greatly impressed by this work, nor might the viewer of today find it visually arresting. Yet it contains many ideas that anticipate developments later in the century. For instance, the notion that the work may take the form of the result of an act or action carried out at a specific time but which itself does not persist can be seen to anticipate the photo works of Richard Long, which record the line or the circle created by the artist in the landscape [18, 21, 34]. The photograph is the work in the gallery, but it is the action, the walk, that is important for Long. In a comparable way, when Andy Goldsworthy[13] reorders elements in nature to create some arresting new form – an ice-arch, or a boulder entirely wrapped in red leaves – only the photograph survives to tell the tale [9]. Just as Picasso restructured Western art by recasting the idea of a painting to include all that is known to be visible rather than simply and exclusively that which is seen at a

particular moment and from a particular viewpoint, so Duchamp allowed art to be the record, or the expression, of an idea. Art can be the expression in the material world of a concept, or the transformation into one material form of a structure that exists in another.

The demonstration by Duchamp that the very act of placing an object on display could establish its status as a 'work of art' had many implications for the further development of the visual arts, as we have noted. The notion of 'art' took on new dimensions of meaning. Moreover, Duchamp's interventions did not leave untouched the notion of 'display' or the status of those places where objects are routinely set upon a plinth or placed inside a glass box and offered for inspection, namely museums.

There has always been something rather bizarre about museums.[14] The very term 'museum' betrays this, since it really has no inherent meaning of its own, other than the vacuous notion of 'home of the muses'. But which muses? In Greek myth there was a muse for tragedy (Melpomene), a muse for history (Clio), a muse for dance (Terpsichore) and several others, but was there a muse for display? We have seen how odd the Renaissance cabinets of curiosities seem today. Indeed, it is remarkable how quickly a museum display, which seemed so fresh and new when first presented, can become out of date and seem not only old-fashioned but also embarrassing in its naiveté. Certainly a visit to the Pitt-Rivers Museum in Oxford today is a fascinating experience, as much for the method of presentation as for the collections themselves, since the museum's layout has changed very little since its institution by General Pitt-Rivers more than a century ago.

In 1968–69 the artist Lothar Baumgarten[15] photographed the ethnographic objects at the Pitt-Rivers Museum in a series of revealing studies. The material was turned into a projection piece of eighty slides and titled *Unsettled Objects* [89]. There is no precise or consistent scheme of classification in the museum, and the objects are grouped

85 *opposite above* A 'readymade' by Marcel Duchamp: *Hat Rack*, 1917.

86 *opposite centre* *Shadows of Readymades*, 1918, photograph by Marcel Duchamp.

87 *opposite below* One of the first 'readymades' by Marcel Duchamp: *Bottle Rack*, 1913.

88 Catching the chance moment: *Three Standard Stoppages*, 1914, by Marcel Duchamp.

according to a number of themes that were chosen by the General himself. As Baumgarten puts it – and his remarks have a relevance going beyond this specific collection – these exhibits have been:

displayed imagined classified reinvented generalized celebrated lost protected consumed climatized confined collected forgotten evaluated questioned mythologized politicized admired analysed negotiated patronized salvaged disposed claimed accumulated decoded composed disciplined named transformed neutralized simulated photographed restored neglected studied subtitled rationalized narrated valued typified framed obfuscated selected fetishized registered juxtaposed owned moved counted treasured polished ignored traded stored taxed sold...

Another artist who has used her work to raise questions about the nature of the museum and indeed about the processes of archaeology is Susan Hiller.[16] Her major installation *After the Freud Museum*, one of several large-scale works produced by Hiller using museological formats, takes as its starting point the private collection of Sigmund Freud, which is exhibited in London at Freud's last home. Freud made a substantial collection of Classical art and other artefacts which,

although catholic in taste for its time, today looks dated, a rather Edwardian version of the heritage of Western civilization. Hiller's installation comprises fifty custom-made cardboard boxes containing artefacts, texts and images, each box being individually titled, captioned and dated. Each, using the conventions of display of the museum object, catches a thought or an idea that may be evocative or that may constitute a commentary upon our ways of thought. As a whole, the installation is somehow more than just a commentary upon museum displays or upon the practices of archaeology. As Hiller puts it:

I worked on the piece for five years. My starting points were artless, worthless artifacts and materials – rubbish, discards, fragments, souvenirs and reproductions – which seemed to carry an aura of memory and to hint they might mean something – sometimes that made me want to work with them and on them. I've stumbled across or gone in quest of objects. I've orchestrated relationships and I've invented or discovered fluid taxonomies. Archaeological collecting boxes play an important role in the installation as containers or frames appropriate to the processes of excavating, salvaging, sorting, naming and preserving – intrinsic to art as well as to psychoanalysis and archaeology.

Like other contemporary artists, Hiller is intrigued by museums, both conceptually, in terms of how their collections are put together, and physically, in terms of their presence.

Hiller's work, following on from that of Duchamp, highlights the process of display. It reveals and emphasizes that we, whether archaeologists or artists, have to choose what we show. It is we as artists or as researchers who define our own preoccupations, who choose what interests us, and who select our own field of study and the nature of our creative activity.

Display is a common theme now in the visual arts, as the tanks of Damien Hirst, the vitrines of Joseph Beuys and indeed the boxes of the distinguished American artist Joseph Cornell reflect. It is a theme energetically and fruitfully explored by the conceptual artist Marcel Broodthaers.[17] And the preoccupations of such artists are not so far from those of the curators who produce very different outcomes within the conventions of the modern museum. The elegant displays of the Goulandris Museum of Cycladic Art in Athens reveal the current aesthetic approach to Cycladic art discussed in Chapter 2. The National Air and Space Museum in Washington presents this particular branch of the history of technology as a national triumph. To call this propaganda might be unfair, but it is certainly difficult to leave the museum without an enhanced awareness of the success of the United States in the space race and a renewed respect for its military technology. Any display reveals the preoccupations and assumptions of those responsible for it.

The work of Mark Dion, like that of Marcel Duchamp before him, focuses our attention on the significance of display, and the wide range of choices involved when objects are selected for display, whether by the artist or by the museum curator. The very action of displaying, of selecting artefacts and placing them together in a display case, attracts and holds our attention [89]. The plinth and the display case are both places where we expect to find 'art', and also places where we may expect to find artefacts that have been selected by archaeologists for their special interest. This reminds us usefully that archaeologists too have to choose. Naturally, when working in museums they choose what to put on display. But in any research endeavour they have to choose what subject matter is worth following up, what objects will repay study. Indeed, in deciding to become archaeologists in the first place they have exercised choice. That reminds us once again of the subjective decisions which, as noted in

Chapter 1, are part of the academic life of any archaeologist, or indeed any research worker. You have to choose first what you wish to do or study.

All visual art in a sense involves display, since there has to be something for the observer to see if communication is to take place. So the artist has to make the work visually available – although, as in the case of Marcel Duchamp's last work, viewed through a peephole as if by a voyeur and only put on display after the artist's death, even this convention is open to challenge. In a sense, the converse is also true: all display can be art. For the act of displaying, of inviting the attention and the contemplation of the viewer, establishes the artist–viewer relationship, and this is particularly so when the display to which the viewer's attention is invited has material form and is an item or installation that might be considered eligible as a work of art. Of course, any sign or advertisement invites attention, often with the obvious intention of eliciting a straightforward commercial response. Yet in a museum, as we have seen, there is not usually any commercial motivation and so the visual 'transaction' is much like that in the art gallery, where works of art are presented for contemplation. The political or propagandist overtones of museum display have been touched on above. For the archaeologist these are important issues, since her or his objective is not only to learn about the past but to make those findings more widely known. To the extent that these discoveries are based upon recovered objects of material culture, it is pertinent to present the latter for display. So the archaeologist is caught up in the enterprise of display, with all the ambiguities and complexities that artists such as Marcel Duchamp and Mark Dion have highlighted.

Archaeology as process

The widening scope of contemporary art, in highlighting the enterprise of display as a crucial one, also has implications for the field of archaeology, as we have seen. The museum is no longer simply a repository of antiquities and art works: it is seen now as an active force, a place where philosophies and discourses are developed and projected and where prevailing doctrines are confirmed.

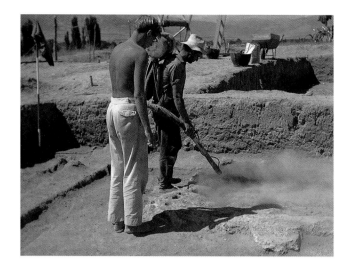

The pursuit of the past, which is the goal of archaeology, is itself a very active enterprise.[18] It involves the search for ancient sites through field survey and through the methods of remote sensing [33]; it involves excavation [92] and all the attendant techniques and specialist ancillary studies that it brings in its wake; it entails the painstaking analysis and publication of results and the formu-

lation of theories and interpretations. Here, once again, a comparison with art is unavoidable and also fruitful. We have seen that the notion of art as display carries consequences for the display of the relics of the past and for the discipline of archaeology. How about the notion of art as process, with which we began this chapter? To what extent should we again be reversing the idea and thinking about process as art?

In the Introduction, we contemplated the varied pleasures of archaeology experienced while actively undertaking the pursuit of the past. And the discussion of the work of Mark Dion brought us face to face with the artist as archaeologist, both in *Raiding Neptune's Vault* and in the *Tate Thames Dig*. As we saw, for Mark Dion the process often seems more important than the end product, the artefact display. We may regard Dion as to a significant extent an archaeologist because he *does* archaeology, not because he puts Roman potsherds in glass cases. He is a naturalist because he *does* botany or zoology, not because he exhibits butterflies. It is not really the end product that counts. The point of the *Tate Thames Dig* is not really the display case [71] at the end of it: it is the work of the volunteers on the foreshore, and all that labour of conservation and classification in the tents. It is because they are doing archaeology, or at least what looks like archaeology, that the enterprise has a special fascination.

Dion can be grouped with postwar artists such as Richard Long for whom the activity in which they are engaged is what matters, not the end product. As we have seen, they may be described as process artists. For Long, as for his contemporary Hamish Fulton, it is the activity of

92 and 93 Archaeology as process.
above The use of compressed air to clarify features in the soil at Sitagroi, East Macedonia, Greece, 1968.
opposite Sieving at Quanterness, Orkney, 1974.

walking that is the essence of the work. The precise form taken by the permanent record of that process – a line of stones left in the landscape, a framed photograph in an art gallery, a word work printed upon paper – is a secondary matter.

Dion's project at the Tate set the daily activity of the archaeologist, the act of collecting and studying, right in the centre of the frame. It reminds us that the archaeologist, by placing a found object on display in a glass case, is himself highlighting that artefact just as if it were a work of art. And what is true for the object is true for the activity. The observer today, the scientist, selects and isolates the object of study and the process of research. Dion goes further still. He makes us uncertain where science ends and art begins, or indeed quite what the difference is.

Such work breaks down the barriers between disciplines. It emboldens us to ask whether, if Dion is undertaking archaeology in pursuit of art, the archaeologist may not be creating art in the process of recovering or studying the past. Perhaps those 'pleasures of archaeology' recalled at the end of the Introduction should not be dismissed simply as agreeable experiences. Perhaps we should rather see them as indications of some-thing larger: of what the undertaking of archaeology could become, of how it should be. Indeed, one might go further and suggest that, for many researchers, that is what it already is. For often, in undertaking the processes of the disciplined archaeologist – the systematic surveys, the meticulous tasks of the excavator, the recording of the professional draughtsman – we are keenly aware actually while doing them of the ultimate goal, the contemplation and better understanding of the past. For quite often the excavator does indeed experience a keen sense of wonder as the dust of ages is removed to reveal those material traces of human activity that lie beneath [29, 30]. The researcher is sometimes aware of a shock of detection or realization as some clear pattern begins to emerge from the data. The draughtsman and photographer experience

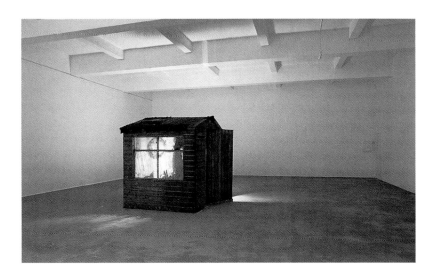

a thrill of recognition in discerning some element of design that has hitherto been overlooked. These are all experiences in which the researcher and the student establish a new relationship with the past activated through the material culture. The art *is* in the process. And the boundaries between the disciplines begin to break down.

I should like to conclude this chapter with a work from 1991 which reminds us that archaeologists are also preoccupied with what they call 'formation processes', that is to say, the way in which the archaeological record is formed – how artefacts come to be buried or incorporated in the earth and how they are preserved or distorted with the passage of time. The English artist Cornelia Parker[19] is very familiar with the experiences of the archaeologist and has taken part in archaeological excavations. In one remarkable work, she set out first to form what one might describe as her own archaeological record before retrieving and then presenting it. The formation process involved was a dramatic one. She took a garden shed in which she had placed various everyday objects such as one might expect to find there – cans of weedkiller, garden tools and so forth – and then she arranged for a corps of military engineers to blow the shed up. That was the

94, 95 and 96 Before, during and after: *Cold Dark Matter*, 1991, by Cornelia Parker. The sequence of photographs shows the hut as first built, during explosive demolition and as exhibited at Tate Modern, London, 2000.

formation-process phase. Without waiting for the passage of the centuries which is usual for an archaeologist, she proceeded at once to the recovery phase. She collected the damaged and broken objects and the fragments of wood from the exploded shed and began a process of reassembly. Here one thinks perhaps of that familiar but macabre image of modern times, the reassembly by accident investigators of a crashed aircraft. Then she created a remarkable installation work in which the broken splinters of wood and the various damaged artefacts were suspended from the ceiling by threads, creating a three-dimensional reassembly, lit from the middle by a single naked lightbulb. The effect was remarkable: the placing of the objects in space recalled the cataclysm of their formation, the initial explosion. Parker called the work *Cold Dark Matter*: a title that at once conjures up change on a galactic scale so that we imagine ourselves to be contemplating material suspended in outer space rather than a disintegrated garden shed. The naked lightbulb cast shadows on the walls of the gallery and it was with a shock of recognition that I realized where I had seen that effect before: it was in the photograph [86] taken by Marcel Duchamp in 1918 of the shadows cast by his 'readymades'.

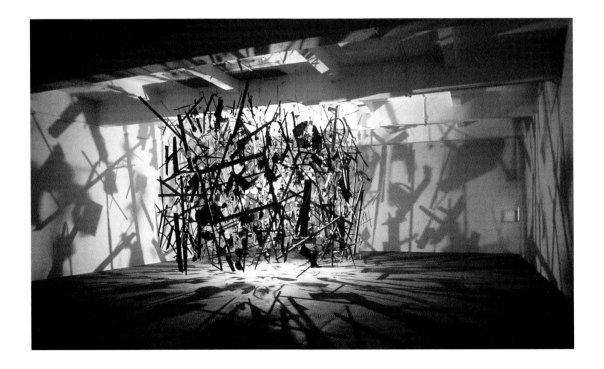

The human condition: Being and remembering

Footsteps

I begin this chapter with an evocative image. These are the ancestral footsteps that Mary Leakey uncovered two decades ago, preserved in the volcanic ash of an ancient eruption in Laetoli, Tanzania:[1] the steps made 3.6 million years ago, the earliest recorded steps by our earliest bipedal ancestor (or ancestral relative), today generally known by the name *Australopithecus*. As far as we know, these early hominids did not yet make stone tools, but they were the ancestors of us all. Insofar as it was ever true to speak of the 'missing link' in the evolutionary sequence between the earlier anthropoid apes and our own species, *Australopithecus* fits the bill.

Humankind has been defined in different ways: 'man the toolmaker' no longer works so well now that we know that other apes can also sometimes make tools. But the elements of upright, bipedal gait, binocular vision, prehensile grip, along with the ability to speak and to reason (through the use of symbols), are generally taken as the defining criteria of our own species, today designated *Homo sapiens sapiens*.

97 The first footsteps: imprints left in ash at Laetoli, Tanzania, by our remote ancestors 3.6 million years ago.

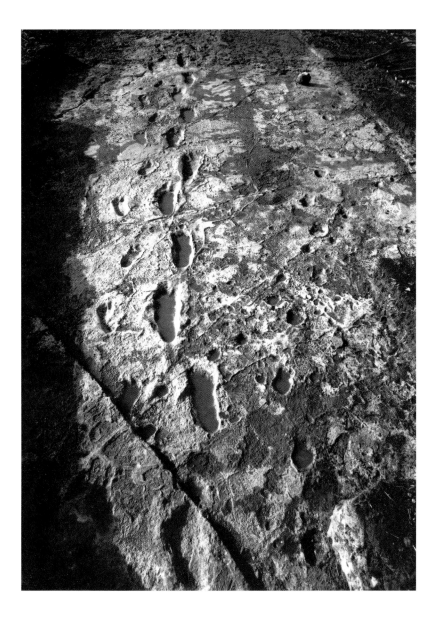

As a result of a century of painstaking palaeontological research, in Africa and elsewhere, we have come to understand in outline the fossil record of what Charles Darwin termed 'The Descent of Man' from the ancestral apes, as reviewed briefly in the Introduction. Nothing evokes that process more directly than this image of footsteps in the ash. A small step for man, a giant leap for mankind, to use the words of Neil Armstrong, spoken in another context.

Now that we have come a long way together in our discussion of art, I can say that I find this image more arresting, more breathtaking, more

99 Episodic culture: the first tools. Pebbles tool from Olduvai, Kenya, *c.* 1.8 million years ago, probably made by *Homo habilis.*

100 *opposite above* Mimetic culture: a handaxe from St Acheul, France, *c.* 500,000 years ago, characteristic of *Homo erectus.*

101 *opposite below* Learning by imitation (mimesis): was this how our remote ancestors, *Homo erectus*, learnt to make handaxes half a million years ago, possibly without the use of language? (After David L. Clarke.)

emergence of our species, already installed in Europe 40,000 years ago, why do we have to wait a further 30,000 years before we encounter major indications of a new and accelerated pace in human cultural development? What took so long?

In the next chapter I shall examine in more detail the process of *engagement* with the material world, that process undertaken in an informed way, which led to those changes, in which an entirely new *software* was developed. By that term 'software' I mean those shared understandings of the world that we sometimes call 'cultures' – very different in different times and places. Paradoxically, that learning came mainly from our interaction with material things, so that 'software' may not be a perfect term when we are speaking of contact with the hard realities of the material world. But first I want to undertake a broad overview which offers some insight into some of the fundamental developments of the human story.

The material-symbolic phase

A decade ago, in his *Origins of the Modern Mind*, the American psychologist Merlin Donald[+] produced a remarkable overview of the evolution of our species, in behavioural and cognitive terms as well as anatomical ones. He brilliantly summarized the key aspects of human cognitive evolution. Let us first recall what the fossil record tells us: that from the ancestral apes there emerged in Africa some four million years ago the genus *Australopithecus*, the bipedal ape that made the footsteps we have been admiring. Around two million years ago there then emerged *Homo habilis*, the first maker of stone tools, and subsequently *Homo erectus*, the first to make those improved tools that we call handaxes, and the first to disperse to other continents. However, it was in Africa, some 150,000 to 100,000 years ago, that from the African variant of *Homo erectus* there emerged our own species, *Homo sapiens sapiens*, which began its dispersal from Africa perhaps 80,000 to 60,000 years ago, reaching Europe 40,000 years ago.

Donald rather brilliantly encapsulates this story in three major transitions from the earliest stage of the primate apes:

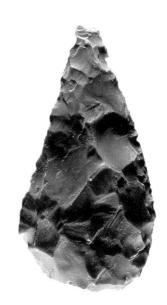

MERLIN DONALD'S SYSTEM OF COGNITIVE PHASES:
– Episodic culture, characteristic of primate cognition,
e.g. *Australopithecus.*
 (first transition)
– Mimetic culture, characteristic of *Homo erectus.*
 (second transition)
– Linguistic or mythic culture, characteristic of early *Homo sapiens.*
 (third transition)
– Theoretic culture, utilizing external symbolic storage.

The first great transition leads, through the development of non-verbal modelling, to the 'mimetic' stage characteristic of *Homo erectus* around a million years ago. These ancestors were so good at handling tools and imitating each other that they developed their own material culture, involving handaxes and no doubt many other things, as well as the use of fire. We must also assume that they had some kind of language, but the extent to which *Homo erectus* was capable of sophisti-cated speech is a matter of considerable controversy.

The next transition was to our own species and (Donald argues) to the fully developed use of modern speech capacity. This was the 'human revolution', about which archaeologists[5] such as Lewis Binford and Paul Mellars have written. This takes us to what Donald terms the 'mythic' stage, involving the use of speech and narrative.

His third and final transition is based primarily upon the use of writing and leads to the modern 'theoretic' stage. It is characterized by what he calls 'external symbolic storage', the means of developing a store of knowledge located outside the human brain, of which written records are the best example.

At the 'mimetic' stage, the stone tools of *Homo erectus*, including the handaxe [100], may have been made, and the skills taught, without the use of developed speech, through imitation, or mimesis, as the late David L. Clarke[6] suggested.

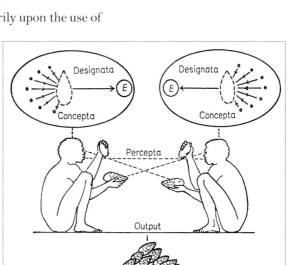

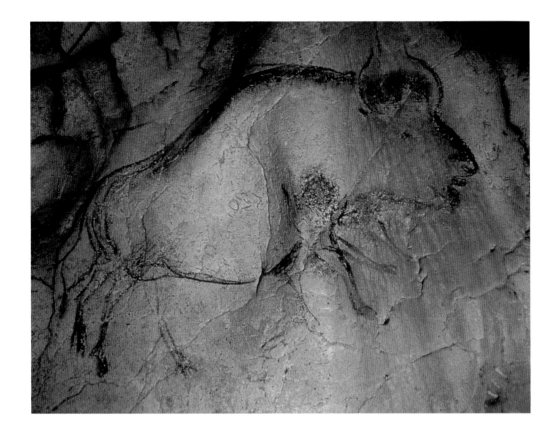

The 'mythic' stage of our own species is, of course, brilliantly illustrated by the cave art[7] of France and Spain, those remarkable painted images of animals on the walls of the limestone caves of France and Spain, of which the earliest may have been painted as much as 30,000 years ago. They will have served as the focus for stories and narratives, for histories and for song, just as we see in hunter-gatherer communities today. But it should be noted that such images are restricted at that time to the territories of what are now France and Spain. For although examples of rock art – paintings and engravings in rock shelters – are found over much of the world during the late Upper Palaeolithic period, they do not rival those of France and Spain in their richness and profusion, nor in what might seem to us as their 'naturalism'.

The later, 'theoretic' stage is epitomized by early writing, seen in the fourth millennium BC in the Near East in the city-states of Sumer and at about the same time in the later years of Predynastic Egypt, just before the formation there of the Old Kingdom. The utility of writing was enhanced by the alphabet script adopted in the seventh century BC by the ancient Greeks, who enjoyed much more widespread literacy. Theoretic developments were assisted by the invention of such further devices for external symbolic storage as maps and diagrams, and weights and measures. These are matters to which we shall return in Chapter 6.

However, while this provides a very illuminating draft outline of human cognitive development, Merlin Donald, in his initial formulation, overlooked a crucial point. We can accept 'mythic culture' as a good description for the life of the Upper Palaeolithic hunter-gatherers, and 'theoretic culture' as suitable terminology for the more sophisticated urban culture of Mesopotamia and in particular of ancient Greece, with its written laws, refined architecture, theatres and coinage, but there is something missing.

For me, Merlin Donald has omitted the most crucial step of all – or at least has passed over it very lightly. For I would argue[8] that the first great revolution or transition in the experience of our species was the sedentary revolution. It was then that humans entered into a series of new relationships with the material world. It was then that they built houses, fashioned images of deities and constructed shrines. As we know, they then soon came to build tombs and monuments. They developed new technologies such as metallurgy and, crucially, new systems of value – they invented valuables. As we shall see below, they defined commodities, and systems of exchange between commodities, which established the basis for trade and the economy. Most or all of this was achieved without the use of writing.

The key to this process was the development of material symbols – symbols of power, symbols of rank and prestige, coveted materials that were the repositories of value. It is necessary to recognize that there was a very significant transition from the 'mythic culture' of early *Homo sapiens* in the Upper Palaeolithic period to the 'material-symbolic culture' which came with sedentism and was often accompanied by

102 *opposite above* The earliest paintings: mural art from the Grotte Chauvet, France, c. 30,000 years ago.

103 *opposite below* Mythic culture and the beginnings of narrative: rock shelter painting of an abduction scene, from Kolo, Tanzania, c. 5,000 years ago.

104 Symbolic material culture: high prestige inherent in valuable grave goods and offerings: handle of jade seal accompanying the burial of the Chinese empress Lu Hou, c. 180 BC.

fishing village of Port Seton. Bellany is preoccupied with the imagery of life's voyage and with his ancestors [8, 121] in the same way that any hunter-gatherer, as exemplified in rock art across the world, is preoccupied with the animals that compose much of its vivid reality, and that no doubt figured in mythical narratives.

So let us remind ourselves of the basics of our existence – that each of us has been and is restricted by and enabled by the body, by our corporeality; that our experience of the world comes to us in the body, and that anything outside it is communicated to us through the senses. That is the starting point for the human condition, just as it must be for any broad consideration of anthropology or of archaeology, or indeed of philosophy. Our subject here, archaeology, naturally lays emphasis upon the material remains of the body – whether in the enduring structure of the skeleton, seen for instance in 'Lucy' of the genus *Australopithecus* or in the well-preserved cadavers of more recent times. Over the millennia the human body has been preserved for modern investigation and inspection through desiccation in the deserts of Egypt, where Predynastic corpses are preserved as well as if they had been mummified, through the preserving waters of the Danish bogs, where bones are dissolved but skin and flesh are remarkably preserved, or through the glaciers of the Alps in the case of Ötzi, the Ice Man.

But I want to turn first to the living body of the human individual. This has been a favourite subject of artists from the palaeolithic period onwards, first seen in those small, so-called 'Venus' sculptures [59, 60], then in the preoccupations of the inhabitants of Greece, from the Early Cycladic through to the Archaic period and on to the achievements of Classical sculpture. But as we saw when discussing the tyranny of the Renaissance, by the end of the nineteenth century and the time of Rodin, the possibilities of sculpting the body had been virtually exhausted: 'naturalism' had run its course. It took the abstractions of Brancusi and Turnbull to give it renewed meaning.

In contemporary sculpture, however, Antony Gormley[9] has given the human body a new lease of life. Although best known in Britain for the colossal *Angel of the North*, Gormley has explored the possibilities and limits of the body in a wonderfully evocative series of sculptures. In each

106 Ancestry of the body: one of the earliest hominid skeletons, 3 million years old: 'Lucy' of the species *Australopithecus afarensis*, from Ethiopia.

107 *opposite* Becoming in the body: *Learning to Be*, 1992, by Antony Gormley, in the Fellows' Garden, Jesus College.

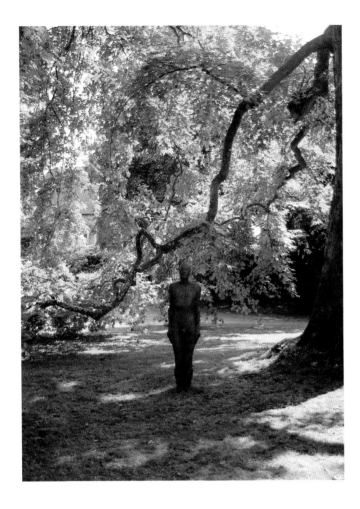

of these, whether cast in lead or iron, the starting point was Gormley's own body. This was wrapped in cloth and plaster [109], making an impression that was then allowed to dry, to form the mould for the casting. By choosing this method, Gormley avoided the long and great tradition of the sculptor in stone, chipping away at the block, and bypassed the triumphant centuries of the worker in bronze, carefully building up in clay the desired form before casting it using the lost-wax process. He simply sidestepped these accumulated skills and conventions, and in doing so created a series of sculptures of remarkable freshness.

I came to know Gormley's work well when he created a sculpture for one of the 'Sculpture in the Close' exhibitions at Jesus College. *Learning to Be* [107, 108], displayed beneath an oriental plane tree in the grounds of the college, had a very direct impact. In the *Learning* series the works are all lifesize, since they were cast from his own body. But I like to think

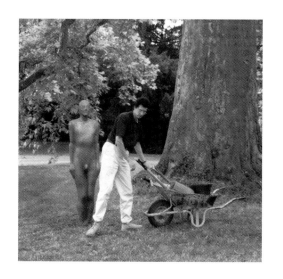

of them as suggesting that we came into the world at full size, so that our earliest years were not a matter of growth in size, but were indeed a matter of emerging awareness and understanding of the world, such indeed as the infant experiences along with the process of physical growth. The related work *Learning to See* reminds us that the infant is first overwhelmed by visual impressions, and that it takes months before we come to see the world in three dimensions, before we come to see that the world may be grasped as consisting of material objects situated in space, and that these are capable of moving without losing their integrity. We come to learn that objects only appear to change in scale as they approach or move away. *Learning to Think*, where the bodies are free, but the heads (and thus the minds) are not yet so but embedded still in solid matter, in this case the ceiling, is part of the same series. Other sculptures, for instance those detailing the orifices of the body [110], survey or redefine the material realities of our existence. Others, such as *Sound II* [111] and *Learning to See*, re-examine our dependence upon the senses.

As Gormley has noted: 'My body contains all possibilities. What I am working towards is a total identification of all existence with my point of contact with the material world: my body... Part of my work is to give

back immanence both to the body and to art.' I see a strong parallel, in one sense, between the work of Gormley and that of Richard Long. You may remember that I described Long's work – at the risk of sounding a shade pretentious – as 'existential'. By that I meant that Long walks alone, and that through his walks and their modest impact upon the world recorded by him, he recalls that he has been there. His presence is felt in the landscape: Kilroy was here. Similarly, in these works, it is the existence of Gormley, standing alone, that is attested and explored. As he has put it:

I want to confront existence. It is obviously going to mean more if I use my own body… I turn to the body in an attempt to find a language that will transcend the limitations of race, creed and language, but which will still be about the rootedness of identity… The body is a moving sensor. I want the body to be a sensing mechanism, so your response to the work does not have to be pre-informed and does not necessarily encourage discourse… If my subject is being, somehow I have to manage to engage the whole *being* of the viewer.

For me as an archaeologist, there is a further dimension. Gormley is speaking of the existence of the individual, and the coming into being and full self-awareness of the individual, as the inhabitant of his or her body. But it is often claimed that ontogeny recapitulates phylogeny: that is to say, that the development of the individual in the various stages of the embryo, and the growing complexity from the egg, in some ways resembles the evolutionary history of the species from simple to more complex forms. This thought, this metaphor, applies to mental and cognitive capacities also, and students of child development, including

108 *opposite above* Antony Gormley with *Learning to Be*, 1992, in the Fellows' Garden, Jesus College.

109 *opposite below* True likeness: Antony Gormley (in plaster) and helpers during the production of the mould for a sculpture.

110 Exploring the body: *Sovereign State*, 1989–90, by Antony Gormley.

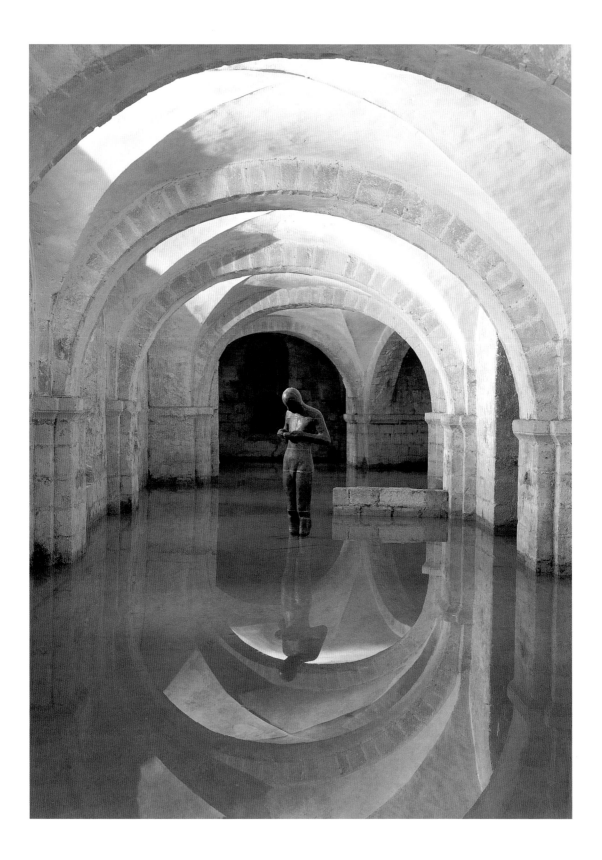

Jean Piaget, have noted the successive phases implicit in the process of 'learning to see' or 'learning to think'. When we as archaeologists are interested in what I have described as the development of the 'software', the changing circumstances in the human condition from the era of the hunter-gatherer through the sedentism of the neolithic to the urbanization of the bronze age, we have to think of these processes of growth. The work of Gormley is a meditation upon human existence and upon human *becoming* – always aware of this immanence and that our being is incarnate. For me, *Learning to Be* and *Learning to See* are not only illuminating meditations upon the condition of each one of us now. They stand also as metaphors for the 40,000 years or more of the development of our species, always with the same body and the same hardware – always *Homo sapiens*, with the same essential genetic code – but always developing in our cognitive capacities, in our software.

I shall argue, however, that that process of development is a social one, involving interactions with others, employing language and contacts via material culture. Gormley's work is not so much about these aspects. It is primarily about the individual and rather less about the socialization process.

The body fixed by time: Pompeii

Now I want to turn again briefly to the archaeology of the body and to another case of 'involuntary art': ancient Pompeii,[10] smothered in volcanic ash in AD 79. Many of its inhabitants fled successfully. But those who did not get away, like Pliny the Elder, the uncle of the Younger Pliny whose narrative of the event we have, were suffocated in the sulphurous fumes that came with the accumulating ash. Not only were the streets and the houses – and the frescoes – preserved. In digging, the excavators found cavities in the ash. They discovered that if they poured in plaster of Paris, the ash that had fallen round the still-living bodies of the inhabitants who did not get away formed a perfect mould, so

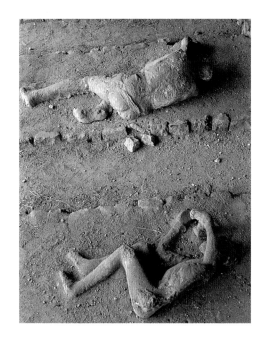

111 *opposite* The sound of silence: *Sound II*, 1986, by Antony Gormley, installed in the crypt of Winchester Cathedral in 1993.

112 The moment of our death: body casts at Pompeii, Italy, AD 79.

115 Conversation piece: *The Diner*, 1964–66, by George Segal.

116 *opposite* Urban anonymity: *Walk – Don't Walk*, 1976, by George Segal.

implied is not between the figures (as in *The Diner*) but between the subject, Alice, and the sculptor himself.

These works by Segal are not the timeless humans of Gormley, nor the unfortunate Romans of Pompeii. Each is rooted in the postwar world of the United States in a way that is already distinctly dated. This is the America of yesterday, not of today. These figures, although they do not speak much to those around them, in the bus or the diner or crossing the road, are to a large extent 'socialized'. They are not free agents, they are not individuals contemplating the world. They live within a social order, which may be one of anonymity, of anomie, but it is social nonetheless. Segal uses artefacts, albeit of a modest character. And the life of these individuals is revealed to us through their relationships with these artefacts. This makes these works an excellent herald for my next chapter, which is indeed about human engagement with artefacts, and how that engagement socializes and changes those humans and their culture. They are enculturated through those processes. Indeed, one could use

these sculptures as an illustration of what the French sociologist Pierre Bourdieu[12] calls *habitus*: 'a permanent disposition, embodied in the agents' very bodies in the form of mental dispositions, schemes of perception and thought... and at a deeper level, in the form of bodily postures and stances... ways of standing, sitting, looking, speaking and walking'.

These figures by Segal are enculturated in a way that those of Gormley are not. The latter are timeless, even if they were evidently made in our own time. Those of Pompeii are in part de-culturated by the stress of the moment and their unsuccessful struggle to survive. Segal's figures belong in the urban world of late-twentieth-century America, the tired world of the bus-riding commuter, the weary worker taking

another repetitive meal in a cheap diner, the pedestrian in the crowd waiting obediently for the DON'T WALK sign to turn to WALK.

These sculptures all have something to say about the human condition. Gormley brings to our attention the whole process of becoming and explores the limits of our bodily existence as well as the development of our cognitive faculties. He is concerned with seeing and with being – another remarkable work is called *Concentrate* – and the artist is as much preoccupied by the mind as by the body. And these are male figures because the artist is male and they are based upon his own body. The Pompeii figures naturally speak to us of mortality, since they are preserved for us precisely through the death of their subjects. I find it rather disquieting that they work for us as sculptures: the reality is just a little too intense for easy contemplation. They too have a timeless quality: we know that they died in AD 79, but without the contextual documentation they could come from a volcanic eruption that took place at any time and in any place.

But Segal's figures tell a different story: here is the body specific to its time and place. Here we are reminded that in life we occupy a definite time and specific place, and we speak a language determined by circumstance; we wear the clothes that convention or fashion dictate, and we obey the instructions of the traffic light.

The body[13] is one of the realities of the human condition with which archaeologists today are seeking more consciously to come to terms. Naturally, there are aspects here that I have not explored. There are several women artists, not least the sculptor Elisabeth Frink, who would give us a rather different view of the human body, and others, including Mona Hatoum and Tracey Emin, who would focus our attention more clearly upon questions of gender [66, 67].

Yet I have chosen to use contemporary representations of the human body, and of ancient footprints, because these speak to us most directly about the human condition. They remind us that some of these things are perennial – the human body has changed very little (like the human genome) in 40,000 years. Indeed, it has changed little enough in three million years, as the footprints of *Australopithecus* so clearly reveal. The sculptures of Gormley and the casts from Pompeii confirm and illustrate this. Yet the sculptures of Segal in a way contradict it. By their bodily actions and gestures, these figures betray themselves to be members of the modern world. For them the human condition has changed. The physical limitations may still be there, the lifespan still three score years and ten (subject to actuarial adjustment). But they are enabled through their culture to do different things: they can ride over great distances in a bus. They can ask for and be given a hot drink without the evident use of fire. They can walk among crowds of strangers in the streets of a conurbation and receive and obey non-verbal instructions as to their locomotion. The sculptures of Segal have much to tell us about the human condition, not least that our incarnation is not timeless: it is here and now.

Already, therefore, although I have been speaking about the body and by implication separating it from the mind, the dichotomy has broken down. And so it should. The figures of Segal are sentient beings rooted in the America of the 1960s and 1970s: their moods and preoccupations, their states of mind, are reflected in their bearing and presence. But now we should turn more explicitly to questions of mind, in the first place during the first of the phases of sapient existence that we have identified: the mythic.

Myth and the social construction of memory

The first phase in the existence of our own species, *Homo sapiens sapiens*, is rightly categorized by Merlin Donald as 'mythic', as one governed by the use of oral language and narrative thought. Of course, each phase also contains the seeds of its successors, and one should not deny to the Upper Palaeolithic hunter-gatherers of this first period the potentiality, indeed the capacity, for the use of material symbols that flourishes so

117 The individual presence: *Alice Listening to her Poetry and Music*, 1970, by George Segal.

prominently in the early stages of the next phase with the development of sedentism. In the first phase, in the Upper Palaeolithic, there is even evidence for external symbolic storage, indicating the development of theoretic thought which we generally associate with the subsequent development of writing.

The so-called 'Venus' figurines of the hunter-gatherers of Upper Palaeolithic Europe [59, 60] must evidently be regarded as material symbols, although we do not yet understand their function. The quite elaborate shell necklaces accompanying some burials during this first phase may already hint at the construction of categories of gender and status. Perhaps most intriguing of all are the notched artefacts [118] of bone and antler, found mainly in the Franco-Cantabrian area, which have been studied in detail by Alexander Marshack.[14] By showing that the incisions were made on several different occasions, Marshack is able to claim them as a form of notation, perhaps recording successive observations of the moon. This would then qualify as the earliest known calendrical notation, a good example of external symbolic storage. And if we are indeed claiming that these early humans were inherently every bit as clever as us, why should this not be so? In the same way, many hunter-gatherers today produce symbolic items of considerable complexity. But of course these contemporaries are partakers in traditional communities that have survived as hunter-gatherers for up to 10,000 years since the emergence of sedentism and farming in other parts of the world. So they have had plenty of time to develop social relationships and symbolic means of facilitating them that may not have been available to their ancestors 10,000 years ago. We should not too readily equate them with their Upper Palaeolithic predecessors.

What is so interesting when we look at the hunter-gatherers of the Upper Palaeolithic, these first pioneers of our own species, active in the wider world, with all their innate capacities, is that we are also seeing the first attempts of what, in some senses, was the modern mind to use its abilities and potentialities in the new ways open to it. These were probably not available to the minds of more restricted cognitive capacity of our earlier ancestors in the 'episodic' and 'mimetic' stages. Earlier in this chapter we contemplated the 'human condition' in terms of the body

that we share not only with all our contemporaries, give or take a little variation, but with all earlier generations of our species. It is interesting, in the same way, to think about the early human mind – containing the same 'hardware' as our own, as discussed earlier, but running only the first level of 'software', whose development is at the heart of the human story. As already noted, the inheritance of this software does not come with our parental DNA but with our upbringing, in most cases our parental upbringing. This is a matter of education not birth.

In this chapter, where we are contemplating the first cognitive stage in the story of our species – and thus the 'human condition' in a very basic and inclusive sense – it is a harder task to consider the mental equipment available than it is to review the limitations and potentialities of our incarnate existence within the human body. That is true because our corporeal reality may not have changed so much, even though, as we looked at the work of George Segal, we saw that bodily posture and gesture are shaped to a large extent by our cultural environment: that body is inseparable from mind.

It is worth stressing also the various cognitive and material advances that the ancestral hominids had accomplished in the preceding 'episodic' and 'mimetic' stages. Tools in a range of materials, and demonstrably stone, were in universal use [99, 100]. Already in the 'mimetic' stage, humans had learnt to control fire. There are signs, moreover, that they were capable of producing and using more complex material artefacts. There is evidence that our *Homo erectus* ancestors had found their way to occupy what were at the time islands, and that they must have done so with the use of boats. Certainly, the very early occupation of Australia by our species, more than 50,000 years ago, shows that these pioneer colonists were making and using craft capable of crossing significant expanses of sea. So we should not underestimate the cognitive attainments of *Homo sapiens* quite early in its career.

Many years ago the French archaeologist Henri Frankfort[15] and his colleagues produced an illuminating book entitled *Before Philosophy*. The authors argued that before philosophy, in the sense of abstract and theoretic thought, human speculations about themselves and the universe were expressed in myths. 'These myths are not mere stories,

118 The construction of memory: bone plaque, about 30,000 years old, with markings possibly recording the phases of the moon, from the Abri Blanchard, France.

121 Enduring myth:
Odyssey, 1998,
by the Scottish painter
John Bellany.

aware of the marital tensions leading to his divorce from his first wife, the insanity and subsequent death of his second wife, and the artist's own decline into alcoholism, his redemption by a liver transplant operation, and the new lease of life that followed this bodily regeneration (including remarriage to his first wife, Helen).

Bellany later made a whole series of paintings, with an underlying leitmotiv of 'life's voyage' with the artist as the travelling Odysseus, accompanied often by relatives and ancestors. In earlier, more sombre days, he also painted his own version of Gauguin's interrogatory canvas [2] with which I began this book, *Whence Do We Come? Who Are We? Whither Do We Go?*, and he has returned to this theme again very recently. As the critic Duncan Macmillan[18] has written of Bellany's early work, relating to the life of the sea:

Bellany was born into the fishing community of Port Seton on the Firth of Forth. There, life and too often death too were focussed on the sea and, perhaps by a kind of projection of its mighty indifference to human fate, on a bleak religion of perpetual atonement, unforgiving as the sea itself.... He was part of a community entirely shaped by the age-old relationship of fishermen to the sea. In a way it was archaic: hunters like our most distant ancestors, pitting their courage against the sea's unpredictable power to hunt for fish in a timeless relationship between man and nature.

There are watchers everywhere, ominous presences... In the earlier paintings these ominous presences are again terrifying images of alienation. Now, however, in *Whence Do We Come? Who Are We? Whither Do We Go?* the two characters seem prepared to ride out the storm... Perhaps, at last, no longer alone they have reached an accommodation, a basis for peaceful co-existence.

In these paintings one sees at work the process of the individual construction of memory. In early days, in what Donald termed the 'mythic' phase of *Homo sapiens*, shared rituals and communal songs are likely to have supported the use of narrative to produce and perpetuate shared memories, giving coherence and expression to the community as a whole. However, it was not until the neolithic period, the period of early farming, to which we shall turn in the next chapter, that the social existence of the community was given material focus and expression in the construction of monuments. Memory was externalized, and more effective mechanisms were developed for the passing on within the community of shared experience. Memory, supported by narrative, is a fundamental characteristic of the human condition. Its perpetuation through human engagement with the material world is perhaps the most remarkable and significant process in the human story.

The (al)lure
of the artefact

We have looked at the 'human condition' as embodied by the first members of our species as hunter-gatherers of the Upper Palaeolithic period roughly 40,000 years ago. And we have reflected a little on the body, the human body, which was then very much as it is now. We have considered also the human mind, which was already in some respects like our own, even if theoretic modes of thought and the accumulating experience of millennia were not yet available.

My thesis in this chapter is central to the book as a whole. I spoke earlier of the 'sapient paradox' – the fact that it took so long, after the widespread appearance of our species, *Homo sapiens sapiens*, for instance in Europe already 40,000 years ago, for the great changes in human existence to take place. The development of large settlements, new technologies like metallurgy, the growth of cities, the emergence of economies and the formation of great exchange systems, the invention of writing and all the other trappings of civilization – what took so long?

The answer, I shall argue, is that it was not until the development of a settled way of life and, soon after, the inception of farming that humans became involved in the more sustained *engagement* with the material world[1] that led, through the use of different artefacts, to a whole range of new activities and processes – processes in which the symbolic role of artefacts was crucial. These were cognitive developments as much as technological ones. This is the material-symbolic stage of human cognitive development, briefly discussed in the last chapter.

122 Man and work: Eduardo Paolozzi with *Girot*, 1964, at Jesus College, Cambridge, in 1994.

123 The mysterious skill of the smith: *The Artist as Hephaestus*, 1987, by Eduardo Paolozzi.

Today we are born into a world of artefacts, and it is these and the way we learn to use them that make us what we are. That is how we differ from those early humans we discussed in the last chapter, whose DNA was already identical to our own. It is a cumulative process. The humans make the artefacts, and then the world of artefacts shapes the humans.

Eduardo Paolozzi [122] was one of the first artists to reflect on this process and to encapsulate it in his remarkable figures. In most of his sculptures, the greater number of which represent the human form, and in many of which, let us admit, that form has a striking resemblance to himself, the image is constructed of artefacts – machine parts forming a three-dimensional collage in which we can discern the human figure [132, 133].

Yet what are these component parts? They are themselves artefacts. Of course, the final work looks a bit robotic – as if robots are busy making robots. But we can read it in a different way. One of my favourite books in the whole field of archaeology[2] is Gordon Childe's *Man Makes Himself*, published in 1936, whose title encapsulates this idea of self-creation, of the human as demiurge. And one of my favourite passages from the work of J. K. Feibleman, which summarizes how this process[3] works in just a few words, is: 'We are the creatures of the institutions we have made, and this is no less so because we have made them. There is a helix of interactions between man and his works so that the effects on him of his works spur him to further works which have further effects, and so on until it is impossible to tell which is man *qua* man and which is his work.' Many of the sculptures of Eduardo Paolozzi epitomize this process, of human existence shaped by the world of artefacts which are themselves the product of human activity.

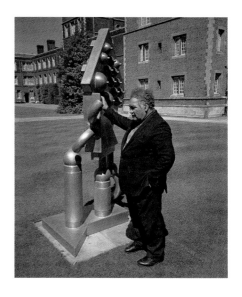

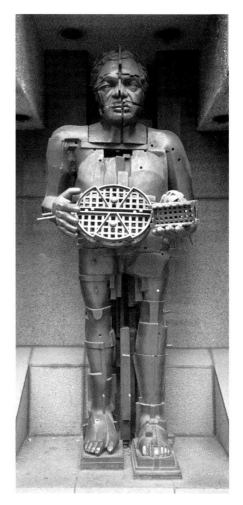

Moreover, the things with which humans have dealings are not mere utilitarian objects. They have symbolic significance; they function also in a cognitive realm; they are imbued with meaning and with value. As the philosopher Ernst Cassirer[4] put it:

No longer can man confront reality immediately; he cannot see it, as it were, face to face. Physical reality seems to recede in proportion as man's symbolic activity advances. Instead of dealing with the things themselves man is, in a sense, constantly conversing with himself. He has so enveloped himself in linguistic forms, in artistic images, in mythical symbols or religious rites, that he cannot see or know anything except by the interposition of this artificial medium.

The daunting figures created by Paolozzi for the National Museum of Scotland [6] embody these ideas. The figures are themselves made of artefacts, which in a sense they or other figures have constructed. And each holds or contains an object which is not merely an artefact: it is a *valuable*, which carries with it an allure of prestige and historical significance; a symbol within a symbol. They are the product of the spiral of interactions, the process of engagement with the material world, which is the key to the creative process, the construction of the realities to which we are born and by which we go on to live.

In this chapter I first want to explore how that process of engagement works: i.e. the active role of material culture. Afterwards I want to look further at the way aspects of its working have been caught so effectively by a number of artists, including Paolozzi and another brilliant contemporary, David Mach.

From sedentism to symbolism

We have spoken already of the mobile life of the hunter-gatherers, and of the rather modest range of artefacts that they can carry with them. Let us turn now to the materiality of the excavations at one of the earliest of major farming sites at Çatalhöyük[5] in Anatolia, in the Konya Plain of what is now Turkey [124]. Dating back to 6500 BC, the excavations of James Mellaart

showed it to be a very large village, a town almost, whose buildings were made of large mud bricks. This was an early farming community, relying on wheat and barley, sheep, goats and cattle. In the later phases its inhabitants used pottery. They chipped obsidian obtained from the nearby quarries, and wove flax to make textiles. The rooms of some of their houses had plaster reliefs and wall paintings perhaps connected with fertility, and they made a range of figurines of baked clay and stone.

This is not the earliest sedentary and farming settlement in the Near East. Indeed, we know now that sedentism preceded farming, and that before cereals and cattle were domesticated these early villagers were making plaster effigies of what we must regard as deities (as at the site of Ain Ghazal in Jordan), and carrying out a practice (or rather a ritual?) in which the skulls of the dead were plastered to produce what must have been an enduring image of the deceased.

These are just some of the material products of the engagement process of which I am speaking. But it is the social relations that really interest us, and the symbolic relationships that become possible and that in a sense are created by the very act of making these material symbols.

This is not a case of material objects and symbols reflecting pre-existing ideas. On the contrary, the active role of material culture determines that it is out of the creation of these artefacts that the symbolic relationship between idea and object, between thing signified and signifier, emerges.

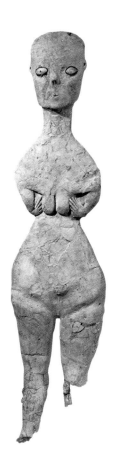

Property Let me illustrate this by the concept of property.[6] Consider the situation if, before animal domestication was widely understood or practised, you caught and reared a calf. Since you now have a house, a permanent dwelling for yourself and your family, you keep the calf in a field near the house where you live. Soon both the house and the calf are 'yours': they become your property. Previously, in a hunter-gatherer existence, many things would have been jointly controlled and 'owned' by the community. But now new concepts of property emerged through the reality of permanent residence and permanent custody. The philosopher John Searle has spoken of 'institutional facts' which are realities precisely because everyone in society accepts them as such. Property, like marriage, is one of these. As we shall see later, so are value and wealth.

Divinity The French archaeologist Jacques Cauvin[7] has recently stressed that, in the Near East, new religious forms finding expression in the development of a range of effigies and symbols [124, 125] actually preceded the development of agriculture and stock-rearing. Indeed, it may be no exaggeration to say that it was in part though the material engagement involved in the creation of images and visual symbols that new concepts of divinity developed.

Those who live in a Protestant nation sometimes imagine that it is a simple matter to worship a god without first creating an image of the deity in the way more familiar in Roman Catholic or Orthodox realms of Christendom where icons are frequent. We can cite non-representational religious traditions such as the Jewish or Muslim faiths by way of example. But, of course, all of these – Christianity, Judaism and Islam – are religions of the Book, and so they belong to the later, literate 'theoretic' phase of human experience. They could not function without the Bible, the Talmud and the Koran. So I think we can claim an earlier creative role for material culture in which the worship of gods may have emerged with the substantiation, the taking of substance, of these divinities.

The neolithic revolution in the Near East, as also in different ways in China and in Mesoamerica, was the process by which the human engagement with the material world took new force and substance. These are ideas that Trevor Watkins[8] has been developing, and they are well expressed in his book on the neolithic revolution. Different areas have different trajectories of development, in which, however, analogous changes may be seen.

Parallel developments seem to have taken place, for instance, in the Yellow River Valley in China. The site of Pan P'o is a well-known early farming village site, where the agriculture was based largely upon the production of millet (rice first became a domesticate in the regions further south). Pan P'o may no longer be the earliest sedentary settlement known in this area, but it certainly exemplifies parallel developments.

Similar comments can be made about the Americas, for instance the Valley of Mexico, where sedentism, based mainly upon the cultivation of maize, is seen at an early date, and with it the development of most of the features discussed in rather abstract and general terms in this chapter.

Community Another example of this process whereby reality and symbol emerged together is given by the construction of monuments in many early societies. In the Introduction we looked at the work of Richard Long and regarded his sculptures as in part existential statements which could be paralleled by the construction of early 'monuments' by prehistoric societies, such as the first farming communities of the Orkney Islands [7]. But my point here is that a monument or tomb like Quanterness [15, 24, 27] does not simply reflect and represent the community that built and used it. It is not a symbol of that community only in a passive sense, merely reflecting its pre-existing corporate status. I would argue that it was the very act of building, by the inhabitants of that territory of the Orcadian Mainland, that (in the course of the 10,000 and more hours of work needed, as well as in the planning and in the accompanying rituals) brought about the formation[9] as a real community of what may initially have been a very loose association of people. Following its construction, it will have acted as the focal centre for that society. They would thereby have become the 'Quanterness people', and access to the surrounding land would have manifestly been theirs, as a matter of right. The construction of the cairn was thus not just a symbolic reflection of a pre-existing social reality. It was a creative act, influential in the establishment of that community, another indication of the active role of material culture and of the engagement process of which we are speaking.

Value and prestige If this active, constructive role of the creative act of shaping the world applies to deities and communities, it may be seen to apply also to power, prestige and value. Let us look for a moment at the very earliest uses of a material that we think of as possessing intrinsic value – gold. The high worth of gold is another 'institutional fact'. It is not a natural or 'brute' fact. There is nothing out there in the world that says that this material, gold, should be highly valued, although it does have the convenient properties of not oxidizing or rusting, and it does reflect light. But there is no evidence that gold was much valued in palaeolithic or even in neolithic times, although native gold must have been in existence then.

The earliest evidence we have in the world for the energetic and systematic use of gold [127] is in the 'Copper Age' cemetery at Varna[10] in Bulgaria around 4500 BC. There, in a series of graves, we see special objects of flint, shell, copper and gold being used to enhance and reflect the prestige of those buried. The position and nature of the golden artefacts indicates that they were highly valued. The same may be true for the other new commodity of the time, copper, which was now being melted and cast as well as hot-worked by annealing. What is particularly interesting here is that new kinds of 'valuables' were being created. In the late Upper Palaeolithic we see necklaces of marine shell, which we may infer was found attractive and hence perhaps valuable. Then, in Europe as elsewhere, in the neolithic other materials came to be used for prestigious artefacts, not least jade.

That this was undoubtedly true in neolithic and early bronze-age Scotland was magnificently displayed by David Clarke and his colleagues at the National Museum of Antiquities in the splendid exhibition 'Symbols of Power in the Time of Stonehenge'. As Clarke suggested then, these artefacts [126] did not simply reflect power: they served to create it.

The use of new – or at least newly utilized – materials, such as jet and amber, at the onset of the early bronze age in Britain brought into being a new kind of society in which the cohesive and egalitarian community, as reflected and embodied in the great communal monuments, was

replaced in significance by a social order centred upon the individual of high status. That high status was not simply reflected in this finery: it was largely created by the new prestige goods and the new weapons of the day. Imagine the impact of the first daggers of copper and bronze, which we see now for the first time in the archaeological record. Before long, the dagger became the rapier and the rapier the long sword and the first arms race had begun. Here again it was a new kind of engagement with the material world that was calling new social relationships into being, a process in which military power played an increasing role. Of course, these relationships were cognitive as much as substantive. Power is not just a matter of brute force. It is also a matter

of the development of categories of rank and the emergence of such 'institutional facts' as kingship, of rights of personal inheritance and of the formulation of the rule of law.

That is, of course, why, with the emergence of power, we also see the emergence of symbols of power.[11] Power may reside in the valuable artefacts that lend prestige to the ruler, but it may also be immanent within the great monuments – the pyramids which signify the might and the divine status of the pharaoh, or the great Maya temples [128] which illustrate the divine forces that sustain and protect the ruler. They do so all the more effectively when that ruler knows well how to perform the symbolic acts – in this case the sacrifice of blood – which, it is understood, are necessary to sustain and propitiate the deity. Other cultures have their own choice of prestige items.

Commodity The development of valuables was one of the things that gave rise to the notion of 'commodity', the idea that value could be measured, could be appraised in units, and could be transferred from one owner to another in the handing over of a measured quantity of the valuable substance. This is how business was conducted in the booming economies of Mesopotamia and Egypt in the millennia before money was invented. The appropriate way of quantifying value was in terms of 'weight'. Weight is another of those 'institutional facts' where the reality and the symbolic representation had to emerge together. You cannot have things to measure weight[12] – things we call 'weights' – without having already experienced the reality in the material world that there is here a property to experience, and through feeling the material reality of the experience of 'balance' on which the measurement of weight originally depended. It is upon the initial construction of such institutional facts as value, commodity and measure (for instance by weight) that the world of commerce depends. This was true in the ancient world of the Near East. It was also true in China, where the first Chinese emperor,

126 *opposite above* Symbols of power in the age of Stonehenge: neolithic jade axe from Scotland, *c.* 3000 BC.

127 *opposite below* Tokens of prestige and the emergence of 'value': grave goods from the 'Copper Age' cemetery at Varna, Bulgaria, *c.* 4500 BC.

128 The power of the state embodied: the Temple of the Inscriptions at Maya Palenque, seventh century AD.

Qin Shi Huang Di, reorganized systems of weight as well as coinage, although, as we shall see in the next chapter, there comes a point in the development of such a system when it moves beyond the material-symbolic into the theoretic. It was true also in Mesoamerica, where the market and the *pochteca* traders functioned in a system of rule that was centrally authorized and divinely sanctioned.

The point here is that the very notion of 'weight' as a measuring device is brought into existence through the experience of weighing: the material reality anticipates the concept or at least participates in its construction. The same principle applies to time. For while days and years may be natural features, noted already in the material-symbolic of the neolithic, the measure of time soon became theoretic, an abstract system, as for instance in the Maya calendar and in the subdivisions of time seen in the sundial and in the Greek clepsydra (water clock).

Memory Special artefacts are charged with mnemonic power:[13] they have life histories, which are recollected and spoken of when they are exhibited or exchanged. In a pre-literate or non-literate world their role is all the more important since the 'symbolic storage' of which Merlin Donald speaks is not entirely external to the minds of the participants of the society in question: the artefact is a focus for the shared recollections of the community, both prompting these and in a sense validating them. In many non-literate societies the symbolism of their artefacts (their 'art', if one chooses to call them that) has a central role in the structuring of the shared memory of the community.

Much the same is true for monuments, whose construction and use play such a key role in the formation of communities and in the enhancement of their self-awareness. Archaeologists have argued recently that the formation of the landscape, as a sweep of land featuring meaningful places, is brought about by the accumulation of markers of human activity, including monuments, which are in a sense the repositories of shared memories. It is not difficult to see, for instance, the landscapes of Orkney, with such monuments as Quanterness and the Ring of Brodgar, in that light, even if some of their histories or at least those of their makers have been forgotten, while other associations and stories have accumulated.

129 The aura of the holy: Celtic bell (eighth century AD) and bell shrine (twelfth century AD), from Kilmichael Glassary, Scotland.

And, of course, the mnemonic role of artefacts and of monuments, and the prestige that they confer, is not restricted to non-literate communities or to prehistoric times. Some of these features are reflected not only in the symbols of power of the age of Stonehenge in prehistoric England, but also in the use of symbols of power, sanctity and history in later periods, as for instance at the time of the Pictish kingdom in the Scotland of the first millennium AD and of the Celtic saints and their aftermath. Not for nothing does one of Paolozzi's figures in the National Museum of Scotland [6] hold the Westness Brooch, one of the finest examples of Celtic metalwork of the eighth century AD. Special artefacts such as this, or the Pictish chains, no doubt created and enhanced the power of the Pictish rulers as much as they merely reflected it. Much the same must be true of the wonderful Symbol Stones of Pictish Scotland, the earliest of which date back to the pagan times of northwestern Europe. But let us not ignore the shrines and reliquaries of the early Christian church [130]. Of course, as I have remarked, this was a religion of the Book. So it is not surprising that the most precious and perfect craftworks were the pages of illuminated Bibles such as those of the Lindisfarne Gospels. And among the most treasured reliquaries were the Bible shrines, constructed to hold the very handwritten text that had been used centuries earlier by the saint who had carried it with him. Admittedly the discussion of literacy here may at first sight seem inappropriate to the material-symbolic phase, but this was only partial literacy, utilized principally in a religious context, where the written text was revered as a material object, as something precious and with its own history, and appropriately enshrined.

I have always found bell shrines to be highly evocative. For the bell itself, used to initiate and punctuate the rituals of the divine office, is again one of those artefacts that somehow help to create sanctity as much as merely to reflect it. And the enormous respect in which some of these early artefacts were later held is documented by the richness of the containers that were fashioned, out of precious metal, to hold them. And if the authority of

their sanctity came in part through the medium of the Good Book, it was enhanced by the saintly associations of each specific object, and it was conveyed to the illiterate by the prestige and beauty and value of the precious substances and the craftsmanship that went into its presentation. Of course, many medieval reliquaries contained relics that were believed to be part of the actual material substance, the preserved bone, of the saint himself – the very distillation of devout memory.

All of these are cases of what one may term the material-symbolic phase of human cognitive development, as defined in the last chapter. In each case the engagement process involved a cognitive or symbolic element. This was no doubt accompanied by a linguistic one – all of these things will have been a matter of intense oral discussion and recollection. But most of these are 'pre-theoretic', in the terms formulated by Merlin Donald, and most are pre-literate also. Of course, as we saw earlier, mimetic modes of action remain a feature of human activity to the present day (that is how we learn to ride a bicycle and largely how we learn to drive a car), and mythic and material-symbolic relationships remain a crucial part of the functioning of literate societies. So there is nothing inappropriate in stressing the material-symbolic functions of the reliquaries used to protect and enhance a holy book.

Everyday artefacts in art

It is worth stressing how slow the visual arts were to make explicit use of pre-existing artefacts as their main subject of contemplation. When we consider modern artists and the deployment of artefacts in their work, we have to note that they are using them in an age marked by widespread literacy which we might well term theoretic. Indeed, as discussed earlier, the very concept of the 'work of art' belongs in a theoretic era. But there is nonetheless much to be learnt about the material-symbolic phase of human cognitive experience by looking at the way contemporary artists have made use of artefacts in their work in an explicit way and by examining their own engagement with the material world.

The world of the arts, at any rate in the Western tradition, was slow to celebrate the artefact.[14] Artefacts were used as 'props', sometimes as fancy clothing, by some of the great Old Masters. Rembrandt, for instance, had a whole collection of exotica, and in one of his most famous works, *Aristotle Contemplating the Bust of Homer*, the bust no doubt came from his studio collection. Saints were commonly distinguished in the iconography by a suitable artefact, often the instrument of their martyr-dom: for instance, St Catherine of Alexandria was frequently pictured with the wheel upon which she was martyred. But rarely did artefacts take a central role. A still life of the High Renaissance or its aftermath would typically contain food or wine and their appropriate containers, but 'things' in themselves were in general not a principal focus.

As in so many other areas, Picasso was one of the pioneers, introducing elements from the real world by using collage (including pieces of news-paper) into some of his paintings, and using what in effect were 'collages' of real objects in some of his early sculptural still lifes. The German artist Kurt Schwitters was one of the first to build up a composition using fragments from 'real life', mainly bits of paper and cardboard such as tickets and passes, and was in this way introducing a new kind of reality into his work by creating it from items that had had an authentic previous life of their own. But of course nothing could compete with the bravura of Marcel Duchamp, as we have already discussed, in setting up his 'ready-mades' as exhibits: such pre-existing artefacts as the bicycle wheel on a stand, the bottle rack, the urinal, the snow shovel and the hat stand [84–87].

But it was Eduardo Paolozzi[15] who was one of the first to make a systematic practice of using objects from the real world in his work by incorpo-rating them into an ambitious structure, which was then often cast in bronze. Born near Edinburgh in 1924, of Italian immigrant parents, he was already producing composite two-dimensional images from

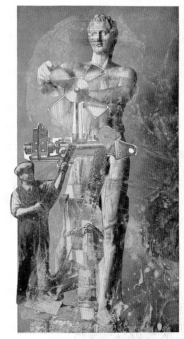

Der Schaber des Lysippos (Apoxyomenos)
Römische Marmorkopie nach Bronze um ... Chr. Höhe 2.05 m. Rom, Vatikan

Eduardo Paolozzi 1946

132 Three-dimensional industrial collage: *His Majesty the Wheel*, 1958, by Eduardo Paolozzi.

photographs and magazine covers [131] in the 1940s. From the 1950s he was also producing substantial bronzes, which were in effect collages in three dimensions, made up of machine parts, toys, discarded elements from everyday life [132], often given some vaguely human form, but always reminding the viewer that these composite parts started off as manufactured objects. Henry Moore had already in the 1930s sought inspiration from the *objet trouvé*, which for him was always some natural object of stone or shell, eroded by the elements and discovered by his discerning eye upon some seashore or wind-blown heath. For Paolozzi, however, such component pieces are manufactured objects, *objets perdus* before they can be *trouvés*, and there is little community of feeling with Moore. Paolozzi's graphic work likewise uses 'found' images, taken from newspapers and magazines, from advertisements and postcards. In this respect he was one of the pioneers of Pop Art, with his collage *Bunk* in 1952, preceded by those earlier composite images.

Paolozzi was one of the first sculptors to realize and reflect in his work the fact that our visual life is made up largely of images and impressions that are previously manufactured: that urban life takes its course in a world of artefacts. For the urban-dwellers of the twenty-first century, advertising and media images and machinery are a more significant part of the environment than the animals or plants of rural life or even other people. As Paolozzi told Jacob Bronowski[16] in 1962: 'A wheel, a jet engine, a bit of machine is beautiful if you choose to see it that way. It is even more beautiful if you can prove it, by incorporating it into your iconography. For instance, something like the jet engine is an exciting image if you are a sculptor. I think it can quite fairly sit in the mind as much an art image as an Assyrian wine jar.'

Paolozzi catches what is commonplace and familiar in the battery of different elements that constitute our world and his figures. And he also catches what is alien. These constructed figures can indeed be 'other', just as

clockwork and machinery sometimes seemed hostile in the nineteenth century – one thinks of the famous and somehow heroic photograph of the great Victorian engineer Isambard Kingdom Brunel beside one of the more gargantuan of his creations, the giant links of an enormous chain. Paolozzi's figures go beyond flesh and blood: there is little that is organic about them. They suggest a world from which the fluidity and grace of organic nature are excluded. They are sometimes powerful figures, just as the presence of Paolozzi is itself powerful [122] – one should not forget that he attained 'black belt' status at karate. But in the otherness and isolated appearance of some of these figures there is also the suggestion of anomie, the solitude and disorientation of the human in an urban world which we sense also in some of the figures of George Segal [114, 116].

Paolozzi's work encapsulates for us the power of the artefact, and the autonomous strength of the artificial world of artefacts that we have created. For that reason he is the artist who in some ways best approaches that mysterious process by which the human engagement with the material world, through the action of the mind as well as of the hand, creates something that is new and almost autonomous. Our interactions proceed henceforth not simply between human beings but between humans and the new reality that we have created. Of course, other artists have caught this notion: the writer Mary Shelley very famously so with her powerful tale of the automaton created by Dr Frankenstein, in which the threat that the product that we have created may not only develop an existence of its own, but then become a hostile and in that sense alien force, is explicit. The same idea motivates Hal the computer in the contemporary parable *2001* by Arthur C. Clarke. But although some of the impact of the brooding presence of Paolozzi's creations comes from that hint of independence or even hostility, their principal power comes from the revelation of human creative abilities: that is why there is something appropriate in his depiction of Athena, goddess of wisdom, or Hephaestus, the blacksmith god [123], or Daedalus, the great human artificer of legend in Minoan Crete [133].

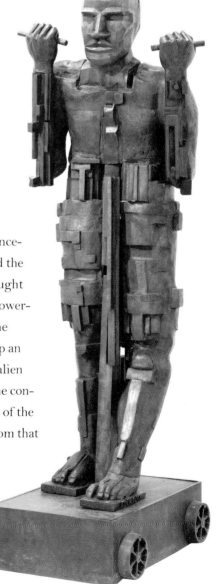

133 The great artificer: *Daedalus on Wheels*, 1995, by Eduardo Paolozzi.

Artefacts as stereotypes

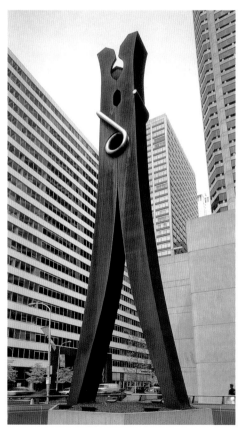

Since the early days of Pop Art numerous sculptors have taken the artefact as their focus. One of the most notable is Claes Oldenburg,[17] who has re-created features of the artefactual world, re-presenting them for our critical contemplation by changing their nature. Artefacts have changed in scale – the clothes-peg, the shuttlecock – and typewriters have crumpled and become soft.

Several artists have looked much more closely at artefacts and the constituent and often artificial materials of which they are made. One of the most interesting of these is the British artist Tony Cragg.[18] We cannot look in detail at his work here, but it has shown an acute sense of the constituent material of the debris of artefacts of the modern world. Paolozzi likes to work in bronze (or some-times wood). Cragg prefers the raw material. In his early days he used brick in a rather inarticulate way;

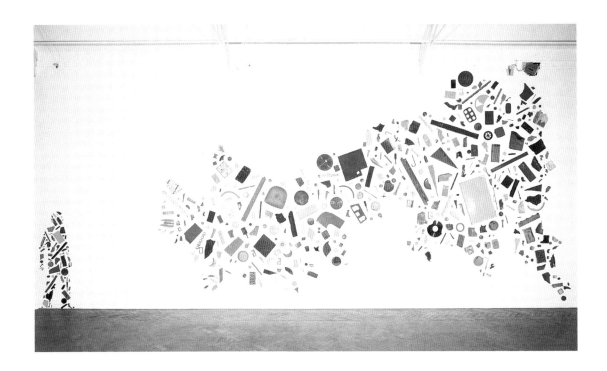

by 1976, in *Stack*, he was using the unmodified materials of the builder's yard [137]. The finished work incorporates a mix of artefacts and materials that leads one right back to contemplate the materiality of things. The archaeologist is used to the processes of time which change the materiality of the past into the poor man's rubbish found in most archaeological excavations. Here, with Cragg, as with some other contemporary artists, the reverse happens, turning junk into art. By 1978 (in *New Stones – Newton's Tones*) we see all the colours of the rainbow in throwaway plastic. There is a kind of poetry in *Britain Seen from the North* [136], where scraps and fragments of plates and containers of the then relatively new plastic material are used to shape an ironic map of the British Isles. In *Five Bottles on a Shelf* he leads us to consider pure form given substance in the most unpromising material.

The exploration of form and material is well exemplified by *Three Modern Buildings*, where Cragg performs sculptural alchemy by transforming a few bricks into modernist skyscrapers by Le Corbusier or Mies van der Rohe. Sometimes he creates strange new artefact forms (as in *Mixed Cylinders*). And sometimes his work uses artefacts to achieve a wonderful poetry. He has produced a series of constructions using glassware under the generic title *Eroded Landscape*: his *Gazelle* of 1992 seems

134 *opposite above* The artefact as stereotype: *Shuttlecocks*, 1994, by Claes Oldenburg.

135 *opposite below* Significant form? *Clothespeg*, 1976, by Claes Oldenburg.

136 Formation processes: contemporary rubbish as art rather than archaeology: *Britain Seen from the North*, 1981, by Tony Cragg.

137 Artefacts and
materials into art: *Stack*,
1976, by Tony Cragg.

138 *opposite* The artefact
as cloudscape: *Cumulus*,
1998, by Tony Cragg.

almost directly a homage to Duchamp – *Bicycle Wheel* and *Bottle Rack*
simultaneously.

And I have to finish with a work that fascinated me when I first saw it
at the Lisson Gallery a few years ago: *Cumulus* [138]. The milky-white
glass of which all the components are made creates a dream-like impres-
sion that sustains the notion conjured up by the title of distant clouds in
a remembered blue sky. Here artefacts are being used to create a still life
– or is it a landscape (more accurately a cloudscape)? Artefacts and their
constituent materials create a language of a kind undreamt of in art in
the early years of the twentieth century.

There is a poetry in the use of these glass forms and a delicacy which
has all the harmony of a landscape by one of the great eighteenth-
century masters. But this is an artefact-scape, and a very beautiful one.

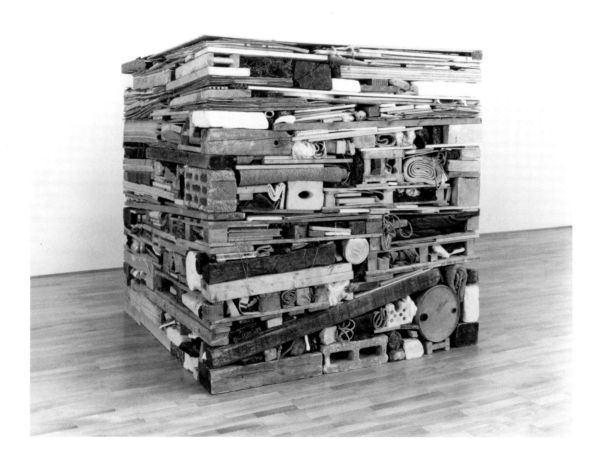

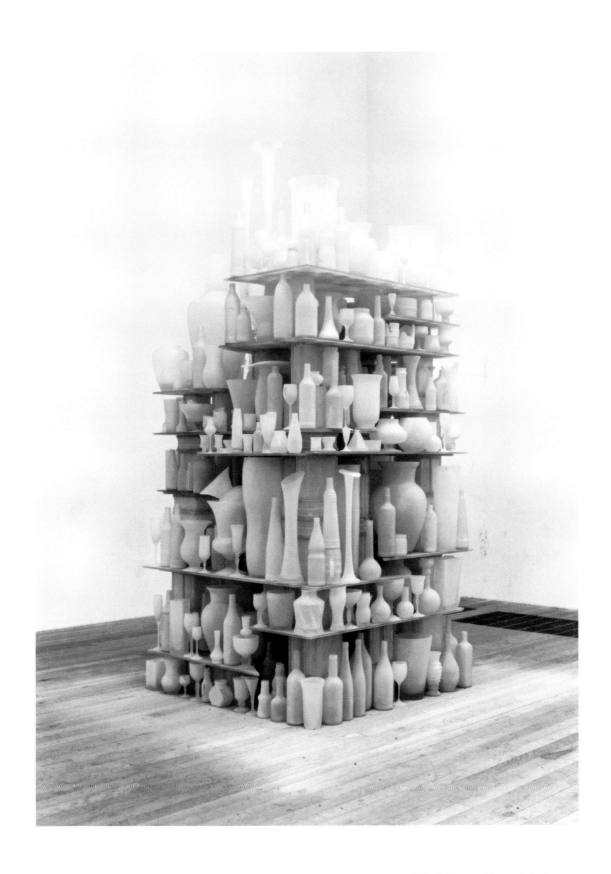

David Mach: The artefact is king

One of the most ingenious contemporary explorers of the world of the artefact is the British sculptor David Mach.[19] He has a particular fascination for multiples – the things that are mass-produced and exist in their thousands. In the next chapter we shall see how the sardonic eye of Ian Hamilton Finlay chose to represent that formidable weapon of war, the Polaris submarine [155]. Mach's evocation of Polaris is different [142]. Using the simple component of the rubber car tyre, he created a forbidding instrument of mass destruction on the Thames South Bank in 1983. It seems central to the work of Mach that it should be made, in this way, of thousands, or hundreds of thousands of repeated commonplace items from our daily lives – in this case rubber tyres [see also 11]. And from these something powerful and forbidding is created. It might be easy to suggest some trite moral conclusion, but to do that would be to undervalue the work, which operates visually, through visual surprise, not with the purpose of creating some verbal aphorism.

One of Mach's specialities has been to use great quantities of identical newspapers or magazines to suggest a surging flood of inundating newsprint, upon which are borne some of the more notable mass-produced objects of the machine age. The raw materials are thus readily

139 Art from the multiple: *Thinking of England*, 1983, by David Mach.

140 *opposite above* Keeping up with the Joneses: collage drawing for *Trophy Room*, 1995, by David Mach.

141 *opposite below* Desirable consumables: detail of the realized *Trophy Room*, 1995, by David Mach, at Ujazdowski Castle, Warsaw.

available *things* from the real world. Thousands and tens of thousands of copies of a newspaper are used to create a surging tide, on which are sometimes placed consumer durables, such as automobiles. The effect is extraordinary, and of course it is very urban in flavour. These works come from the streets where the figures of George Segal would be at home, not those of Antony Gormley.

The Scottish National Gallery of Modern Art in Edinburgh is the possessor of the deceptively simple work *Thinking of England*, made out of

Baneful signs:
The archaeology
of now

I n this chapter we approach the modern era. We move the human
story on from the material-symbolic phase reviewed in the last
chapter to the theoretic, and to embrace the key developments that
followed the emergence of writing, especially in the Near East and Egypt,
and the intensive use of the alphabetic script in Greece and beyond.

Within the same context we can use the insights of contemporary
artists to let us see more clearly how the engagement between humans
and the material world is still subject to change. We can, as archaeolo-
gists, look at the world in terms primarily of its material culture and in
this specific sense turn to contemplate the archaeology of now. In the
later part of this chapter I would like to move on to consider further
major innovations that have shaped the modern world. First printing –
as many authors have discussed, not least Marshall McLuhan[1] in *The
Gutenberg Galaxy*. Yet in some ways an equally significant innovation
was money. For in its own special way it has had the effect of codifying
value and giving us a universal standard by which almost everything in
the world could in principle be measured. It also represents an early
influential example of mass production, in a sense the counterpart of the
dissemination of information through printing. As we shall see, the two
have come to converge in a disquieting way in the electronic age.

143 Writing as a
specialized trade: seated
scribe from Old Kingdom
Egypt, *c.* 2500 BC.

Writing, money and printing came together in the eighteenth century to produce the banknote; paper money led on to the company share and the rise of an equity market, opening up everything from the ownership of limited companies to mass capitalism. With the industrial revolution came the possibility of mechanized production, and also new potential for travel – the first fresh developments of contact at a distance since the development of the oceangoing sailing ship. With electricity – electromagnetism – came the electronic telegraph, heralding electromagnetic communication by radio wave. All of this soon merged in new configurations with the development of electronic media and the possibility of trading via the internet. Indeed, as we shall see, these innovations lead on towards a kind of dematerialization: energy (in the form of electronic information) begins to replace matter. It may be that this revolutionary shift heralds the end of another phase in human development.

As in previous chapters I hope to use contemporary visual art to give us fresh insights into these processes. Sometimes the artist permits us to perceive more clearly the working of new cognitive categories, and can sometimes offer insights that we may otherwise lack in our attempt to develop a true cognitive archaeology.

Writing

We have seen how the engagement process, whereby humans become increasingly involved with the material culture that they themselves have created, develops a spiral of interactions. With sedentism, at the inception of the material-symbolic phase of human experience, comes the possibility of property. From the notion that goods can be systematically exchanged come commodity and value, and then measure, and units of measure, and so the development of the exact sciences. From the circumstance that objects can have value and prestige comes the possibility of inheriting wealth and authority. From the capacity for making representations of divinities come new avenues of development in religious practice and belief.

144 Early writing in Egypt. The Narmer Palette, *c.* 3000 BC, with hieroglyphic signs before the king's head indicating his name.

All of this helps to resolve our 'sapient paradox' – how it was that, after thousands of years living as hunter-gatherers, human societies quite rapidly changed direction and moved speedily from early sedentism towards more complex societies and urbanization. The 'material-symbolic' phase of human cognitive activity, with its greater degree of engagement with the material world, proved more dynamic and expansive than the 'mythic' or 'narrative' phase. That had been an era when language was in use as an effective instrument but was restricted in its application to purely social purposes, and it did not in every case generate or facilitate a growing human impact upon the material world.

But then around 3000 BC in Mesopotamia and Egypt, around 1500 BC in China, and rather later elsewhere, we see another revolutionary development which in due course was to change the nature of human existence: writing.[2]

Merlin Donald rightly regards writing as a defining characteristic of the 'theoretic' phase of the development of mind: the most important device facilitating what he calls 'external symbolic storage', whereby information is stored outside the body and therefore the brain. There is also the possibility of long-term retention of information, beyond the span of an individual's life and memory. In many cases writing started out as ideograms, where one sign represents one idea or one word in a language. That was true of Egyptian hieroglyphs, and of the earliest pictographic tablets of Sumer. But soon signs also came to represent sounds, and syllabic scripts were developed. This was the case for the cuneiform scripts of the Near East (and indeed became partly true for the formerly ideographic scripts also). But it is not until early in the first millennium BC that we see the widespread development of alphabetic scripts where each letter represents a sound rather than a complete syllable. We see them first in the Levant, and then in Greece and Italy. It was not until the development of the alphabet that mass literacy became possible in Europe and Western Asia – although I have always marvelled at the capacity of the Chinese and the Japanese to use their more complex scripts with almost equal facility.

The story of Bellerophon

The mysterious power of writing and of literacy is illustrated in a splendid parable from Homer. It is one of the earliest surviving comments upon the power of the sign.

In Greece in the fifth century BC, in the great days of Athens, when most male citizens were literate, they were dimly aware that some centuries earlier, when Agamemnon ruled at Mycenae, there flourished what we today would call the Mycenaean civilization. The Greeks knew about it not from archaeology but from the Homeric account of the Trojan War in *The Iliad*, and of the subsequent wanderings of one of the Greek heroes in *The Odyssey*. And curiously, in the whole of Homer, although we know from the archaeological record of literacy in the Mycenaean palaces, there is just a single mention of writing: what Homer referred to as 'baneful signs'.

So let us turn now to Homer's *Iliad*, the first major written work in the Greek language, and thus the first major classic of European literature (as well as the earliest literature anywhere written in an alphabetic script), and to the story of Bellerophon.[3] He was wooed but not won by the wife of the king of Argos, who then in anger told lies to the king and asked him to kill Bellerophon. The king did not have the nerve to do this:

To slay him he forbare, for his soul had awe of that; but he sent him to Lycia, and gave him baneful tokens, graving in a folding tablet many signs and deadly, and bade him show these to his own wife's father, that he might be slain. So he went his way to Lycia under the blameless escort of the gods. And when he came to Lycia and the stream of Xanthus, then with a ready heart did the king of wide Lycia do him honour: for nine days space he shewed him entertainment, and slew nine oxen. Howbeit when the tenth rosy-fingered Dawn appeared, then at length he questioned him and asked to see whatever token he bare from his daughter's husband.

When the king of Lycia (in Anatolia) read and understood the 'evil token', he delayed carrying out the written wishes of his daughter and son-in-law in Argos, but instead set Bellerophon many fabulous tasks. These he so admirably accomplished that 'the king now knew he was the

vast. Although oral records are sufficient for the practice of religion, as the Indian oral retention of hymns and other religious texts in Vedic Sanskrit for centuries before they were first set down clearly shows,[4] their preservation and dissemination are facilitated by writing. Religious texts like the Egyptian *Book of the Dead* survived for millennia by this means, as indeed have the Old and New Testaments of the Bible, and subsequently the Koran: in short, the religions of the Book. Other forms of writing that we see fully developed at the time of the ancient Greeks are medical texts, theatre works, mariners' texts like the *Periplus of the Red Sea*, and works of philosophy which are still read with profit today.

The formation of the state: Organization and the iconography of power
In some early societies, writing was the province of the scribes, learned men of high status: it is clear that rulers themselves could not, or did not always master the complex syllabaries or series of glyphs. The clay tablets were in the main read by bureaucrats. And even the great inscriptions on the walls of the temples of Egypt, for instance Thebes, or the corridors of Assyrian palaces as at Nineveh, were probably intelligible only to a minority – but impressive for all that.

Their significance, however, runs far deeper. For organization, along-

side power, lies at the heart of any society more complex than the loosely structured social groups of peasant farmers, and certainly at the kernel of most urban societies. Economic systems of exchange and redistribution require records, and the earliest recording systems, seen in the seals and counters [146] of the early Near East, prefigure[5] the first clay tablets of the proto-literate period of Sumer in the fourth millennium BC. Already in early neolithic Çatalhöyük baked-clay stamp seals are found. Their function is not well understood, but the design upon each may have had a specific significance which may anticipate that of the first written signs by nearly 2,000 years.

These recording systems made possible administrative control by the rulers and temple hierarchies of these early

state societies. Indeed, it was within the temple and the palace that the scribes worked, and that the early pictographic scripts developed into the amenable cuneiform script more suitable for writing upon clay tablets. Great archives of these tablets have been found in excavations of the palaces of the Early Dynastic period of Sumer in the third millennium BC. From then on in western Eurasia, and similarly from the second millennium BC in China, writing was an essential tool of government and administration and an integral part of the functioning of state society.

One of the most complete archives discovered *in situ* by archaeologists is that of the palace of Ebla[6] in Syria [147], dating from the third millennium BC. Nothing could better exemplify Merlin Donald's notion of external symbolic storage than this assemblage of clay tablets inscribed with the cuneiform script and systematically stored on shelves in a special room of the palace. The German artist Anselm Kiefer has recently evoked something of the cognitive power and hoary antiquity of such external symbolic storage in his remarkable work *The High Priestess/ Mesopotamia* (1989), which deliberately recalls the mystery and the fascination that these assemblages of baneful signs hold for us today.

146 *opposite above* Signs before script: stamp seals dating from *c.* 6500 BC from neolithic Çatalhöyük, Turkey.

147 *opposite below* External symbolic storage: part of the library of cuneiform tablets from Ebla, Syria, *c.* 2300 BC.

148 The symbolic power of writing evoked in *The High Priestess/ Mesopotamia*, 1989, by Anselm Kiefer.

The map and theoretic thought

The major mode of external symbolic storage, other than writing, is the map:[8] that is to say, a diagram indicating spatial relations. Indeed, it may be argued that this is a more basic element of human thought than writing, which after all only makes a relatively late appearance in the human story. It is arguable that many animals construct a mental map, an internal spatial representation of the elements of the external world which are of relevance to them. Certainly this is true of all humans, who have an ability to navigate themselves in familiar territory using remembered landmarks and other memories that are spatially ordered. It is arguable that many schematic indications from prehistoric times worked in approximately this way, by constructing a diagram in which relationships, often spatial ones, were clearly configured but without any necessary use of the written word.

But diagrams can configure relationships other than spatial ones. Thus the notations [118] discussed in Chapter 4, claimed by Alexander Marshack to indicate phases of the moon, are at once, if he is correct, a record and a diagram. Certainly, by the time that literacy developed in Mesopotamia, clay tablets were being used to give building plans in two dimensions [152] and soon also to document mathematical arguments. And of course the Maya and other cultures of Mesoamerica are famous for their calendrical notations.

Contemporary artists have not often made use of the map or diagram as the central feature of their work, although there are exceptions. One of these is the remarkable work by Simon Patterson entitled *The Great Bear*. The title recalls the star constellation and its representation in the form of an animal, like the other recognized constellations and indeed the signs of the zodiac. Here, however, the diagram is based upon the famous map of the London Underground, but with the names of the stations replaced by a rather odd assortment of personal names famous in our own time. The star constellation has been replaced by the mental map of an impressionable kind of Londoner of the late twentieth century in a

work that manages in a subtle way to touch on much that is arbitrary in many maps and diagrams. They are, however, as important a component of life in the twenty-first century as literacy itself, and maps, like computers, require only a very limited degree of literacy for their use.

The written sign in contemporary art

Now I would like to turn again to contemporary art for further insights into the use of language and signs. For we shall see that the written word can play a major role in contemporary art works, even though these remain works of *visual* art. Such works are informative: they are not usually long texts, but rather short ones functioning as visual signs with an iconic significance.

The Swiss-born painter Paul Klee[9] gave titles to his works that often add a special new dimension to them. He was not content with 'Composition No. 3' or some other tediously noncommittal name of the kind offered by several recent abstract artists. In many of his illuminating drawings or paintings the title gives a further insight which might not be on offer from the image alone, viewed without the title.

Klee is one of the most delightful of artists. His works are generally small in scale, intimate almost. They intrigue the viewer with painterly ingenuity and graphic wit. That wit is often driven home with a title sometimes as sharp and focused as a caption by one of the great cartoonists such as Steinberg. What fascinates me about these works is the way their title, although it is not part of the image, somehow haunts it. Some of Klee's work has a certain enchantment, in which the concept (as revealed in the title) underlies the image. It is not usually given careful treatment in discussions of conceptual art, and indeed does not have the visual simplicity which that term often implies. Yet it has a place there.

Of course, it was Picasso who was among the first to employ the autonomous and authentic written word in his work, with the use of elements of newspapers incorporated into collages as early as the Analytical Cubist period. But he was not in fact the first. We saw earlier how Gauguin wrote out in full upon his canvas three fundamental ontological questions to serve as the title for one of his final masterpieces. Moreover, artists have commonly offered their own name in a short inscription since the time of the Renaissance in signing their paintings (just as medieval craftsmen sometimes signed their 'masterpiece'). Still earlier, we can see the names of the potter and the painter on Greek vases, and sometimes of die engravers upon Greek coins. The name of the issuing city was often a significant part of the design of Greek coins [163]. And indeed one of the earliest inscriptions that has come down to us, that of the Narmer Palette [144] from the Egyptian First Dynasty, incorporates the name of the pharaoh into the design. Yet some modern artists have done much more than this. In their work the written word can be the central focus, not some mere ancillary. I believe that from such work we can come to appreciate more clearly something of the changing function of writing and signs.

Ian Hamilton Finlay: Writing as inscription

For Ian Hamilton Finlay,[10] the written word is usually an integral part of the work. Yet his are unmistakably visual works of sculpture or graphic art. Born in 1925, and working in his early years as a poet, he now lives in rural seclusion twenty-five miles southwest of Edinburgh in the remarkable and extensive garden which he has established at Stonypath in the county of Lanark. Here he has created a series of vistas and locations, of pools and groves, in many of which the focus is a small sculpture that usually takes the form of a short inscription [10]. It is a Poet's Garden in the tradition of those established by literary figures such as Alexander Pope in the eighteenth century. Indeed, it bears comparison with the significant early landscape gardens, such as Stour-bridge in Wiltshire, created by the antiquary Sir William Colt Hoare, or with the creations of Capability Brown. The setting is part of the work, and Stonypath could take us back to some of the issues we touched on in our discussion of the work of Richard Long, sometimes called 'Land-scape Art' or 'Land Art' by critics. But I am not sure that Ian Hamilton Finlay can be so easily classified.

With many of the sculptures there is a strong Neoclassical flavour. A lawn and a group of well-ordered shrubs accompanied by the engraved sign 'Poussin' together recall the ordered Classicism that imbues the canvases of that great painter, while a subtly different arrangement and the sign 'Claudi' invoke the romanticism of a pastoral idyll characteristic of Claude Lorrain [157]. Another vista, this time accompanied by the name 'Corot', suggests a freer naturalism. Nearby, the monogram 'AD' (as habitually used by Albrecht Dürer), set at the foot of the gnarled trunk of a tree surrounded by the stems of plants, evokes the botanical prints of the great Renaissance painter and engraver.

But underlying the Classical or Romantic idyll there is often a threat-ening note. Down by the lake a simple ovoid shape in black stone is more than an abstract form. It becomes the conning tower of an atomic sub-marine – *Nuclear Sail* [155] – a recurring image of menace in the Scottish psyche of the late twentieth century (already noted in the case of David Mach [142]), reflecting general unease at the proximity of Britain's

LULLABY

principal nuclear submarine port at Faslane. For while some of Finlay's works, particularly those evoking fishing boats and the life of the sea, are delightful in their pure lyricism, many more betray his pre-occupations with the French Revolution [156], where the revolutionary aspirations in the spirit of Rousseau were soon followed by the Terror and the guillotine. Whether in the sculpted inscriptions or in the wonderful series of graphic works, handprinted by Finlay himself at his 'Wild Hawthorn Press', the terror underlying the Neoclassical surface is often evident. Indeed, the images of the French Revolution are sometimes replaced by those of Nazi Germany and World War II. *Homage to Victor Sylvester* transforms footprints indicating a particular dance manoeuvre into a plan for barrage-balloon installations and submarine pens.

The contrast is well brought out in some of Finlay's more notable prints. *Acrobats* is a simple play upon the letters forming the word of the title. The letters constitute the work, orange against the radiant blue ground, and their agile, supple play has a lightness and a delicacy that makes this one of the most delightful (and simple) prints of the twentieth century. Another print of 1966, *Star/Steer*, achieves a comparable lyricism. Again it takes the form of words, white on a silvery-grey ground. It evokes a small boat, sailing slowly and peacefully by night, with a helmsman who navigates by the stars. In contrast, *Lullaby* carries menace and danger beneath its orderly, tranquil forms [154]. We see first apparently steady, peaceful shapes, before perceiving that they are fighter aircraft with folded wings ready for service on an aircraft carrier. We are lulled by their peaceful forms, but we know that they are instruments of destruction. When the siren sounds, the cradle will fall and down will come baby, cradle and all.

154 When the bough breaks, the cradle will fall: *Lullaby*, 1975, print by Ian Hamilton Finlay with John Andrew.

155 *opposite* Another ominous note threatens the idyll: *Nuclear Sail*, 1974, by Ian Hamilton Finlay with John Andrew, in his garden at Stonypath.

One marvels at Finlay's ability to evoke and create a mood, the spirit of Classicism, or a peaceful awareness of nature, for instance by the simple device of a well-inscribed stele, suitably placed in a garden grove, such as *Wood Wind Song*. But another work can send a chill down the spine when one sees that the subject is a simple, workmanlike guillotine. Indeed, so powerful is the menace underlying the superficial tranquillity of such works as *Nuclear Sail* that one begins to look with a tinge of suspicion, a hint of anxiety, even upon the most peaceful and idyllic of his images. Is there some hidden danger beneath the surface? Will this idyllic tranquillity be shown to mask some terrible underlying reality? In Ian Hamilton Finlay's work, accompanying this stillness, order and peace is the suggestion that underneath all is flux. When Finlay says that 'a garden is not an object but a process', one senses a wider allegory, and the equilibrium is never stable.

On the outer fringes at Stonypath, overlooking the lake, is an inscription, written Roman-style on shattered stones as if from some fantasy of Piranesi, carrying a pronouncement of the French revolutionary Saint-Just: 'The present order is the disorder of the future.' Inherent in all the work of Finlay is the written word. Indeed, some critics have chosen to regard him as a poet. In the context of the present discussion, what is interesting is the way that the written or inscribed word is constitutive of the work, even though it does not form part of an extended text. This is not writing which is operating in some systemic complex to provide efficient 'external symbolic storage' in the sense of Merlin Donald.

We should note also the role of play and ambiguity, and the use sometimes of a verbal pun. In the case of 'Bring back the birch' [10], in the context of his garden, the pun is visual as well as verbal.

Writing as message

What we see in the work of Ian Hamilton Finlay is the written word forming an image that evokes an instantly perceived idea. But typically with Finlay the letters are set in stone – these are public monuments, like the decrees of Classical Greece. We are dealing with an aspect of writing that is highly relevant to its early development, where it is not yet being used to convey a heavy burden of detailed information, as in an extended text, but to communicate a simple message more immediately to the passer-by.

Here we can recall the WALK – DON'T WALK of the New York traffic sign celebrated by George Segal [116]. But we can turn also to the work of two further artists who use the written word, sometimes in neon, likewise to produce a 'sign' rather than a text. And here I am not using the word 'sign' with any special meaning acquired in semiotic jargon, but in the everyday sense of a very short

156 *opposite* Recollections of the Terror: *The Present Order Is the Disorder of the Future*, 1983, inscription after Louis-Antoine Saint-Just (1767–94), 'apostle of the Terror', by Ian Hamilton Finlay, in his garden at Stonypath.

157 The evocation of mood: inscription ('Claudi' referring to the painter Claude Lorrain) by Ian Hamilton Finlay with Nicholas Sloane, from *Nature Over Again After Poussin*, 1980, at his garden at Stonypath.

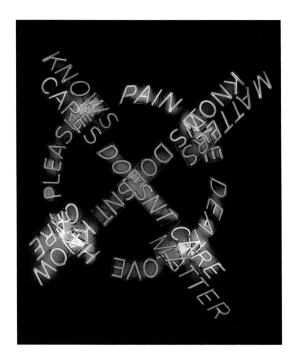

written message intended to convey instant information to the non-specialist public.

The first of these artists is Bruce Nauman,[11] a conceptualist of great originality, who has used a whole series of visual (and aural) devices in his work, the written word being only one of these. In one notable series he used the neon/argon discharge lighting of twentieth-century advertising to produce a series of alternative or contradictory statements or aphorisms, which were flashed up in succession by means of a switching device, providing a sequence of ambiguous or contradictory messages. Nauman is an artist of visual contradiction, and one of the pioneers of that variety of 'conceptual art' that seeks to offer the viewer an experience rather than simply an art work for contemplation.

Nauman has observed: 'I think the point where language starts to break down as a useful tool for communication is the same edge where poetry or art occurs.' Tate Modern in London has a pencil sketch [159] of his, perhaps a preparatory drawing for an alternating neon light which at first sight seems rather innocuous, but which on reflection comes close to a pithy and effective encapsulation of the engagement process between humans and the material world which is at the very nub of the argument of this book. It is intended, no doubt, as an invitation to conceive of and create some work, to shape it and inspire it with life (as the sculptor Pygmalion shaped Galatea in the Greek myth), or at least to carry out some visual and conceptual projection. It might indeed be taken as a comment on the visual arts, and one would no doubt situate the work broadly within the field of what is sometimes called conceptual art. But it has a more general resonance, being applicable to the entire human creative process. At first it doesn't look much, and it might easily be dismissed by the sceptic. Yet the creative process is exactly that: to conceive of a project and then to carry it out. But sometimes the artist discovers what the end product will be only in the

158 Neon words as art: *Life, Death/Knows, Doesn't Know*, 1983, by Bruce Nauman.

159 *opposite* The crux of the engagement process, matter and concept: *Make Me, Think Me*, 1994, by Bruce Nauman.

course of the creative process. And if *Make Me, Think Me* expresses well
the request by the work of art itself to be created by the artist, those
four words in a sense convey the whole creative process by which
innovation comes about, especially in the pre-theoretic phase, where the
nub of the engagement process is the simultaneous development of
the conceptual and the material. *Make Me, Think Me* expresses the kernel
of the creative process in the material-symbolic phase. But being
expressed in writing, it also pertains to the theoretic phase. It has the
concision that conceptual art sometimes shares with minimal art.
In this context it is a good example of the power of the written word,
or rather the short written statement, to be very effective as a work
of visual art.

Showplace Square in 1987 and in Piccadilly Circus in 1988 [161, 162].
The translation of the work from San Francisco to London is arresting.
In what precisely does the 'work of art' now consist? The facility for
displaying such messages already exists at both these locations: it is a
straightforward commercial provision routinely used for advertising.
The status of the work is therefore rather paradoxical, since the artist
has not done very much in each location beyond punching the keys for

this specific message in the same way that any advertiser would. The work of art has become disembodied: the artist has not actually made anything with her hands. There is here a telling commentary upon a process now under way in the urban society of the developed world, and one that the archaeologist as a student of material culture is well placed to recognize: the dematerialization of the material world. This is a process that we shall encounter in a different context below.

161 and 162 Mobile messages: the same text, 'Protect me from what I want', by Jenny Holzer, seen in Showplace Square, San Francisco, 1987 (opposite), and in Piccadilly Circus, London, 1988 (this page).

Money as a form of communication

In the sixth century BC the Greeks of Asia Minor invented coinage.[13]
Of course, in a sense money had existed earlier, in that valuable commod-
ities such as gold and silver were used as units of exchange and were
measured carefully by weight. But coinage was different: it involved the
stamping of standardized pieces of the chosen valuable material (almost
invariably precious metal) with the insignia of the issuing authority.
Croesus, king of Lydia (in western Anatolia), is sometimes credited as
the first to take this significant step, but soon the various city-states of
the Greek world were doing the same, and the 'owls' of Athens and the
'turtles' of Aegina or the 'winged horses' of Corinth were universally
recognized in the Mediterranean as units of exchange.

It is worth noticing in passing that the minting of coinage was also
one of the earliest instances of mass production, just as the production of
machine-made or 'milled' coinage in Europe in the seventeenth century
AD was one of the very first products of the inchoate machine age. We
have already seen, moreover, that the emblem of the city-state, such as
the owl of Athens, soon came to be accompanied by the name in letters of
the issuing authority, the people of the city-state in question. In some
cases the die engraver also inscribed his own name: for instance, some of
the beautiful decadrachms of fifth-century BC Syracuse in Sicily [163]
bear the name of one of the greatest of them, Euainetos.

Money exists in convenient units, which are therefore the most obvi-
ous way of expressing price. It soon follows, therefore, that the economic
standardization imposed by the minting of the coin (implying that the
weight and fineness of metal are certified) widens until the prices of
whole ranges of commodities come to be expressed in these units.

Price becomes an international language: you can haggle
in the market without knowing other words in the local
language than the numerals. Indeed, the universality of such
language is graphically illustrated by a Greek drinking cup of
the fifth century BC in the British Museum [164] where clients
are seen haggling over price with prostitutes, the former offering
'three' coins, the latter holding out for 'four'.

The relationship between money and communication became closer with the twin developments of paper money and printing. In the West, printing came first, as a means of communication, and the notion that notes or letters of credit of paper could stand in for coins of gold and silver was rather slower in appearing. But examples survive from China of printed paper money from as early as AD 1374, well before the invention in the West of printed paper or the printed book [165].

The pervasive influence of money as a means of communication, subverting the need for further exchange of information, was evident in the nineteenth century. As the great historian Thomas Carlyle put it in 1840: 'In these complicated times… Cash Payment is the sole nexus between man and man… Cash Payment the sole nexus; and there are so many things which cash will not pay! Cash is a great miracle, yet it has not all power in Heaven nor even on Earth.' But if Carlyle[14] still felt that there were things that money couldn't buy, the cynical view maintaining that everything (and every person) has a price was not so far away. As Marx and Engels wrote in 1848 in *The Communist Manifesto*: 'The bourgeoisie… has left remaining no other nexus between man and man than naked self-interest, than callous "cash payment".' For many years after the introduction of printed banknotes in the West in the eighteenth century, currency was still based upon the gold standard, even though the notes and later the coins (of base metal) no longer had 'intrinsic' value. But when national economies came off the gold standard in the twentieth

century exchange rates between currencies could fluctuate much more widely. The exchange rate, like the official interest rate, became one of the most important financial parameters. Moreover, these parameters, like numerals themselves, function within a universal language that is understood as readily in the stock exchanges of Tokyo or Singapore as in London or New York. Money is now the true universal language. The world economy has entered a truly theoretic age and in some senses has become dematerialized as well as depersonalized. Certainly it has become remote from the coinage of silver and gold of the ancient Greeks.

Paradoxically, the flow of money has become part of the flow of information. Stocks and shares are more now than tokens of ownership: their

price tells you what you want to know about the economy. The busy financier does not spend time reading the articles in the *Financial Times* or the *Wall Street Journal*, but turns instead first to the share prices. And in more individual, personal terms, the transfer of a banknote of appropriate denomination, in a face-to-face encounter, is more telling than any verbal communication. A 'backhander' does not need translation. Money talks. Actions speak louder than words.

The dematerialization of material culture

Mass production and the development of effective electronic communication at the interpersonal level are transforming the world in a way that was difficult to foresee just a few decades ago, although Marshall McLuhan saw further than most with his talk of the world as a 'global village' and his assertion that 'the medium is the message' – observations that the art of Andy Warhol[15] seems so effectively to reflect [167].

Consumerism and mass consumption have been with us for nearly a century, as we saw well expressed in the art of David Mach with the pointed symbolism of *The Trophy Room* [140, 141]. Certainly there is one kind of materialism that shows no sign whatever of diminution in contemporary consumer society. The stereotyping, the way the world of humans has increasingly been turned into the endless repetition of almost identical units, has been brilliantly caught by the photographer Andreas Gursky [169]. The soul-destroying repetition of the production line has established itself also outside of the factory and moved into the office and the apartment block, so that sometimes we seem to live in a world where mass production[16] and mass consumption are the dominant forces, and where the individuality of human beings is made subordinate to their passive role as consumers of the identically packaged products that they themselves are constrained to manufacture.

But in this advanced stage of the 'theoretic' age, a separation is now taking place between communication and substance. In Andy Warhol's work we saw expressed clearly the idea of over-exposure to the repeated image [168] to which we are subjected by the mass media and by political propaganda. The substance of the image is secondary – often it may be on paper, but increasingly it is electronic and thus no longer tangible.

Today the electronic impulse is replacing whatever remained of the material element in

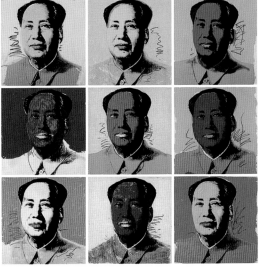

166 *opposite above* Financial 'truism' from Jenny Holzer: *Money Creates Taste*, 1992, appropriately seen in Times Square, New York City.

167 *opposite below* Multiple, fungible images: *One Dollar Bill*, 1982, by Andy Warhol.

168 Dematerialization through repetition of the disembodied image: *Fifteen Small Coloured Maos*, 1980, by Andy Warhol.

the images on paper to which we became accustomed in the nineteenth
and twentieth centuries: the banknotes, the newspaper headlines,
the advertising hoardings, even the bus tickets are all obsolescent. The
engagement with the material world where the material object was
the repository of meaning is being threatened. There is a process of
dematerialization,[17] where the physical, palpable material reality is
disappearing, leaving nothing but the smile on the face of the Cheshire
Cat. The signs are becoming disembodied. $E = mc^2$, and everything is
now electronic radiation, travelling at the speed of light. What I particu-
larly have in mind is the electronic transfer of vast sums of money, or of
stock ownership, by bankers and traders in just a few seconds. This flow
now continues without cease: as soon as the Tokyo stock exchange
closes, London opens; before London has closed, Wall Street is operat-
ing, and so it goes on around the globe.

One of the most telling finds in Mark Dion's *Tate Thames Dig*, on
which attention has not previously focused, was a bundle of credit cards
and phone cards [170]. Here is the archaeological find of a tomorrow that
has become today. Already early phone cards are collectors' items, and the

169 *above* The
depersonalization of the
individual: *Hong Kong
Stock Exchange*, diptych,
1994, by Andreas Gursky.

170 *opposite below*
Instant archaeology:
credit and phone cards
from the *Tate Thames
Dig*, 1999, by Mark Dion.

same may well be true of credit cards. And already some of these are 'smart cards', which can be recharged electronically, and which will soon be able to perform a wide range of operations. The individual customer, through the smart card, can be interactive at a distance and be effective financially, just as the 3G mobile phone allows one to communicate globally by internet, fax and satellite phone.

Most interesting of all, perhaps, is the impact that the home computer linked to the internet is already having upon the learning and education of children, many of whom can operate a PC before they can read or write. We have already seen, with Ian Hamilton Finlay and Bruce Nauman, that the written word can easily function as a sign, in a context where extended texts are not necessary. Literacy is no longer a prerequisite for efficient communication: it is possible to operate the computer without the need to create or peruse the extended text implied by what has hitherto been termed 'writing'.

171 The dematerialized image rematerialized: *You Are in a Car (Volkswagen)*, 1996, by Julian Opie.

172 *opposite* Urban sophistication depicts the rural: *My Aunt's Sheep*, 1997, by Julian Opie.

Electronic images in the form of computer graphics are now also influencing our visual language. Once again this trend is brilliantly caught by another contemporary sculptor, Julian Opie,[18] whose personal style has developed towards the representation in three dimensions of material objects not as they appear in the real world but as they are seen graphically on the computer screen, for instance in an interactive game. His *You Are in a Car (Volkswagen)* of 1996 [171] or *My Brother's Office* of 1997 are re-creations of a world that comes to us not from direct experience of the material reality but from what we have come to know from the computer screen.

The dematerialization of the real world is well exemplified by the distinctly artificial view that many urban-dwellers in Britain (and no doubt elsewhere) have of the countryside. Many urban children have never seen a sheep or cow and experience a sort of rural agoraphobia when exposed to actual woods and fields. The two-dimensional flatland of a world experienced primarily from the computer screen is brilliantly evoked in other recent works by Julian Opie, for instance *My Aunt's Sheep*, clearly as visualized by a town-dwelling child who has a rarely or never-visited relative who lives in the country [172].

The archaeologists of tomorrow will certainly have no difficulty in finding and excavating both urban centres and rural outposts when they seek to examine the material culture of the early twenty-first century.

There will be abundant evidence of mass production and of consumer durables. But when it comes to the archaeology of mind they will certainly have a difficult task on their hands. Material evidence for the electronic flow of information, for the expression of ideas and perhaps for a large component of the external symbolic storage facility may no longer be available. They will be lost in the ether, like yesterday's television programmes and last year's e-mails.

Perhaps it is an exaggeration to speak of the dematerialization of material culture, since our bodies remain corporeal and our bodily needs have not altered very much. But certainly many of the symbolic elements of material culture are increasingly finding expression in electronic form. For future generations they will already have vanished, leaving an echo as remote and unattainable as the 'song the Sirens sang' or indeed the conversations, the rituals, the songs, the narratives and the myths of those ancestral hunter-gatherers of the mythic phase of human experience who peopled much of the earth some 40,000 years ago.

school of that Renaissance city – Duccio, Simone Martini and the brothers Pietro and Ambrogio Lorenzetti. We had a series of lectures from real experts in the arts and in music. Here was simultaneously a music festival and masterclass. The wise old cellist Pablo Casals gave a solo concert, playing with a quiet intensity that I have never forgotten, and the leading historian of Sienese painting, Enzo Carli, offered an introduction to the arts of the city. All this in the weeks leading up to that medieval happening, the urban horse race called the Palio in honour of the banner carried before the procession to celebrate the Assumption of the Blessed Virgin on 15 August. Every weekend in the different *contrade*, the districts and quarters of the town, the band and the liverymen of the district would parade with their drums and their flags in a spectacle of medieval colour.

It was at one of these lectures for the benefit of the foreign students, mostly of university age, that one of the speakers – I think it was Enzo Carli himself – offered a Latin aphorism, set at the head of this chapter, which he thought of value. It struck me as interesting then, and I remembered it. And it strikes me as both interesting and relevant now:

The things we see are beautiful.
The things we know are more beautiful.
The things we do not yet know are the most beautiful of all.

In Chapter 2, while looking at the works of William Turnbull and in contemplating Early Cycladic sculpture, we came face to face with the Renaissance ideal of beauty, which in turn derives from the fascination of the ancient Greeks for order and proportion, in the human form as well as in architecture. As we saw in that chapter, the modern movement liberated us once again from the notion that, for it to be beautiful, a painting or a sculpture has to be an accurate likeness, a simulacrum, of something seen in the world. The Impressionist painters and then Cézanne concentrated upon the way we see the world and the way we may therefore represent it. And in taking liberties with the latter, they managed to make paintings that in some ways looked more like the real thing, were more real, than the most 'realist' of the painters who preceded them.

But it was in France in the first two decades of the twentieth century that painters like Picasso and Matisse showed that it was possible to make wonderful paintings of how we know or imagine the world to be, rather than simply how it may look at a particular moment from a single point of vantage. That was already, in a sense, an ideal of beauty that was concerned with what we know rather than simply what we see. Brancusi brought about a similar revolution in sculpture. Then knowledge moved on with the development of abstraction. In the New York School in the 1950s what we know and what we see were wrapped into a single resonant unity in the energetic complexities of the paintings of Jackson Pollock or the contemplative calm of the works of Mark Rothko. Meanwhile, a different way of visual knowing came about through the minimalism of artists like Donald Judd, Dan Flavin and Carl Andre. Half a century earlier Marcel Duchamp had initiated another kind of visual knowing, and following his lead many of the artists of the late twentieth century made works that fascinate by virtue of their novel exploration of the world and of how we know the world (or what we imagine the world to be). If we look at the work of the *arte povera* school of Italy in the 1960s and 1970s or, in a rather different way, at the BritArt school of the 1990s, we experience some of the delights of visual knowing.

But in this book I have in addition been gnawing away at a different kind of beauty, closer to the beauty of the scientist who aspires to understand some of the regularities that underlie the world of nature – the beauty that drove Newton in his elucidation of the laws of motion, or that impelled Albert Einstein to delve deeper into the relationships between space and time, matter and energy. Or indeed the curiosity that led Francis Crick and Jim Watson to formulate their 'double helix' model for DNA. When we seek to uncover and study the past, there is something that is beautiful in the very process of discovering the unknown, just as there is something beautiful in the works of other communities that we uncover. For many archaeologists, as I have tried to indicate, the fascination lies in the process of using the scant traces surviving from those far-off times to put together a coherent statement that may validly be made about them. Very often the archaeologist starts off in *terra incognita*, unknown territory, investigating a place and time in

human existence about which little information has been established. Gradually, bit by bit, and through the research activities of different individuals and groups, a picture emerges, or a series of pictures. One splendid example of such advancing knowledge is the cumulative work that has been conducted over the past fifty years on the origins of farming in the Near East. Another shining instance is the gradual development in our comprehension of the ancient Maya civilization of Mesoamerica, about which more and more has become known, culminating in the decipherment of the Maya script. There are so many different worlds about which there is more to learn, so many enigmas to be unravelled. An intriguing example is offered by the beautifully worked carved stone balls of neolithic Scotland [173]: dating from before 2000 BC, they show a sophistication in their grasp of form[2] that rivals that of the Greek mathematicians of 1,500 years later.

The historian of ideas David Lowenthal entitled his influential book *The Past Is Another Country*, and in many senses he was right. But the past is more than that: it is many countries, many worlds – as many worlds as there have been communities at different times and in different regions. There lies for us still the pleasure of the chase, of discovery and reconstruction, in relation to many of those.

Underlying this book, however, is another, perhaps broader curiosity, another search for something that we do not yet know or understand very well. For the prehistorian, one of the greatest goals is to understand better how it is that we have come to be in the condition in which we find ourselves. How – that is to say, as a result of what processes – human societies have developed and changed, leading us to the state of being of the modern world. That is the process that Gordon Childe described in his book *Man Makes Himself*. Although written more than sixty years ago, it still gives us a good picture of those processes, even if

we now know more of the detail as a result of subsequent research. That then is the promised beauty that continues to drive the research worker. And for the archaeologist, that research goal has an additional allure, for the knowledge that we seek pertains to ourselves – it is to understand the nature of Us: who we are, how we came to be where we are. As we have seen, all artists have their own take upon the world, their own way of investigating and discovering, and their own path to the beauty of discovery. The path of the prehistorian and the archaeologist is a different one. But as I have sought to show, we can learn much from artists as they pursue their own endeavours. And our own goal is also clear: *pulcherrimae quae ignorantur*.

Acknowledgments

This book is based upon the six 2001 Rhind Lectures[1] delivered to the
Society of Antiquaries of Scotland at the invitation of the President,
Dr Graham Ritchie, from 11–13 May at the National Museum of Scotland,
under the title 'Art as Archaeology and Archaeology as Art: The
construction of the world through material culture'. I should like to express
my thanks to Graham and Anna Ritchie, as well as to Fionna Ashmore,
Director of the Society of Antiquaries of Scotland, for her help and encour-
agement, and to Dr David V. Clarke, Keeper of Archaeology at the National
Museum of Scotland. It is largely through his enthusiasm that the new
prehistory galleries at the museum include major installation works by
Andy Goldsworthy and Eduardo Paolozzi.

My interest in contemporary art was stimulated years ago by a family
friend, Ted Power,[2] who as early as the 1950s had in his collection works by
Jean Dubuffet, Sam Francis, Alberto Giacometti, Asger Jorn, Ellsworth
Kelly, Barnett Newman, Jackson Pollock, Mark Rothko, Clyfford Still,
Antonio Tàpies, etc, and later by noted British artists including Patrick
Caulfield, Barry Flanagan, Howard Hodgkin, Eduardo Paolozzi and
William Turnbull. Through his encouragement I first had the pleasure of
meeting William Turnbull in 1962. I have valued his friendship ever since.
At the University of Southampton in the 1970s, through the activities of the
artist in residence, Ray Smith, I met Richard Long and David Nash. Then,
through the 'Sculpture in the Close' series of exhibitions at Jesus College,
Cambridge, from 1988 to the present,[3] I have come to know personally
many of the artists who figure in this book, including John Bellany, Mark
Dion, Barry Flanagan, Antony Gormley, Richard Long, David Mach,
Eduardo Paolozzi and William Turnbull. For their generosity and
encouragement I am particularly grateful. The Visual Arts Society at Jesus
College has also had the pleasure of welcoming other artists who figure in
these pages, including Andy Goldsworthy and Christo and Jeanne-Claude.
I thank them, and Bill Stronge, Jim Roseblade and other members of the
Jesus College Works of Art Committee, as well as my wife, Jane, for their
enthusiasm, and the Fellows of the college for their forbearance.

Notes

Introduction

1 Gauguin's evocation of the human condition may be seen as a changed and updated version of the 'Three Ages of Man' theme popular already in the Renaissance (Panofsky and Saxl 1926; Biadene 1990), although characteristically Gauguin's principal protagonists for infancy (the baby on the right), maturity (the figures in the centre) and old age (the woman on the extreme left) are female. Gauguin has situated his allegorical view of the human condition in Polynesia (he was living in Tahiti at the time). Although some of his critics found his vision 'over-primitive' (Walther 1993, 80) and his settings 'exotic', Gauguin gives a view of a tropical world with which he empathizes and in which one may see today a universality springing from a freedom from racial prejudice which was unusual in the nineteenth century. Indeed, Gauguin was one of the first artists in the Western tradition to accord to the 'natives' of what was then the colonial world a sympathy and equality of treatment, avoiding the opposing extremes of the 'noble savage' of Rousseau or the denigration of 'savage' life expressed by most nineteenth century anthropologists (e.g. Lubbock 1865).

2 See Renfrew 1996b for more on the 'sapient paradox'; for a more standard view of the 'human revolution', see Mellars 1991.

3 See Renfrew and Bahn 2000 with further references there; also Burenhult 1993.

4 Paolozzi was invited by the National Museum of Scotland to create these sculptures for its Early People Gallery, which opened with the inauguration of the new museum in 2000 under the curatorship of Dr David V. Clarke. Paolozzi was one of the pioneers of Pop Art in Britain and, as discussed in Chapter 5, has systematically used a sort of collage process, incorporating abandoned artefacts and machine parts into his sculptures. As his exhibition 'Lost Magic Kingdoms' at the Museum of Mankind indicated (Paolozzi 1985), he is fascinated by the artefacts of other cultures as well as of our own, and the incorporation or assimilation of prehistoric artefacts from the museum's collections into the very body of these strange and rather ramshackle anthropoid forms recalls pointedly the dictum that 'the past is a foreign country' (Lowenthal 1985), an observation valid for present worlds also. The display of these special objects as prehistoric 'relics' behind glass panels is reminiscent also of what is perhaps one of the earliest traditions of the controlled and protected display of precious artefacts as seen in the reliquaries containing sacred relics (from the Crown of Thorns and the True Cross to the bodies of saints) in the medieval Greek Orthodox and Roman Catholic churches [see figures 129,130].

5 The World Heritage site in the central Mainland of Orkney (Renfrew 1979; Renfrew 1985a; Richards 1996; Ritchie 2000) is one of the most numinous places in the world. The Ring of Brodgar and the Stones of Stenness fall into the category of stone circles situated within henge monuments, of which Stonehenge and Avebury in Wiltshire are other notable examples, all dating to before 2000 BC. Close by the Ring of Brodgar are two neolithic chambered tombs, Unstan and Maeshowe, which are part of the remarkable concentration of megalithic monuments of northwestern Europe. Their origin goes back far before the time of the pyramids of Egypt (Renfrew 1973; Bradley 1993).

6 The idea of juxtaposing prehistoric monuments or artefacts on the one hand and contemporary art on the other is not a new one. Lippard (1983) drew attention to some of the resonances between the two (see also Critchlow 1979; Jaeger 1984; Kelso and Most 1990; Edmonds and Evans 1991; Esche and Palmer 1991; Noble 1991). Moreover, the development of what has been called Land Art in both Britain and the United States (Causey 1977; Beardsley 1984; Tiberghien 1995) has emphasized the observed similarities between prehistoric monuments in their landscape and the open-air works of various contemporary sculptors, many of whom have been well aware of this remote, indeed prehistoric, background to their work. Michael Heizer, one of the pioneers of Land Art in the United States, has carried the comparison further by enlarging the forms of flint arrowheads and prehistoric stone tools to achieve works on a monumental scale which are then displayed in the art gallery (Heizer 1990).

Sculptors such as Henry Moore (Finn 1981), Alberto Giacometti and Eduardo Paolozzi have drawn freely upon the inspiration offered by prehistoric and early sculptural forms. And of course 'primitivism' in the shape of ethnographic art was one of the inspirations for the pioneering moderns at the beginning of the twentieth century (Laude 1967; Rubin 1984) who transformed the visual art of the West.

Chapter 1 Encounters

1 At the time the excavation was undertaken, not long after the full weight of the radiocarbon revolution had been felt (Renfrew 1973; Henshall 1963, 227), it still seemed altogether remarkable that a monument like Quanterness had been constructed some five centuries before the pyramids of Egypt. Yet this was the clear conclusion resulting from the radiocarbon dating of samples from the site, when calibrated using the tree-ring sequence of the bristlecone pine, *Pinus aristata*, of the White Mountains of California.

2 Bradley 1993.

3 The excavations at Quanterness were reported in full, in distinctly traditional format, in a definitive excavation report, *Investigations in Orkney* (Renfrew 1979), which was published by the Society of Antiquaries of London. It incorporated specialist studies by Audrey Henshall on the artefacts found and by others on the human and animal bones, and reproduced the meticulous drawings made by Alec Daykin, the excavation architect, recording the plans and elevations of the structures found. But, in keeping with the conventions of such publications, it did not seek to evoke the brilliant silvery light of the Orkney landscape, or the personal pleasures of excavating through sun and rain in an Orcadian summer, or the rhythms of Orkney life so well recorded and evoked by the Orcadian poets Edwin Muir and George Mackay Brown.

4 The best study of Richard Long's work remains the account by Fuchs (1986), supplemented by the impressive volume that accompanied his exhibition at the Hayward Gallery, London, in 1991 (Seymour 1991). One aspect of the meticulous quality of his work, with its scrupulous attention to detail, is the care that he himself devotes to his exhibition catalogues (Long 1979; 1996; 1997) and to the beautiful small publications published principally by the Anthony d'Offay

Gallery in London (Long 1983; 1988; 1992), which makes these exceptionally attractive to handle. The potential relevance of his work for the prehistoric archaeologist has been noted previously (Renfrew 1990). Yet although Long is clearly well aware of the prehistoric monuments visible in the English landscape (including the great neolithic mound Silbury Hill: see Fuchs 1986, pl. 29), I do not believe that he is greatly influenced by them: the impetus for his work derives from his own experiences of walking the earth, and the forms that he finds to mark his presence are among the simplest and the least intrusive conceivable.

5 Richard Long, *Five, Six, Pick Up Sticks* (short printed statement), published by the Anthony d'Offay Gallery in 1980 (see Fuchs 1986, 236).

6 Graziosi (1960, pl. 262) illustrates a hand outline from the Castillo Cave, Santander, Spain, which is in effect the negative of a hand-print, since the pigment is applied not by means of the hand but in outline around it. By contrast, at Pech Merle in France (Graziosi 1960, pl. 116), there are the traces of muddy fingers that have scrabbled on the muddy wall of the cave to produce a patterned, agitated effect. These 'meanders' in the Upper Palaeolithic caves of north Spain and southern France have been discussed by Alexander Marshack (1977). They might be regarded as a prehistoric analogue or precursor for Richard Long's more agitated mud works, produced by rapid splashing and scrabbling motions (e.g. Seymour 1991, pls 163, 210 and 216), quite unlike the care and precision seen in the application of his mud handprints (e.g. Seymour 1991, pl. 214) or indeed the works produced by the muddy imprint of his feet (Seymour 1991, pls 153 and 204).

It should be noted, however, that while there are undoubtedly formal similarities between some of Richard Long's work and various features seen on the walls of Upper Palaeolithic caves, the appropriate interpretations could be very different in each case. Lewis-Williams (2002) has suggested that the hand outlines and other paintings on the walls of Upper Palaeolithic caves should be interpreted in the light of our knowledge of the practice of shamanism (see Clottes and Lewis-Williams 1996), where the work may be created or perceived by persons in an altered state of consciousness (or trance: see also Tilley 1991),

and where the cave walls might be considered a membrane dividing, yet at the same time relating, this world and the other world, the world beyond, the *au-delà*.

There is, however, nothing mystical or other-worldly about the work of Richard Long, no sense of deeper hidden meanings, no cryptic messages. As Long makes clear in the passage quoted, what you see is what you get.

7 Renfrew 1973, 151; Renfrew 1979, 216.

8 Christopher Tilley (1994) in his *A Phenomenology of Landscape* has illuminatingly described his own personal (and bodily) experiences in walking the length of the Dorset 'cursus', a long linear earthwork of the neolithic period, where he observed the changing perspectives of the landscape and the varying impressions that they made upon him. These experiences encouraged him to make further interpretive suggestions about the use and meaning of the monument in prehistoric times. Likewise Julian Thomas (1996) in *Time, Culture and Identity* has drawn upon the thought and writings of Heidegger, one of the most influential exponents of a phenomenological approach (see Embree 1997), to produce a systematic and influential rethinking of the character of the neolithic way of life in Britain and the experiences of those who lived it. His conclusions differ in several radical ways from those of earlier generations of scholars. Both workers draw attention to the bodily experience undergone now, our being in the world, and presumably also in prehistoric times, as one approaches the entrance of a monumental structure, proceeds through the entrance and goes on to view the interior. What we experience now must approximate in some respects to what was experienced in neolithic times, given that the human body has changed very little in its physical constitution over the intervening period. Critics of this approach have noted that experience, like beauty, is in the eye of the beholder and that there are no universal rules allowing us to infer from our own experiences to those of individuals in prehistoric times. Our bodies may be much the same in physical terms, but the social context in which we live, what the French sociologist Bourdieu (1977, 15) terms the *habitus*, must be very different. My own assertions are perhaps more modest, namely that the direct experience of the work of Richard Long has allowed me to engage with prehistoric field monuments in what for me is a new and

different way. Such an encounter may promote fresh observations as well as speculations about their function in neolithic times, whose validity for these or other monuments remains to be assessed.

9 One of the pioneers of what one might term an *affective* approach to archaeology, where one's own personal and subjective feelings are valued and recorded, was Jacquetta Hawkes who, in her *A Land* (Hawkes 1951), described the bodily experience of lying upon the ground with the accompanying physical awareness of the earth beneath and the knowledge of its underlying geology. She deliberately evoked and described her experiences and feeling in relation to the archaeology as well as the geology. More recently Michael Shanks (1999) has laid emphasis upon the process of *experiencing* the past. But we were anticipated in this respect by Rose Macaulay (1953), whose *Pleasure of Ruins* deliberately developed a *sentimental* approach, with roots going back beyond Richard Burton's *Anatomy of Melancholy* or Thomas Browne's *Hydriotaphia* or *Urn Burial*, right back to the philosophers of Classical Greece and Rome. Macaulay's own view of the picturesque derives in part from the Romantic era in England, when artists as notable as Thomas Girtin and John Constable took pleasure in depicting prehistoric monuments such as Stonehenge in dramatic conditions of weather and light (Smiles 1994). Indeed, the influence of the early field archaeology of William Stukeley or Sir Richard Colt Hoare (see Schnapp 1996) upon the exponents of landscape archaeology in the early twentieth century, such as O. G. S. Crawford, and of these upon the present generation of landscape archaeologists, remains to be studied in detail.

10 The satisfaction for an excavator of drawing for oneself really high-quality plans and sections for the final publication is evident from the works of such meticulous scholars and draughtsmen as Sir Mortimer Wheeler and Stuart Piggott, and has been described to me by one of their notable successors in this respect, Barry Cunliffe (pers. comm., 1981). These are aesthetic pleasures. Piggott has himself written sensitively on the theme of archaeological draughtsmanship (Piggott 1976; 1978), drawing attention to the high quality of the very personal archaeological drawings, mainly maps and plans, of the Hampshire archaeologist Heywood Sumner (see Coatts and Lewis

1986). Likewise the remarkable and pleasing contributions made by the illustrator Piet de Jong, who undertook much illustrative work for Sir Arthur Evans at the Palace of Minos at Knossos in Crete, are increasingly appreciated today (Hood 1998).

11 The excavations of the shrine at Phylakopi have been published in a volume entitled *The Archaeology of Cult* (Renfrew 1985b), where The Lady of Phylakopi was discussed in detail by Elizabeth French, accompanied by fine drawings undertaken by Jennifer Moody and photographs by Lyvia Morgan.

12 There is an aesthetics of fragmentation and of reconstruction relevant both to the practice of archaeology and of contemporary art. Artists such as Tony Cragg [see Chapter 5: figure 136] and Christine Borland (Patrizio 1999) have deliberately smashed artefacts and presented the debris as a work of art. Likewise the damaged condition of Duchamp's *Great Glass/ The Bride Stripped Bare by her Bachelors Even* (see Chapter 3) is today part of its allure. The same may be said for the artefacts that Mark Dion displayed as an end product from *Raiding Neptune's Vault* or the *Tate Thames Dig* (also in Chapter 3). The way in which discarded objects become 'rubbish' and then later the 'rubbish' is exalted into valued relics is discussed in Michael Thompson's *Rubbish Theory* (Thompson 1979). The intriguing idea that some classes of artefact were deliberately smashed in prehistoric times so that the fragments could serve as tokens relating those persons present in a developing network of 'enchainment' has recently been developed by John Chapman (2000).

A different but perhaps related theme is what Pollard (2001) has termed the 'aesthetics of depositional practice', in which he examines pit deposition in the British neolithic, arriving at a consideration of deposits as art works.

13 The physical qualities of the material and of texture are something with which the excavator soon becomes familiar, and the recording of successive layers in the stratigraphic succession is one of the key means of chronological control (seen for instance in the stratigraphy at prehistoric Sitagroi [figure 31], Renfrew *et al.* 1986). It is one of the pleasures of working with experienced and sometimes professional archaeological workmen in Greece or in Western Asia that they have a profound experience of the colour, consistency, grain, resonance and other physical and textural qualities of the soil, and are particularly adept at recognizing such features as mud brick or plastered mud, which are indicative of walls of structures and often quite difficult to detect.

A concern for the textures of matter, going beyond the repertoire of oil or acrylic on canvas, has been a feature of later twentieth-century art, with the *art brut* of painters like Jean Dubuffet, or the thick, sand-like pastes of Antonio Tàpies. A similar feeling for material and textures is seen in the *arte povera* of Italy at the same time, sometimes involving an intensive scrutiny and modification, for instance in the extraordinary pared-down tree trunks of Guiseppe Penone. The Boyle family [see figure 28] have gone so far as to reconstruct the precise appearance of a square metre or two of ground, replicating for instance the exact appearance of a specific area of pavement, kerb, gutter and street (Boyle 1986; Patrizio 1999). When they undertake this on a vertical, for instance on a cliff face, reproducing precisely the appearance of one or two square metres on the vertical plane, the result strikingly resembles the samples of archaeological sections which some archaeologists were taking already in the 1960s, using tough fabric and strong adhesives. Of course, it is no surprise that geo-archaeologists and artists should have convergent interests in the textures of materials seen at close quarters and encountered through tactile as well as visual experience.

The microscopic examination of archaeological deposits has now become a specialist sub-discipline of the subject: archaeological soil micromorphology. Microscopic examination of the wall plasters at Çatalhöyük by Dr Wendy Matthews, for instance, has revealed the detailed sequence of re-plastering with striking clarity ([figure 32]; Matthews *et al.* 1996). The micrograph reveals clearly what may have been annual replastering episodes and gives a vivid impression of the passage of time – time as experienced (Boivin 2000, 382) by the inhabitants (and not merely the consequence of the annual temperature changes revealed by dendrochronology or in the varves, the annual sedimentary deposits arising from annual melting in periglacial regions).

14 Whiteford 1990.

15 The argument here compares the position of the gallery-goer, who has to interrogate what he or she

sees in order to come to terms with the work and reach some understanding of it, with that of the archaeologist seeking to understand or interpret the material remains of the human past. The point, however, is not the formal similarity between certain modern works and very much earlier ones that may have served as their inspiration, but in the correspondences between the two modes of engagement with material culture.

It is of course frequently the case that the material remains of the human past, in the form for instance of prehistoric monuments or Classical ruins, have inspired the art of later ages. Renaissance artists and their successors down to Piranesi and beyond were inspired by the monuments of ancient Rome and then Greece [see figures 41 and 61]. The opening up of Egypt during the Napoleonic Wars made Egyptian motifs, including obelisks, very popular in the West (Curl 1982), and the discovery of Pompeii and Herculaneum or indeed of the Maya temples of Mesoamerica (Ingle 1984) have had their impact upon later artists and architects. In Britain, prehistoric monuments and prehistoric decorative motifs have inspired a number of twentieth-century painters and sculptors, from Paul Nash and Henry Moore or John Piper and Barbara Hepworth, down to Kate Whiteford and Stephen Cox in our own time.

Works like Hepworth's *Two Personages (Menhirs)* (1965) and *Six Forms in a Circle* (1967) (see Bowness 1971, 39 pl. 115, and 45) immediately indicate the inspiration of prehistoric monuments and of the prehistoric landscape, an influence that was significant also for much of the work of Henry Moore (Renfrew 1998b). It is clearly exemplified in his *Stone Figures in a Landscape Setting* (Garrould 1988, fig. 40) and in the portfolio *Stonehenge* (Moore 1974). These instances of the influence of forms, of styles and of feelings of earlier periods upon those of much later periods, following their archaeological rediscovery or their *in situ* survival, constitute an interesting theme, significant to the development both of twentieth-century British archaeology and of one strand in British art of the same time. It is not, however, the central preoccupation of this book.

16 The archaeology of the senses (see Houston and Taube 2000; Jones 2001; Hamilakis, n.d.) has developed into a contemporary theme of interest, where the visual impact of monuments has been assessed in terms of colour (Jones and MacGregor 2002), and of their acoustic properties, such as may have been employed in ritual, in terms of sound (Watson and Keating 2000). There have been considerations also in terms of taste and smell as well as in the stimulant effect of narcotics (Sherratt 1987). The tactile qualities of materials such as jade or feathers have long been recognized (Clark 1986) as contributing to the value and prestige attributed to artefacts.

17 The work by Richard Long called *Turf Circles* [figure 34] recalls the ubiquity of the circular form in monuments and sacred places on a worldwide basis (see Renfrew 1997): the circle, like the straight line, is a form to which he frequently returns. But of course he is not alone in this, and different cultures have given very different meanings to the circular form (see Coe 1976). Just as the prehistoric long barrow and the cursus monument in the neolithic have a linear form, so the 'causewayed camps' and the henge monuments are circular.

Chapter 2 What is art?

1 Some of the questions touched upon in this chapter, on the nature of art or the conception of beauty, fall very much within the scholarly sphere of the discipline of aesthetics (see Carpenter 1959; Gilbert and Kuhn 1956; Beardsley 1966). For the intersection of aesthetics and archaeology, see Gosden 2001; Ouzman 2001; Gell 1998; Groenewegen-Frankfort 1951. Neither term, 'art' or 'beauty', is very helpful for a general discussion about figuration or iconography, particularly when one is dealing with objects, monuments or works falling outside the European Classical and Renaissance traditions. For, as noted in this chapter, the term 'art' developed its current meaning within that developing tradition at the time of the Italian Renaissance and cannot be used without Eurocentrism outside that broad context of origin. Moreover, our understanding of the term 'art', even within the Western tradition, has changed so much over the past fifty years, with such developments as Pop Art (Lippard 1966), conceptual art (Godfrey 1998), and performance art (Goldberg 1979), and indeed Land Art (Tiberghien 1995), that most earlier discussions seem today very restricted in their scope.

2 Renfrew 1962.

3 Wolters 1891.

4 Renfrew 1969; Fitton 1989; Getz-Preziosi 1987; Renfrew 1991.

5 Finn 1981; Sachini 1984; Zervos 1957.

6 Gill and Chippindale 1993; Elia 199; Renfrew 2000.

7 Muscarella 2000.

8 Haskell and Penny 1981; for the Grand Tour, Wilton and Bignamini 1996; for 'marble mania' in England, Guilding 2001.

9 For the horses of St Mark's see Perocco 1977. For Flanagan, see Flanagan 1982, and for his 1983 *Bronze Horse* [figure 41], inspired by the visit to Britain of one of the bronze horses from Venice, exhibited at the Royal Academy of Arts, see Renfrew 1996a, 4. The theme of the enduring influence into our own time of such Classical icons as the Venus de Milo, for instance in the work of Salvador Dalí or of the contemporary American artist Jim Dine [figure 61], was brilliantly surveyed in a recent exhibition, 'D'après l'antique', at the Louvre in Paris (Cuzin *et al.* 2000). This, however, should not be seen as perpetuating the 'tyranny' of the Renaissance: such recent and direct uses of Classical or Renaissance inspiration have generally been very self-aware, often ironic. One might well apply to them the term 'postmodern', were not some of them decades in advance of the early declarations of postmodernism.

10 The established view of art history, privileging the Graeco-Renaissance tradition, is well outlined from a mid-twentieth-century perspective by E. H. Gombrich in *The Story of Art* (Gombrich 1954; see Renfrew 1962).

11 For different modes of representation, and for Art as Illusion, see Gombrich 1960. For Picasso, see, for instance, Penrose 1958, and Cowling and Golding 1994; for Brancusi, see Gideion-Welcker 1958, Brancusi 1979, and Geist 1984; see also Werner 1965 for Modigliani; for Mondrian see Bois *et al.* 1996, and Cooper and Sprank 2001.

12 The history of collecting has been surveyed by Alsop (1982), and the concept of the 'masterpiece' by Cahn (1979). Gimpel (1969) gives an incisive critique of the concept of 'art' in contemporary society.

13 The definition of 'art' as 'any painting or sculpture or material object which is produced to be the focus of our visual contemplation and enjoyment' arises from this view, originating in the Renaissance (or perhaps

in Classical Greece), of the 'masterpiece' produced and displayed for our aesthetic appreciation, like the objects displayed in the Tribuna of the Uffizi or a gallery of modern art. But already, as we shall see in the next chapter, at the beginning of the twentieth century this definition betrays its limitations, even from the standpoint of the Western tradition and of the art gallery in New York or London. Any examination of 'installation art' (see De Oliveira *et al.* 1994) suggests that the reference to 'material object' would need to be changed at least as far as 'displayed assemblage of material objects'. At the time of writing (autumn 2001) one of those shortlisted for Britain's annual Turner Prize competition (in principle awarded to the contemporary artist who is judged to have made the greatest contribution over the previous year) was Mike Nelson, whose installations comprise backrooms and corridors filled with ill-assorted objects, resembling a neglected storeroom (Bradley 2001). Another candidate, and indeed the ultimate winner, was Martin Creed (see Patrizio 1999), whose distinctly minimalist contribution was an empty room where the lights go on and off. The two other competing artists worked through photography and video. So my attempted definition, predicated upon material objects, does not fare too well!

Such an attempted definition can, however, be questioned on two other grounds. In the first place, is it appropriate to restrict the term 'art' exclusively to products situated in the Western post-Renaissance tradition? One can scarcely deny the term 'sculpture' to the great traditions of African wood carving, for instance to the work of Olowe of Ife [figure 52] (Walker 1998) or to the Benin bronzes, nor 'painting' to the worldwide manifestations of rock art or to the bark paintings of the Australian aborigines (Ucko 1977; Caruana 1993; Morphy 1989; Ryan 1990). Furthermore, the dividing line is difficult to draw, on such a definition, between 'art' and 'decoration', where the designs are thought to fulfil some subordinate purpose. But it is already clear that decoration is often more than merely decorative (Gombrich 1979) and may have a range of purposes, including the formation and declaration of a sense of identity or even of ethnicity (Hodder 1982). Its functions are not merely secondary.

Second, at this point we come close to one of the

central themes of this book, further developed in Chapter 5, namely the active role of material culture. In his work *The Present Past*, Hodder (1982) stressed the active role of material culture, and chose examples of personal body decoration, notably jewellery, and also decorated artefacts, to exemplify his theme. The matter was taken further by Alfred Gell (1998) in his *Art and Agency*, who developed there a number of issues influential to current thinking.

However the theme can be taken further, as noted in Chapter 5. For the active role of material culture is not something that has to involve 'decoration' or indeed representation. Valuables and objects of prestige, for instance, can have enormous symbolic power without showing any of the representational or decorative features traditionally associated with the notion of 'art' in the sense that might be intended by Gell. The introduction of bronze weapons, it has been well argued, had a fundamental impact upon the societies of bronze-age Europe (see Treherne 1995). Yet a single impressive weapon – a well-made bronze dagger, or a handsome sword – while possessing considerable symbolic power (within its own context of manufacture and use), might not be thought by many to qualify as an art object. At the same time it can certainly function as what one might term a 'constitutive symbol' (Renfrew 2001a), with a cognitive significance which is partly based upon its perceived material presence.

The conclusion must be that such definitions as the above may have a utility in developing discussion and so in inviting analysis. But in the field of aesthetics they are soon belied by further developments brought about by the artists themselves.

14 Laude 1967; Rubin 1984.

15 Sachini 1984; Finn 1981.

16 For Greek art of the Archaic and Classical periods, see Lullies and Hirmer 1957; for the *kouroi* and the *korai*, Richter 1970 and 1968.

17 Walker 1998.

18 For the work of William Turnbull, see Morphet 1973; Sylvester 1995; also Renfrew 1962, and various exhibition catalogues published by the Waddington Galleries: the 1998 exhibition catalogue included an interview of the artist in discussion with Colin Renfrew.

19 Quoted from the catalogue of the 1956 exhibition 'This Is Tomorrow' (Anon. 1956).

20 Turnbull's work, both in sculpture and in painting,

gives some remarkable insights into processes of 'abstraction' in the art of the later twentieth century, concerning which his few written and spoken statements are particularly lucid. The following extract is taken from 'William Turnbull in conversation with Colin Renfrew, Waddington Galleries, 6 May 1998' in the exhibition catalogue *William Turnbull: Sculpture and Paintings*, published by the Waddington Galleries, London, 1998:

WT: I have always been very interested in this idea of metamorphosis. Ambiguity can give the image a wide frame of reference.

CR: Which sets up a great tension.

WT: It creates cross-reference between something that looks like an object and that looks like an image. For me in making sculpture there is always that tension between the sculpture as object and the sculpture as image. I think that is quite different from the intention of naturalistic sculpture.

CR: In your painting there is also a tension. But it isn't the same tension, because your painting is completely abstract so far as I am aware. It has no figurative referent, whereas every one of your sculptures has a title, 'Figure' or 'Head', and certainly it has a referent. So we are saying there is a tension between the figuration and the form in the sculpture, but it's a different tension in the painting.

WT: It's very difficult for me to put my finger exactly on it but it is there also in my painting. There is common ground between the tension in my painting between object and image as against the tension in the pictures between surface and object. What matters is the painting as an object, not the painting as an illusion. The paintings do have a very strong sense of 'thing-ness'. As you know, I have no doctrinaire attitude of figuration and abstraction: the one doesn't matter more than the other. My paintings are monochrome or duochrome in colour, and so the colour and the texture are the way that you structure the pictures in terms of paint. That is the way the pictures are made and it seems to me different from the way you make sculpture.

21 Quoted from the same interview as note 20.

22 Quoted from Fry 1928, 295.

23 For Giacometti, see Lamarche-Vidal 1984; Giacometti and Ben Jelloun 1992.

24 While the function and 'meaning' of the 'Venus'

Bronowski in the BBC programme *Monitor*, June 1962, quoted from Frank Whitford, 'Eduardo Paolozzi and *Bunk*', in the introduction to *Bunk*, the boxed collection of forty-seven prints by Eduardo Paolozzi, published in 1972.

17 For Claes Oldenburg, see Rose 1970; Celant *et al.* 1995.

18 For Tony Cragg, see Henger 1991; Celant *et al.* 1996.

19 For Mach, see Ash and Bonaventura 1995; Mach 1995.

20 Veblen 1925, 26–9 and 38–9.

21 The notion of the *engagement* with the material world which human individuals and societies increasingly achieve seems to me of central relevance for the understanding of the way that humans have constructed and created the social and material worlds in which they live (Renfrew 2001a; Renfrew 2001b; see also Wilson 1988). But rather than regarding this as a process of *materialization*, by which artefacts reflect or symbolize pre-existing social institutions and concepts (DeMarrais *et al.* 1996), I see it instead as one where symbol and concept emerge together, as in the case of 'weight'. The material reality in some senses precedes the concept which forms in the human mind, and such artefacts may be regarded as 'constitutive symbols', the material manifestation of the 'constitutive rules' of which the philosopher John Searle (1995, 27) speaks when discussing such institutional facts as government or marriage, as well as more material ones including wealth, money and property.

This chapter, then, seeks to fill the lacuna left in the original formulation of Merlin Donald by stressing the role of artefacts in an age before literacy, as well as subsequently. That artefacts are the means by which many institutional facts are made to operate is implicit in the discussions in this chapter of such institutional facts as community, property, divinity, value and commodity, and the list can of course be extended.

The study of artefacts from a number of interesting standpoints has recently come to the fore, much of it deriving ultimately from the pioneering work on the gift by Marcel Mauss (1925). Several scholars have worked on the ways that artefacts are used as social instruments (Douglas and Isherwood 1979) for the construction of categories (Miller 1985) and as social and symbolic instruments (Robb 1999; Lubar and

Kingery 1993). The 'life histories' of artefacts have been examined (Appadurai 1986), and the interactions between social and technological aspects discussed (Lemonnier 1993; Dobres and Hoffman 1999), and their role in communication considered from a semiotic viewpoint (Schiffer 1999). While the issues are of salient importance for the prehistoric period, they are relevant also for much more recent times (Jardine 1996). I see this as one of the growth fields of contemporary archaeological research, and one that can be illuminated by considering the ways in which contemporary artists have approached such issues from their own perspectives.

Chapter 6 Baneful signs

1 McLuhan 1962; 1964.

2 For early writing, see Gelb 1952; Diringer 1962; Robinson 1995; Parkinson 1999; Trigger 1998.

3 The story of Bellerophon is from Homer's *Iliad* vi, 155–231 (Murray 1924, I, 273–9).

4 For the power of oral tradition, see Vansina 1973; for the effects of early literacy, see Goody 1968.

5 The early stamp seals at Çatalhöyük are illustrated in Mellaart 1967; for the very early use of counters as a first step towards literacy in Western Asia, see Schmandt-Besserat 1992.

6 The excavation of the library of the site of Ebla in Syria, dating from the third millennium BC, has been described by Matthiae (1984). Such an archive of clay tablets inscribed in the cuneiform script was a very early and quintessential means of external symbolic storage of the kind envisaged by Donald (1991). The German artist Anselm Kiefer constructed a remarkable sculpture consisting of lead books with lead pages which conveys a feeling of awesome antiquity and of destruction, whether wrought by time alone or also by war one cannot tell (Kiefer 1989). The title *The High Priestess/Mesopotamia* recalls immediately the libraries and temple archives of the Sumerians and the passage of vast periods of time, but as with so much of his work there is also the bitter taste of the aftermath of World War II.

7 The *ostraka* inscribed with the names of the Athenian generals were found during the excavations at the Athenian Agora and are to be seen modestly displayed in the Agora Museum (Camp 1986, 59 fig. 39). Here again the notion of 'involuntary art' comes

into play. These inscribed sherds have as great an impact upon us, when their significance is realized, as a sculpture by Ian Hamilton Finlay, or a word work by Richard Long, or again a 'truism' of Jenny Holzer. Obviously they were not inscribed with the intention of impressing later viewers, but like many relics of antiquity they have an effect that is at once arresting at the moment of recognition and poignant in its aftermath. Some of the works of Cornelia Parker (see Parker 1996) have a similar effect upon me.

8 Mental maps are well discussed by Gould and White (1974). For the early history of the map, see Zubrow and Daly 1998.

9 For Klee, see Kort 2000.

10 For Ian Hamilton Finlay, see Abrioux 1985; also Morgan 1991.

11 For Bruce Nauman, see Nauman 1998.

12 For Jenny Holzer, see Waldman 1989; Joselit *et al.* 1998.

13 The early history of money is well surveyed by Williams (1998) and by Morgan (1965), with overviews of early and non-European currencies in Einzig 1988; Quiggin 1949. The crucial role of cash as a nexus of communication is well emphasized by Ferguson (2001).

14 Quotations from Ferguson 2001.

15 For Warhol, see Ratcliff 1983.

16 The impact of mass production and mass consumption has been discussed by many scholars, including Miller (1987). The depersonalization of modern society, with the individual lost among a thousand human equivalents, has been brilliantly caught in the photographs of Andreas Gursky (Galassi 2001).

17 For late twentieth-century dematerialization, see Lippard 1973.

18 Opie 1997.

Postscript

1 In writing this book and reviewing its contents, I am very much aware that there are whole areas of human experience that have been given distinctly short shrift. The emphasis upon material culture, and human engagement with material culture, has led to a perhaps understandable preoccupation with things, and the way human cognition incorporates material things into our world and indeed constructs whole new social worlds out of material things. The more general (and in some respects universal) cognitive dimensions, involving space, time and social formations, have not been emphasized. They are implicit, of course, in many of the archaeological contexts that have been considered here and indeed in the work of the artists discussed.

Among late-twentieth-century artists whose work I have found most interesting, and sometimes astonishing, are Jackson Pollock (Varnedoe 1999), Mark Rothko (Weiss 1998), Barnett Newman (Rosenberg 1978) and Ellsworth Kelly (Waldman 1997) among painters, and Richard Serra (Krauss 1986) among sculptors. Their impact upon the way we think about space and even the way we perceive space has been considerable. But the emphasis here upon material things has led to the under-representation of painting, especially abstract painting, in these pages, and thus to a lack of any serious consideration of the extent to which contemporary painting has had a significant impact upon the way we think about space and time.

There is clearly a whole book to be written, indeed several books, upon perceptions of space and time in ancient societies. Works like Gaston Bachelard's *The Poetics of Space* (Bachelard 1964) and Chris Gosden's *Social Being and Time* (Gosden 1994) have already begun to explore these fields in a general sense, and other studies such as Groenewegen-Frankfort's *Arrest and Movement* (Groenewegen-Frankfort 1951) and Schäfer's *Principles of Egyptian Art* (Schäfer 1986; see Davis 1989) have contributed valuable case studies devoted to specific cultural contexts. These are fields of experience that the archaeologist has only begun to explore, and where the expansion over the past century in our notions of what might constitute 'art' has yet to be fully assimilated.

2 The mysterious carved stone balls of Scotland, assigned to the neolithic period (see Clarke *et al.* 1985, 254–5), have no clear function (Edmonds, 1992) and they remain an enigma. They have been ingeniously discussed by Critchlow (1979, 131–49), who sees in them 'Platonic spheres – a millennium before Plato', although the priority on a revised chronology would rather be of the order of two millennia. His consideration of the Platonic solids is an interesting one: although it may be a shade elaborate, it is the only sustained discussion I know of the form of these intriguing artefacts. *Pulcherrimae quae ignorantur!*

Hood R., 1998, *Faces of Archaeology in Greece: Caricatures by Piet de Jong*, Oxford, Leopard's Head Press.

Horne D., 1984, *The Great Museum: The Re-presentation of History*, London, Pluto Press.

Houston S. D., 2001, 'Decorous bodies and disordered passions: Representations of emotion among the Classic Maya', *World Archaeology 33*, 206–19.

————— and Taube K., 2000, 'An archaeology of the senses: Perception and cultural expression in ancient Mesoamerica', *Cambridge Archaeological Journal 10*, 261–94.

Hutchinson J., Gombrich E. H., and Njatin L. B., 1995, *Antony Gormley*, London, Phaidon (2nd edn. 2001).

Ingle M., 1984, *The Mayan Revival Style*, Salt Lake City, Gibbs M. Smith.

Ingold T., 1983, 'The significance of storage in human societies', *Man 18*, 553–71.

Jaeger E., 1984, *Neolithic Stone Circles and Contemporary Art in the Landscape*, New York, Vantage Books.

Jardine L., 1996, *Worldly Goods: A New History of the Renaissance*, London, Macmillan.

Jones A., 2001, 'Drawn from memory: The archaeology of aesthetics and the aesthetics of archaeology in Earlier Bronze Age Britain', *World Archaeology 33*, 335–56.

————— and MacGregor G. (eds), 2002, *Colouring the Past: The Significance of Colour in Archaeological Research*, Oxford, Berg.

Joselit D., Simon J., and Salecl R., 1998, *Jenny Holzer*, London, Phaidon.

Kelso W. and Most R. (eds), 1990, *Earth Patterns: Essays in Landscape Archaeology*, Charlottesville, University Press of Virginia.

Kiefer A., 1989, *The High Priestess*, London, Anthony d'Offay Gallery.

Kopytoff I., 1986, 'The cultural biography of things: Commoditization as process', in A. Appadurai (ed.), *The Social Life of Things: Commodities in Cultural Perpsective*, Cambridge, Cambridge University Press, 64–91.

Konnertz W., 1984, *Eduardo Paolozzi*, Köln, DuMont Buchverlag.

Kort P., 2000, *Paul Klee: In the Mask of Myth*, München, Haus der Kunst.

Krauss R. E., 1986, *Richard Serra: Sculpture*, New York, Museum of Modern Art.

Lamarche-Vadel B., 1984, *Alberto Giacometti*, New York, Tabard Press.

Laude J. (ed.), 1967, *Arts primitifs dans les ateliers d'artistes*, Paris, Musée de l'Homme.

Leach E., 1976, *Culture and Communication: The Logic By Which Symbols Are Connected*, Cambridge, Cambridge University Press.

Lemonnier P. (ed.), 1993, *Technologies of Choice: Transformation in Material Cultures since the Neolithic*, London, Routledge.

Lesure R., 1999, 'On the genesis of value in early hierarchical societies', in J. E. Robb (ed.), *Material Symbols, Culture and Economy in Prehistory*, Carbondale, Ill., Southern Illinois University Press, 23–55.

Lewis-Williams D., 2002, *The Mind in the Cave*, London, Thames and Hudson.

Lippard L.R., 1966, *Pop Art*, London, Thames and Hudson.

—————, 1973, *Six Years: The Dematerialization of the Art Object from 1966 to 1972*, New York, Praeger.

—————, 1983, *Overlay: Contemporary Art and the Art of Prehistory*, New York, Pantheon Books.

Livingstone M., 1998, *George Segal. A Retrospective: Sculptures, Paintings Drawings*, Montreal, Montreal Museum of Fine Arts.

Lock A. and Peters C. R. (eds), 1999, *Handbook of Human Symbolic Evolution*, London, Blackwell.

Long R., 1979, *Richard Long*, Eindhoven, Van Abbemuseum.

—————, 1983, *Sixteen Works*, London, Anthony d'Offay Gallery.

—————, 1988, *Old World New World*, London, Anthony d'Offay.

—————, 1992, *Mountains and Waters*, London, Anthony d'Offay Gallery.

——, 1996, *River to River*, Paris, Les Amis du Musée d'Art Moderne de la Ville de Paris.

——, 1997, *From Time to Time*, Ostfildern, Cantz Verlag.

Lowenthal D., 1985, *The Past Is a Foreign Country*, Cambridge, Cambridge University Press.

Lubar S. and Kingery W. D. (eds), 1993, *History from Things: Essays on Material Culture*, Washington DC, Smithsonian Institution.

Lubbock J., 1965, *Prehistoric Times*, London, Wiliams

and Norgate (7th edn 1913 by Lord Avebury).

Lullies R. and Hirmer M, 1957, *Greek Sculpture*, London, Thames and Hudson.

Macaulay R., 1953. *Pleasure of Ruins*, London, Weidenfeld and Nicholson.

Mach D., 1995, *David Mach at the Zamek Ujzdowskie*, Tokyo, Lampoon House.

Macmillan D., 1998, *John Bellany: A Scottish Odyssey*, London, Beaux Arts.

Marcus J., 1974, 'The iconography of power among the Classic Maya', *World Archaeology* 6, 83–94

Marshack A., 1971, *The Roots of Civilization: The Cognitive Beginnings of Man's First Art, Symbol and Notation*, New York, Harper and Row.

—————, 1977, 'The meander as a system: the analysis and recognition of iconographic units in Upper Palaeolithic compositions', in P. J. Ucko (ed.), *Form in Indigenous Art*, London, Duckworth, 286–317.

—————, 1991, 'The Tai plaque and calendrical notation in the Upper Palaeolithic', *Cambridge Archaeological Journal* 1, 25–61.

Marshall D., 1977, 'Carved stone balls', *Proceedings of the Society of Antiquaries of Scotland* 108, 40–72.

Matthews W., French F., Lawrence T., and Cutler D., 1996, 'Multiple surfaces: The micromorphology', in I. Hodder (ed.), *On the Surface: Çatalhöyük 1993–95*, Cambridge, McDonald Institute, 301–42.

Matthiae P., 1984, *I tesori di Ebla*, Roma, Editori Laterza.

Mauss M., 1925, *The Gift*, London, Routledge.

McEwen J., 1994, *John Bellany*, London, Mainstream Publishing.

McLuhan M., 1962, *The Gutenberg Galaxy: The Making of Typographic Man*, London, Routledge and Kegan Paul.

—————, 1964, *Understanding Media: The Extensions of Man*, London, Ark.

McShine K., 1999, *The Museum as Muse: Artists Reflect*, New York, Museum of Modern Art.

Mellaart J., 1967, *Çatal Hüyük, a Neolithic Town in Anatolia*, London, Thames and Hudson.

Mellars P., 1991, 'Cognitive changes and the emergence of modern humans', *Cambridge Archaeological Journal* 1, 63–76.

————— and Gibson K (eds.), 1996, *Modelling the Early Human Mind*, Cambridge, McDonald Institute.

Meskell L., 2000, 'Writing the body in archaeology', in A. R. Raitman (ed.), *Reading the Body: Representation and Remains in the Archaeological Record*, Philadelphia, University of Pennsylvania Press, 13–21.

Miles R., 1977, *The Complete Prints of Eduardo Paolozzi, Prints, Drawings, Collages 1944–77*, London, Victoria and Albert Museum.

Miller D., 1985, *Artefacts as Categories*, Cambridge, Cambridge University Press.

—————, 1987, *Material Culture and Mass Consumption*, Oxford, Blackwell.

Mink J., 2000, *Duchamp*, Köln, Benedikt Taschen.

Mithen S., 1996, *The Prehistory of the Mind*, London, Thames and Hudson.

—————, 1998, 'The supernatural beings of prehistory and external symbolic storage of religious ideas', in C. Renfrew and C. Scarre (eds), *Cognition and Material Culture: The Archaeology of Symbolic Storage*, Cambridge, McDonald Institute, 97–106.

Montserrat D. (ed.), 1998, *Changing Bodies, Changing Meanings: Studies in the Human Body in Antiquity*, London, Routledge.

Moore H., 1974, *Stonehenge*, with Introduction by Stephen Spender, London, Ganymede Original Editions.

Morgan E., 1991, *Evening Will Come, They Will Sew the Blue Sail: Ian Hamilton Finlay and the Wild Hawthorn Press 1958–91*, Edinburgh, Graeme Murray.

Morgan E.V., 1965, *A History of Money*, Harmondsworth, Penguin Books.

Morphet R., 1973, *William Turnbull: Sculpture and Painting*, London, Tate Gallery.

Morphy H., 1989, 'From dull to brilliant: The aesthetics of spiritual power among the Yolnyu', *Man* 24, 21–40.

Mundy J. (ed.), 1996, *Brancusi to Beuys: Works from the Ted Power Collection*, London, Tate Gallery Publishing.

Murray A. T. (ed.), 1925, *Homer: The Iliad* (Loeb Classical Library), Cambridge, Mass., Harvard University Press.

Muscarella O. W., 2000, *The Lie Became Great: Forgery of Near Eastern Cultures*, Groningen, Styx.

Mussi M. and Zampetti D., 1997, 'Carving, painting, engraving: Problems with the earliest Italian

design', in Conkey M., Soffer O., Stratman D., and Jablonski O. (eds), *Beyond Art: Pleistocene Image and Symbol* (Memoirs of the California Academy of Sciences 23), San Francisco, California Academy of Sciences, 217–38.

Nauman B., 1998, *Bruce Nauman*, London, Hayward Gallery.

Noble A. (ed.), 1991, *From Art to Archaeology*, exhibition catalogue, London, South Bank Centre

Noble W. and Davidson I., 1996, *Human Evolution: Language and Mind*, Cambridge, Cambridge University Press.

Opie J., 1997, *Julian Opie*, London, Lisson Gallery.

Ouzman S., 2001, 'Seeing is deceiving: Rock art and the non-visual', *World Archaeology* 33, 237–56.

Panofsky E. and Saxl F., 1926, 'A late antique religious symbol in works by Holbein and Titian', *Burlington Magazine* 49.

Paolozzi E., 1985, *Lost Magic Kingdoms*, London, British Museum.

Parker C., 1996, *Avoided Object*, Cardiff, Chapter.

Parkinson R., 1999, *Cracking Codes: The Rosetta Stone and Decipherment*, London, British Museum.

Patrizio A., 1999, *Contemporary Sculpture in Scotland*, Sydney, Grafton House.

Pearson F., 1999, *Eduardo Paolozzi*, Edinburgh, National Galleries of Scotland.

Penrose R., 1958, *Picasso: His Life and Work*, London, Victor Gollancz.

Perocco G. (ed.), 1977, *The Horses of San Marco, Venice*, London, Thames and Hudson.

Piggott S., 1976, *Ruins in a Landscape*, Edinburgh, Edinburgh University Press.

————, 1978, *Antiquity Depicted: Aspects of Archaeological Illustration*, London, Thames and Hudson.

Pollard J., 2001, 'The aesthetics of depositional practice', *World Archaeology* 33, 315–34.

Putnam J., 2001, *Art and Artifact: The Museum as Medium*, London, Thames and Hudson.

———— and Davies W. V. (eds), 1994, *Time Machine, Ancient Egypt and Contemporary Art*, London, British Museum.

Quiggin A. H., 1949, *A Survey of Primitive Money: The Beginnings of Currency*, London, Methuen.

Ratcliff C., 1983, *Andy Warhol*, New York, Abbeville Press.

———— and Rosenblum R., 1993, *Gilbert and George: The Singing Sculpture*, London, Thames and Hudson.

Renfrew C., 1962, 'The tyranny of the Renaissance', *Cambridge Review* 83, 219–23.

————, 1969, 'The development and chronology of the Early Cycladic figurines', *American Journal of Archaeology* 73, 1–32.

————, 1973, *Before Civilisation: The Radiocarbon Revolution and Prehistoric Europe*, London, Jonathan Cape.

————, 1979, *Investigations in Orkney*, London, Society of Antiquaries and Thames and Hudson.

————, 1982, *Towards an Archaeology of Mind* (Inaugural Lecture), Cambridge, Cambridge University Press.

———— (ed.), 1985a, *The Prehistory of Orkney*, Edinburgh, Edinburgh University Press.

————, 1985b, *The Archaeology of Cult: The Sanctuary at Phylakopi*, London, British School of Archaeology at Athens.

————, 1986, 'Varna and the emergence of wealth in prehistoric Europe', in A. Appadurai (ed.), *The Social Life of Things*, Cambridge, Cambridge University Press, 141–68.

————, 1990, 'Languages of art: The work of Richard Long', *Cambridge Review* 111, 110–14.

————, 1991, *The Cycladic Spirit*, New York, Harry Abrams and London, Thames and Hudson.

————, 1996a, *Sculpture in the Close: The Quincentenary Exhibition*, Cambridge, Jesus College.

————, 1996b, 'The sapient behaviour paradox: How to test for potential?' in K. Gibson and P. Mellars (eds), *Modelling the Early Human Mind*, Cambridge, McDonald Institute, 11–14.

————, 1997, 'Setting the scene', in B. Cunliffe and C. Renfrew (eds), *Science and Stonehenge* (Proceedings of the British Academy 92), London, British Academy, 3–14.

————, 1998a, 'Mind and matter: Cognitive archaeology and external symbolic storage', in C. Renfrew and C. Scarre (eds), *Cognition and Material Culture: The Archaeology of Symbolic Storage*, Cambridge, McDonald Institute, 1–6.

————, 1998b, 'Sculpture as landscape: The Englishness of Henry Moore', Unpublished paper delivered at the University of East Anglia, December 1998.

—————, 2000, *Loot, Legitimacy and Ownership: The Ethical Crisis in Archaeology*, London, Duckworth.

—————, 2001a, 'Symbol before concept: Material engagement and the early development of society', in I. Hodder (ed.), *Archaeological Theory Today*, Cambridge, Polity Press, 122–40.

—————, 2001b, 'Commodification and institution in group-oriented and individualizing societies', in W. G. Runciman (ed.), *The Origin of Human Social Institutions* (Proceedings of the British Academy 110), London, British Academy, 93–118.

————— and Bahn P., 2000, *Archaeology: Theories, Methods and Practice*, London, Thames and Hudson, 3rd edn.

—————, Gimbutas M. and Elster E. S. (eds), 1986, *Excavation at Sitagroi*, vol. 1, Los Angeles, University of California Institute of Archaeology.

————— and Zubrow B. W. (eds), 1994, *The Ancient Mind: Elements of Cognitive Archaeology*, Cambridge, McDonald Institute.

Richards C., 1996, 'Monuments and landscape: Creating the centre of the world in Late Neolithic Orkney', *World Archaeology* 28, 190–208.

Richter G., 1968, *Korai: Archaic Greek Maidens*, London, Phaidon.

—————, 1970, *Kouroi: Archaic Greek Youths*, London, Phaidon.

Ritchie A. (ed.), 2000, *Neolithic Orkney in its European Context*, Cambridge, McDonald Institute.

Robb J. E. (ed.), 1999, *Material Symbols: Culture and Economy in Prehistory*, Carbondale, Center for Archaeological Investigations, Southern Illinois University.

Roberts M. N. and Roberts A. F., 1996, *Memory: Luba Art and the Making of History*. Washington DC, Museum of African Art.

Robinson A., 1995, *The Story of Writing: Alphabets, Hieroglyphs and Pictograms*, London, Thames and Hudson.

Rose B., 1970, *Claes Oldenburg*, New York, Museum of Modern Art.

Rosenberg H., 1978, *Barnett Newman*, New York, Abrams.

Rubin W. (ed.), 1984, *'Primitivism' in Twentieth-Century Art*, New York Museum of Modern Art, 2 vols.

Ryan J., 1990, *Spirit in Land: Bark Paintings from Arnhem Land*, Melbourne, National Gallery of Victoria.

Sachini A., 1984, 'Prehistoric Cycladic figurines and their influence on early twentieth-century sculpture', Unpublished M. Litt. dissertation, University of Edinburgh.

Schäfer H., 1986, *Principles of Egyptian Art*, Oxford, Griffith Institute (first published Leipzig, 1919).

Schele L. and Miller M. E., 1986, *The Blood of Kings: Dynasty and Ritual in Maya Art*, New York, George Brazilier.

Schiffer M. B., 1999, *The Material Life of Human Beings: Artifacts, Behaviour, and Communication*, London, Routledge.

Schmandt-Besserat D., 1992, *How Writing Came About*, Austin, University of Texas Press.

Schnapp A., 1996, *Discovering the Past*, London, British Museum.

Searle J. R., 1995, *The Construction of Social Reality*, Harmondsworth, Allen Lane

Seymour A., 1991, *Richard Long: Walking in Circles*, London, Anthony d'Offay.

Shanks M., 1999, *Experiencing the Past: On the Character of Archaeology*, London, Routledge.

Sherratt A., 1987, 'Cups that cheered', in W. Waldren and R. Kennard (eds), *Bell Beakers of the Western Mediterranean*, (BAR International Series 331), Oxford, British Archaeological Reports.

Skeates R., 2000, *The Collecting of Origins: Collectors and Collections of Italian Prehistory and the Cultural Transformation of Value (1550–1999)* (BAR International Series 868), Oxford, British Archaeological Reports.

Smiles R., 1994, *The Image of Antiquity: Ancient Britain and the Romantic Imagination*, New Haven, Yale University Press.

Sørensen M. L. S., 2000, *Gender Archaeology*, Cambridge, Polity Press.

Sylvester D., 1995, *William Turnbull: Sculpture and Paintings*, London, Merrell Holberton and Serpentine Gallery.

Tanner J., 2001, 'Nature, culture and the body in Classical Greek religious art', *World Archaeology* 33, 257–76.

Thomas J. S., 1996, *Time, Culture and Identity: An Interpretive Archaeology*, London, Routledge.

Thompson M., 1979, *Rubbish Theory*, Oxford, Oxford University Press.

Tiberghien G. A., 1995, *Land Art*, London, Art Data.

Tilley C., 1991, *Material Culture and Text: The Art of Ambiguity*, London, Routledge.

————, 1994, *A Phenomenology of Landscape*, London, Berg.

————, 1999, *Metaphor and Material Culture*, Oxford, Blackwell.

Treherne P., 1995, 'The warrior's beauty: The masculine body and self-identity in bronze age Europe', *Journal of European Archaeology* 3, 105–44.

Trigger B. G., 1998, 'Writing systems: A case study in cultural evolution', *Norwegian Archaeological Review* 31, 39–62.

Tuchman P., 1983, *George Segal*, New York, Abbeville Press

Ucko P. J. (ed.), 1977, *Form in Indigenous Art: Schematization in the Art of Aboriginal Australia and Prehistoric Europe*, London, Duckworth.

Van den Boogert B. (ed.), 1999, *Rembrandt's Treasures*, Amsterdam, Rembrandt House Museum.

Vansina J., 1973, *Oral Tradition.* Harmondsworth, Penguin Books.

Varnedoe K., 1999, *Jackson Pollock*, London, Tate Gallery Publishing.

Veblen T., 1925, *The Theory of the Leisure Class: An Economic Study of Institutions*, London, Unwin.

Voutsaki S., 1997, 'The creation of value and prestige in the Aegean Late Bronze Age', *Journal of European Archaeology* 5 (2), 34–52.

Waldman D., 1989, *Jenny Holzer*, New York, Guggenheim Museum.

————, 1997, *Ellsworth Kelly: A Retrospective*, London, Tate Gallery Publishing.

Walker R. A., 1998, *Olowe of Ife: A Yoruba Sculptor to Kings*, Washington DC, National Museum of African Art.

Walther I. F., 1993, *Paul Gauguin, 1848–1903: The Primitive Sophisticate*, Köln, Benedikt Taschen.

Watkins T., 2002, *The Neolithic Revolution in Southwest Asia*, London, Routledge.

Watson A. and Keating D., 2000, 'The architecture of sound in neolithic Orkney', in A. Ritchie (ed.), *Neolithic Orkney in its European Context*, Cambridge, McDonald Institute, 259–65.

Weiss J., 1998, *Mark Rothko*, Washington DC, National Gallery of Art.

Werner A., 1965, *Modigliani the Sculptor*, London, Peter Owen.

Wheeler R. E. M., 1954, *Archaeology from the Earth*, Oxford, Clarendon Press.

White L. A., 1940, 'The symbol: The origin and basis of human behaviour', *Philosophy of Science* 7, 461–3 (reprinted in L. A. White, 1949, *The Science of Culture*, New York, Grove, Press, 22–39).

White R., 1997, 'Substantial acts: From materials to meaning in Upper Palaeolithic representation', in Conkey M. W., Soffer O., Stratman D., and Jablonski N. G. (eds) *Beyond Art, Pleistocene Image and Symbol* (Memoirs of the California Academy of Sciences 23), San Francisco, California Academy of Sciences, 93–121.

Whiteford K., 1997, *Remote Sensing: Drawings for the British School at Rome*, London, British School at Rome.

Whitford F., 1971, *Eduardo Paolozzi*, London, Tate Gallery.

Williams J. (ed.), 1998, *Money: A History*, London, British Museum.

Wilson P. J., 1988, *The Domestication of the Human Species*, New Haven, Yale University Press.

Wilton A. and Bignamini I., 1996, *Grand Tour: The Lure of Italy in the Eighteenth Century*, London, Tate Gallery.

Wolters P., 1891, 'Marmorkopf aus Amorgos', *Athenische Mitteilungen* 16, 46–58.

Zervos C., 1957, *L'Art des Cyclades*, Paris, Éditions Cahiers d'Art.

Zubrow E. B. W. and Daly P. T., 1998, 'Symbolic behaviour: The origin of a spatial perspective', in C. Renfrew and C. Scarre (eds), *Cognition and Material Culture: The Archaeology of Symbolic Storage*, Cambridge, McDonald Institute, 157–74.

Sources of illustrations

Half-title *Archaeologia*, 1800. **Frontispiece** Courtesy of the artist. Photo Colin Renfrew. 1 Photo Constantin Brancusi. © ADAGP, Paris and DACS, London 2003. 2 Tompkins Collection, Museum of Fine Arts, Boston. 3 By courtesy of Professor J. T. Robinson. 4 Photo John Reader/Science Photo Library. 5 Musée de l'Homme, Paris. 6 © Trustees of the National Museums of Scotland. © Eduardo Paolozzi 2003. All Rights Reserved, DACS. 7 Photo Colin Renfrew. 8 Courtesy of the artist. Photo Beaux Arts, London. 9 Courtesy of the artist. 10 Courtesy of the artist. Photo David Paterson. 11 Courtesy of the artist. Photo Ant Critchfield. 12 © Tate, London 2003. 13 Tompkins Collection, Museum of Fine Arts, Boston. 14, 15, 16 Photos Colin Renfrew. 17 Courtesy of the artist. Photo Colin Renfrew. 18, 19, 20, 21 Courtesy of the artist. 22 Courtesy of the artist. Photo Gwil Owen. 23 Courtesy of the artist. Photo Colin Renfrew. 24, 25, 26 Photos Colin Renfrew. 27 © Alec Daykin. 28 Private Collection. Photo James Ryan. 29, 30, 31 Photos Colin Renfrew. 32 Photo Wendy Matthews. 33 Courtesy of the artist. 34 Courtesy of the artist. Photo Colin Renfrew. 35, 36, 37 National Museum, Athens. Photos by John Bigelow Taylor, N.Y.C. 38 Musée du Louvre, Paris. Photo Christian Zervos. 39 Courtesy of the artist. 40 Royal Collection, Windsor. 41 Courtesy of the artist. Photo Colin Renfrew. 42 The Museum of Modern Art, New York. © Succession Picasso/DACS 2003. 43 The Pushkin State Museum of Fine Arts, Moscow. © Succession Picasso/DACS 2003. 44 Haags Gemeentemuseum, The Hague. © Piet Mondrian 2003 Mondrian/Holtzman Trust c/o Beeldrecht, Hoofddorp & DACS, London. 45 Private Collection. © Piet Mondrian 2003 Mondrian/Holtzman Trust c/o Beeldrecht, Hoofddorp & DACS, London. 46, 47 Philadelphia Museum of Art. © ADAGP, Paris and DACS, London 2003. 48 National Gallery of Art, Washington, D.C. Gift of Eugene and Agnew E. Meyer, 1967. © ADAGP, Paris and DACS, London 2003. 50 Galerie Louise Leiris, Paris. © Succession Picasso/DACS 2003. 51 Musée Picasso, Paris. 52 Photograph by William B. Fagg (WBF1959/81/5) © Royal Anthropological Institute of Great Britain and Ireland. 53, 54 Courtesy of the artist. 55 Musée du Louvre, Paris. 56 © Tate, London 2003. 57 Courtesy of the artist. Photo Colin Renfrew. 58 Courtesy of the artist. 59 Naturhistorisches Museum, Vienna. 60 Musée de l'Homme, Paris. 61 Photo Colin Renfrew. 62 Copyright Christo, 1995. Photo Wolfgang Volz. 63 Copyright Christo, 1983. Photo Wolfgang Volz. 64 Damien Hirst c/o Science. 65 Courtesy Artangel. Photo Stephen White. 66, 67 Courtesy Jay Jopling (London). 68, 69, 70 Courtesy of the artist. Photos © Andrew Cross. 71 Courtesy of the artist. Photo © Tate, London 2003. 72, 73 Courtesy of the artist. Photos Galleria Emi Fontana, Milan. 74 Courtesy of the artist. Photo © Andrew Cross. 75 Archaeological Survey of India. 76, 77, 78 © Mark Dion & Robert Williams. Photos Roger Lee. 79, 80 Courtesy of the artists. 81 By courtesy of the National Portrait Gallery, London. 82 British Library, London. 83 *Archaeologia*, 1800. 84 Photo Barney Burstein. © Succession Marcel Duchamp/ADAGP, Paris and DACS, London 2003. 85 Collection Galleria Schwarz, Milan. © Succession Marcel Duchamp/ADAGP, Paris and DACS, London 2003. 86 © Succession Marcel Duchamp/ADAGP, Paris and DACS, London 2003. 87 © Succession Marcel Duchamp/ADAGP, Paris and DACS, London 2003. 88 The Museum of Modern Art, New York. © Succession Marcel Duchamp/ADAGP, Paris and DACS, London 2003. 89 Courtesy the artist. 90, 91 Tate Gallery, London. Photos Steve White. 92, 93 Photo Colin Renfrew. 94, 95, 96 Courtesy Cornelia Parker/Frith Street Gallery. 97 Photo Joan Root. 98 Photo Jean Vertut. 99 Musée de l'Homme, Paris. 100 Photo Goran Bührenhalt. 101 David L. Clarke. 102 Courtesy of the French Ministry of Culture and Communication, Regional Direction for Cultural Affairs – Rhône-Alpes, Regional Department of Archaeology. 103 Photo Sinclair Stammers/Science Photo Library. 105 British Museum, London. 106 Photo John Reader/Science Photo Library. 107, 108 Courtesy of the artist and Jay Jopling/White Cube (London). Photos Colin Renfrew. 109, 110 Courtesy of the artist and Jay Jopling/White Cube (London). 111 Courtesy of the artist and Jay Jopling/White Cube (London). Photo John Crook. 112 Photo Scala, Florence. 113 Photo AKG, London. 114 Hirshhorn Museum and Sculpture Garden, Smithsonian Institution, Washington, D.C. © The George and Helen Segal Foundation/DACS, London/VAGA, New York 2003. 115 Walker Art Center, Minneapolis. © The George and Helen Segal Foundation/DACS, London/VAGA, New York 2003. 116 Whitney Museum of American Art, New York. © The George and Helen Segal Foundation/DACS, London/VAGA, New York 2003. 117 Staatsgalerie Moderner Kunst, Munich. © The George and Helen Segal Foundation/DACS, London/VAGA, New York 2003. 118 Musée des Antiquités Nationales, St. Germain-en-Laye. Photo Jean Vertut. 119 National Museum of Scotland, Edinburgh. Courtesy of the artist. 120 Hirmer Fotoarchiv. 121 Courtesy of the artist. Photo Beaux Arts, London. 122 Photo Colin Renfrew. 123 Photo Emily Lane. 125 Photo Kathy Tubb. 126 © Trustees of the National Museums of Scotland. 127 Photo Colin Renfrew. 128 Photo Simon Martin. 129 © Trustees of the National Museums of Scotland. 130 Photo Giraudon. 131 Photo Flowers East Gallery, London. © Eduardo Paolozzi 2003. All Rights Reserved, DACS. 132 © The Dean Gallery, Scottish National Gallery of Modern Art. © Eduardo Paolozzi, 2003. All Rights Reserved, DACS. 133 © The Dean Gallery, Scottish National Gallery of Modern Art. © Eduardo Paolozzi, 2003. All Rights Reserved, DACS. 134 The Nelson-Atkins Museum of Art, Kansas City, Missouri. Photo Attilio Maranzano. 135 Centre Square Plaza, Fifteenth and Market streets, Philadelphia. Photo Attilio Maranzano. 136, 137, 138 Courtesy of the artist. Photos © Tate, London 2003. 139 Courtesy of the artist. Photo © Tate, London 2003. 140 Private Collection. Courtesy of the artist. 141 Courtesy of the artist. Photo John Christie. 142 Courtesy of the artist. 143, 144 Egyptian Museum, Cairo. 145 From *Annual of the British School in Athens*, VII, 1900. 146 Mrs M. A. Mellaart. 147 Paolo Matthiae. 148 Courtesy the artist. 149 Photo British Museum, London. 150 Museo Archeologico Nazionale, Naples. 151 Agora Excavations, American School of Classical Studies, Athens. 152 Courtesy Hilprecht Collection of Near Eastern Antiquities, Jena. 153 Courtesy Lisson Gallery. Photo John Riddy, London. 154 Courtesy of the artist. 155, 156, 157 Courtesy of the artist. Photos David Paterson. 158, 159 © ARS, NY and DACS, London 2003. 160, 161 Photos Edward Klamm. © ARS, NY and DACS, London 2003. 162 Photo Steve White. © ARS, NY and DACS, London 2003. 164, 165 British Museum, London. 166 Photo Lisa Kahane. © ARS, NY and DACS, London 2003. 167 Private Collection, Switzerland. © The Andy Warhol Foundation for the Visual Arts, Inc./ARS, NY and DACS, London 2003. 168 Louisiana Museum of Modern Art, Humlebaek, Denmark. © The Andy Warhol Foundation for the Visual Arts, Inc./ARS, NY and DACS, London 2003. 169 Courtesy Monika Sprüth, Cologne. Copyright: Andreas Gursky © DACS 2003. 170 Courtesy of the artist. Photo © Andrew Cross. 171 Courtesy Lisson Gallery. Photo Stephen White, London. 172 Courtesy Lisson Gallery. Photo Harry Cock. 173 © Trustees of the National Museums of Scotland.

Index